BETTER BUILD
LEARNING FROM BUILDINGS IN USE

RICHARD PARTINGTON
SIMON BRADBURY

RIBA ⬚ **Publishing**

© RIBA Publishing, 2017

Published by RIBA Publishing, 66 Portland Place, London, W1B 1AD

ISBN 978-1-85946-586-8

The rights of Richard Partington and Simon Bradbury to be identified as the Authors of this Work have been asserted in accordance with the Copyright, Designs and Patents Act 1988 sections 77 and 78.

British Library Cataloguing-in-Publication Data.
A catalogue record for this book is available from the British Library.

Commissioning Editor: Ginny Mills
Project Manager: Michèle Woodger
Designed and typeset by HD Design
Printed by: W&G Baird Ltd, Great Britain

While every effort has been made to check the accuracy and quality of the information given in this publication, neither the Author nor the Publisher accept any responsibility for the subsequent use of this information, for any errors or omissions that it may contain, or for any misunderstandings arising from it.

www.ribaenterprises.com

Contents

Acknowledgements

We are very grateful to the following individuals for their expertise, advice and contributions to essays and case studies found in this book:

Tom Kordel, Director, XCO2 Energy; Bill Gething, University of the West of England; Mark Lumley, Associate Director, Architype; Dr Judit Kimpian, Director of Sustainable Architecture and Research, AHR Architects; Bill Bordass, Principal, William Bordass Associates; Roddy Langmuir, Practice Leader, Cullinan Studio; Max Fordham; Rajat Gupta, Director, Oxford Institute for Sustainable Development; Ian Goodfellow, Partner, Penoyre & Prasad; Robin Nicholson, Senior Practice Partner, Cullinan Studio; Rachel Stancliffe, Studio Partington.

About the authors

Richard Partington is co-founder and director of Studio Partington, an award winning design practice working in housing, urbanism and regeneration. Richard has written and illustrated best practice guides for the NHBC Foundation and various construction organisations including the Zero Carbon Hub, where he served as architect advisor. Richard co-chaired the Design vs As Built steering group set up by the Hub to investigate the potential performance gap between predicted and actual performance in new housing. Richard has been an expert advisor to the Ministerial Advisory Group in Northern Ireland and a Design Council CABE enabler. He has taught and lectured at Cambridge University, UCL and University of Wales, Cardiff and has written articles for RIBA, CIBSE and Architect's Journals.

Simon Bradbury is Head of Architecture and the Built Environment at Plymouth University. He sits on the RIBA research and innovation group and has published research on the influence of design process on the performance gap and guides for the RIBA on undertaking post occupancy evaluation in practice. He has a background in both industry and Government. In Government he worked at the Commission for Architecture and the Built Environment (CABE) where he was responsible for the commissioning of research to influence changes in policy on issues including sustainable masterplanning, housing and the value of good design. He is a registered architect with over 10 years experience and has worked for internationally recognised architecture and urban design practices.

Preface

Better Buildings – learning from buildings in use

This book started life as a successor to David Turrent's popular *Sustainable Architecture*, first published in 2007 by RIBA Publishing. Since that book's appearance, much has changed in the UK: we have seen the birth, accompanied by a great fanfare, of a Zero Carbon Buildings policy both for new homes and non-domestic buildings. Considering the comparatively low starting point, the proposed trajectory for achieving zero carbon was astonishingly rapid, and in the interim the Building Regulations have been updated twice and become increasingly complicated. But neither the technical standards nor the intended programme for zero carbon have built in space for analysis, reflection and measurement, or for learning. Surprisingly, far fewer than half of the buildings originally featured in *Sustainable Architecture* have been subject to a post-occupancy review or even revisited by their designers. This book sets out to redress this balance by considering how buildings work and are occupied, and the methods used to study them.

Introduction

One of the aims of this book is to raise interest in building performance among designers and their clients, whether through better handover processes or by commissioning more structured research and study. It goes without saying that most building professionals recognise the value of follow-through and involvement after handover, but they are often obstructed by the procurement processes or distanced, unintentionally, through a lack of planning and forethought when a commission is undertaken. We hope that by showing the benefits, to clients and occupiers, of what has been achieved in individual projects and by leading practices, some of these perceived barriers can be overcome.

If architects and the wider construction industry fail to build in time for analysis, reflection and measurement of buildings we may lose opportunities to develop technical solutions, improve details and learn from our mistakes. In the lead up to completion much effort is put into certification and getting sign-off and we routinely consider that the job is done when the building is handed over.
As a consequence design processes are often focused on the wrong outcomes. Any amount of theoretical ingenuity can now be deployed in calculations to demonstrate compliance, often with little understanding of how this will be followed through by building users. We rarely return to a project to ensure that it is performing as intended. We have neglected to talk to users, observe how our buildings have worked, and look at how they have been adapted and whether the environments we are creating are enjoyable to be in.

The book is divided into two sections: a selection of short essays is followed by a series of case studies across different building types. The case studies try to present an honest account of the buildings in use, and the contributors – both clients and designers – should be commended for sharing information about failures as well as successes. The case studies we have selected are all buildings whose design quality has been recognised, many through awards, but which exhibit a wide range of design approaches. This has implications for their performance, both technically and in terms of how they are appreciated by their users. Great skill in detail and execution is needed to achieve, for example, the joyful exuberance of John Hope Gateway (featured on the cover), but the building's design brings its own complications for systems and operation. By contrast, the seemingly stark exteriors of some of the other case study buildings are rooted in an environmental approach that influences every early decision about form and complexity. The purpose of this book is not to promote a particular approach over any other, but to bring more closely into scrutiny the balance that designers have sought between technical surety and formal invention. In editing and reviewing the case studies we have been conscious of

the difficulty of trying to present objective analysis and supporting data alongside illustrative material that conveys the quality of materials, daylight and space. The case studies are fewer in number but longer than those in this book's predecessor, *Sustainable Architecture*, allowing for more commentary and evaluation. A short section that explains the evaluation techniques precedes the case studies.

The introductory essays at the start of the book are intended, as far as possible, to be self-contained – and, as with the case studies, do not need be read sequentially. There are three themes: Essays 1 and 2 discuss performance evaluation techniques. The first is a simple introduction aimed at a reader unfamiliar with the concepts. It makes a case for practical, well-planned evaluation that does not necessarily require large sums of money to be invested in academic research. It suggests that, with the input of an experienced building performance evaluator, in-use analysis is possible using the capabilities of building designers, constructors and operators. There are simple recommendations here for all projects to achieve better outcomes and more feedback for design and professional development. The first essay also outlines the value of structured empirical research, and this leads on to the second contribution, by Tom Kordel, which summarises the programme of work supported by Innovate UK, in which a large number of buildings were studied in a systematic way over a usefully long period of time. Each of the research teams was supported by an academic and an experienced building evaluator, and each project had a structured survey of user feedback. The essay identifies the common techniques used in all of the Innovate UK projects, and the lessons that emerged from this very substantial survey. Kordel also discusses some of the challenges facing the industry, in terms of collecting and interpreting building performance information. Many of the projects featured were unable to accurately report energy use for different activities from the sub-meters as installed. Nearly all suffered under-performance through unsatisfactory commissioning and set-up of building services controls. It would seem that there is some way to go before we have reliable protocols for managing these processes. The Innovate UK programme has been the source of a number of our case studies, and each of these has a full and publicly available research report that analyses all of the measured data and occupant feedback.

The second theme is the 'performance gap' introduced in Bill Gething's summary of the work overseen by the Zero Carbon Hub. His essay draws largely from evidence from the house-building sector, but the lessons are relevant more generally for architectural education, design and procurement, and construction management. Here Gething sets out the scale and consequences of the problem. In Simon Bradbury's essay it becomes very clear how simple design decisions have a substantial impact on outcomes. Bradbury gives advice to designers, drawing on experiences in teaching, research and practice. He highlights the need to model impacts on energy intelligently, but also to be

aware of the limitations of the modelling tools especially where these have become so closely tied to the compliance processes of achieving Building Regulations approval. This discussion raises questions about the role of the energy modeller or building physicist within the design team, and emphasises the collaboration and understanding that is needed across building professions, and between practice and academia. In most of the projects in this book researchers have been working alongside practices to help them interrogate and understand their buildings and disseminate the findings.

To illustrate this collaboration the next pair of essays, by Mark Lumley and Dr Judit Kimpian, give accounts of the way that working processes within their respective practices have evolved after many years' involvement in research and building evaluation. Both Architype and AHR have been able to secure repeat commissions for particular building sectors based on the accumulated knowledge and experience collected through 'research in practice', or through collaborations and formal knowledge-sharing structures. Lumley's Architype essay describes how the practice's passion for Passivhaus evolved out of a concern with energy performance and internal comfort in schools. Judit Kimpian brings a wider experience of low-energy design and policymaking from a European perspective, reflecting on the importance of disclosing performance data and the value of benchmarking through platforms such as CarbonBuzz, which she helped to establish. Kimpian suggests that with all of the changing standards, definitions and calculation protocols we have focused on theoretical performance and predictions, and not on real outcomes. By separating 'regulated' energy from the total energy consumed 'in use' and restricting the scope of Building Regulations to the fixed systems that supply ventilation, heating and lighting, we are ignoring the substantial part of the energy 'budget' that the occupiers control. She also introduces alternative frameworks for improving performance, such as commitment agreements between designers and constructors, and clients. Using these quite personal accounts we hope that the approach of these practices can be emulated, and that some familiarity with building performance evaluation techniques can be obtained by a wider spectrum of professionals.

Appropriately, these three groups are rounded off by Bill Bordass, who reflects on decades of political and cultural inertia that seem to have prevented progress in this area – but also looks, more optimistically, to the future. If you are a client or a building professional completely new to the subject and unaware of its significance, this is the place to start.

ESSAY 1

Richard Partington, Studio Partington

Building performance evaluation

At every stage of building design we have to navigate a multitude of technical standards and regulations, from the mundane rules that fix the width of a stair to the elusive performance indicators that seek to safeguard 'design quality'. But, as Bill Gething explains in his essay, despite this barrage of performance standards, the difference between what we intend, through design, and what we achieve, in reality, is widening – most obviously in energy use, but also in comfort and productivity.

Although evidence of a performance gap has existed for decades, it is only recently that industry has widely recognised that what matters is the building's actual operation in use. A new stage in the restructured RIBA Plan of Work (Stage 07) anticipates an architect's involvement post-completion. Though loosely defined it recognises that information gathering, evaluation and review after handover will help to get buildings working better. However, it is not just the immediate period of 'bedding in' – when the systems can be monitored, adjusted or fine-tuned – that should be of concern. If we really want to understand how buildings are working and improve our future designs, we need to commit to a sustained period of observation and some form of post-occupancy evaluation (POE).

This essay introduces the common tools for structured information gathering (from the indicative to the more diagnostic), and suggests some of the benefits for architects and their clients.

Types of evaluation

The techniques for POE are well established. Building on the pioneering work of the Building Performance Research Unit at the University of Strathclyde in the 1960s and 1970s, the PROBE Studies[1] of the 1990s combined an assessment of technical and energy performance, an air-pressure test on the building fabric, and a user survey based on a concise and targeted questionnaire.

Similar tools had also been applied in the United States in the study of university dormitory buildings, housing and Federal buildings. Wolfgang Preiser, who documented the evolution of POE and developed process models for conducting evaluations, describes POE as 'a process of systematic performance evaluation of buildings after they have been built and occupied for some time'.[2]

A POE can serve a range of purposes from simply observing a building in use 'as it is' to testing against specific performance criteria set in the briefing process, but it always has a component of user feedback. POE tends to be undertaken in the early years and ideally provides useful information for the client, design and building team. The term building performance evaluation (BPE) usually refers to the whole field of building study including purely academic research. More recently work by the Usable Buildings Trust has translated these techniques into more client-oriented tools, helping to diagnose and solve problems and get buildings working efficiently for their users, balancing 'hard' technical measurement (temperature, air quality, carbon emissions) with 'softer' issues (productivity, ease of use, comfort) identified by questionnaire, interview and observation.

Soft Landings

POEs show that new buildings seldom work at their best without some running in, like the 'sea trials' of an ocean vessel. However, as Bill Bordass observes, most designers are only required to direct their efforts to design and construction up to handover: 'their job description being to procure the facility, not to breathe life into it'.[3]

Soft Landings[4] was therefore developed to help improve the situation, using a framework that can be applied to any procurement process, to give more attention to in-use outcomes. It allows considerable flexibility, so that teams can make it their own. It starts at inception and briefing, helping to change the culture of a project. It continues with review and reality checking through

design and construction, before entering the critical stages in the weeks or months immediately before and after handover and finishing with extended aftercare and POE. Experience, particularly though the User Group convened by BSRIA, shows that the most important ingredient is leadership, helping team members to collaborate and understand each other.

Most buildings do undergo some testing: an airtightness test and possibly some acoustic testing, and commissioning of heating and ventilation equipment. But these tests are usually done once, to demonstrate regulatory compliance, rather than seasonally to prove effective operation throughout the year. Rigorous commissioning of equipment and controls is essential, but is no guarantee that a building will be comfortable to occupy, practical to operate and maintain, or perform as intended. An essential component of a POE, therefore, is the user's assessment, and this implies a judgement of successes and failures.

Recent studies

BPE has continued since the PROBE studies, spurred by a greater adoption of the Soft Landings methodology. In addition, work on domestic housing in the UK and internationally began to reveal a performance gap between design intentions and energy in use. The government-sponsored BPE studies, funded by Innovate UK covered buildings of all types and combined the three common POE activities: a review of the design intention, measurement and data collection, and a survey of user experiences. For the user survey the BUS (Building Use Studies)[5] methodology was adopted, and for reporting energy use CIBSE's TM 22 tool[6] was required for all non-domestic projects, with the aim being to make ready comparisons across each building type. Innovate UK also required data from the projects to be uploaded to CarbonBuzz[7] and that the studies provided feedback to the occupier of the building. The Innovate UK projects gathered lots of measured information over a long period, often frequently. One of the aims was to build a better picture of how new buildings were performing for benchmarking, but it is not necessary to collect large amounts of metered data to conduct a useful evaluation. The outcomes of this study are discussed in Essay 2.

Levels of evaluation

It is possible to undertake POE for individual projects without getting research funding, but one needs to establish the scope and purpose of an evaluation by setting reasonable expectations and working to a manageable programme, not collecting data for the sake of it. The resources for POE must be considered early on and built in to the relevant work and tender stages to ensure that everyone involved is committed. Preiser emphasised the planning and briefing as well as the actual evaluation, and the RIBA has sensibly coupled Stages 0, 1 and 7 in its guide to the Plan of Work.[8] He describes three distinct levels of evaluation: indicative, investigative and diagnostic.

Indicative studies based on walk-rounds and user feedback give an indication of the buildings' strengths and weaknesses and may trigger improvements in themselves, especially where they reveal difficulties with the use of controls and management systems. Indicative studies may also shape a second phase of investigation. Learning that a building is too hot in summer might prompt investigative study of internal and external temperature measurements, CO_2 levels, equipment gains and occupancy. Generally these will be objective measurements to obtain a better understanding of causes and effects and to help solve problems. In theory some or all of this information will be available from the building management system or the sub-meters, if installed and commissioned correctly.

Further study might be at a component level (heat pump or fan efficiencies) or in the detail of the controls software and settings, leading to improvements informed by the previous investigations rather than by hopeful experimentation or 'fiddling' with the controls. Diagnostic POE aims to thoroughly correlate environmental measurement with subjective user response to establish what can be done to improve a building and provide learning for the future. In *Retrofit for Purpose*[9] Roderic Bunn gives a full description of BPE processes and illustrates how evaluation activities can be integrated within the Plan of Work. The main principles apply to both new build and retrofit, and general advice is to take on a manageable amount without being too ambitious.

- Adopt handover procedures that recognise the time the building will take to 'bed in'.
- Start POE with a structured walk-round with an experienced evaluator, the contractor and the building users.

- Undertake a user survey and an energy audit.
- Use measurement and analysis in a graduated way (observe, investigate, interrogate) based on the performance measures that are important to the user.
- Use Soft Landings to change cultures and aspirations, not as a bolted-on box-ticking exercise.

The benefits of evaluation

In addition to being used to optimise performance and support building users, evaluation can also be used to set design targets within projects and to learn and provide feedback to practices across projects. Many practices in this book are using evaluation as a tool to deliver better quality to clients through these processes.

For example, BPE has played a substantial role in setting the environmental targets and design standards for the Joseph Rowntree Housing Trust (JRHT), which has been working on plans for a new community at Derwenthorpe on the edge of York for over two decades. Derwenthorpe aims to be sustainable, equitable and affordable: a template for future developments. Evaluation of the performance gap and the wider sustainability objectives has been built in to a feedback process as the project has developed, through a series of prototypes and in the delivery of the main project (see Case Study 9).

The idea of the prototypes was to develop workable construction details and heating and ventilation systems using affordable technology, so that all the future homes could adopt these on the large-scale build (550 homes in total).

The learning gleaned from the prototypes was transferred via JRHT's team to the development partner, who adopted the construction details developed for the prototypes. A robust feedback and learning process was embedded in the early building phases, and the results of testing set a new benchmark for volume builders. All of the Phase 1 homes achieved an airtightness of around $2m^3/(h.m^2)$ with very little variation across the phase – an indication of the consistently high build quality. Testing, measurement and inspection also played a significant part in the delivery of the first phase.

Not every project sets out with ambitions to influence industry, and not every client would be willing, as JRHT has, to share its findings, including the shortcomings of earlier pilot projects. However, the work sponsored by JRHT has been highly influential, initiating research into the performance gap

and helping develop techniques for measuring housing performance. For larger institutional clients who are building over a long period, benchmarking and performance testing are recognised tools for improving the quality of their estate over time – resulting in long-term savings on energy, and more productive and happier occupants.

Evaluation can also provide feedback across different projects. The Woodland Trust project (Case Study 1) builds on work from an earlier project for the National Trust, at its central office, Heelis in Swindon. The Wilkinson Primary School project (Case Study 6) builds on learning from a similar team that delivered St Luke's Primary School (Case Study 5). Finally the design approach for Greenfields House (Case Study 2) draws heavily on a design strategy established by the Charities Aid Foundation building, which was reviewed as one of the original PROBE Studies in the 1990s.

This structured learning between projects allows architecture practices to develop their knowledge, and as a consequence offer a valuable service to their clients. Evaluation and learning between projects is an important factor for many of the architecture practices represented in this book.

Conclusions

BPE and POE must become critical processes for clients, architecture practices and the industry if we are to improve what we do and solve the societal challenges we currently face. This does not necessarily mean complex and expensive design, but rather focusing on an essential understanding of what we are trying to achieve and how to test it on occupation.

A common theme in this book is the complicating effect of design for 'statutory compliance' (Building Regulations) rather than designing for end users. What seems to us simple can be unfathomable to the end user in operation, and in an age of seemingly constant technical advancement we may confuse 'functionality' with improved 'usability'. Although Bill Bordass's maxim to 'keep it simple and do it well' should be recited before every design team meeting, we are still learning what simple really means.

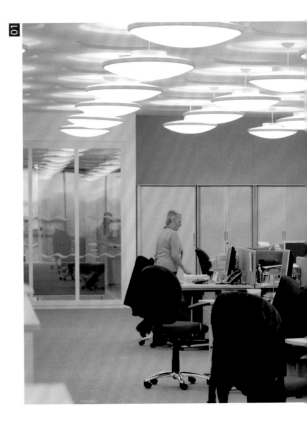

01

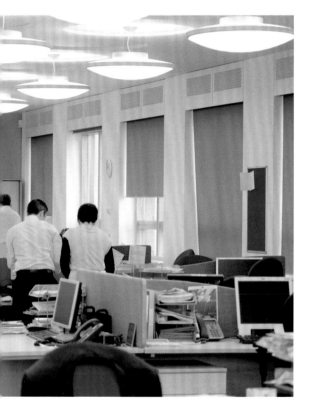

How much evaluation is needed?

Undertaking an evaluation of a building is often seen as a costly and time-consuming process that clients will not be able to afford. However, this is not necessarily the case, and often the most important issues can be picked up through structured observation and a user survey.

In the photograph in Figure 01 the sky is light but overcast. All the blinds are down, which suggests that earlier in the day there must have been some issues with brightness and glare. The desks that were affected by glare are no longer occupied, but those deeper into the space have less daylight because the blinds are still down. It is the middle of the day but all of the lights are on.

In this building the glare issue was quite localised, and could have been managed when first reported. Instead of encouraging the proper use of the blinds, the issue was ignored and escalated. Eventually a glazing film manufacturer recommended that the south, east and west elevations of the entire building be retrofitted with anti-glare film. As a result daylight was reduced and artificial light increased, with a corresponding increase in energy consumption that was revealed by the measured data. Perhaps a meeting between the designers, an experienced evaluator, the contractor, the users and managers would have averted this hasty decision, which has led, unintentionally, to the lights being on unnecessarily.

ESSAY 2

Tom Kordel, XC02

Learning from the Innovate UK building performance evaluation programme

In May 2010 Innovate UK began an £8m funding programme of building performance evaluation (BPE) studies for new buildings in the UK. In total 101 in-depth post-occupancy studies were completed on a range of domestic and non-domestic building types, with the aim of identifying the extent of and contributing factors to the 'performance gap'. The studies involved project teams collecting design and in-use operational data in order to assess performance aspects such as energy, CO_2, comfort and occupant satisfaction.

This chapter discusses the programme's findings, and next steps for BPE.

It is widely acknowledged that within the building industry a 'performance gap' exists between design potential and operational reality. In other industries, such a disparity between pre-purchase promise and actual performance would lead to recall and replacement. However, in construction, where feedback is often non-existent, few are held to account. As a result, our end product fails to improve.

It was with this performance gap in mind that Innovate UK launched an £8m, four-year programme of competitive funding to carry out BPE studies on new buildings in May 2010. The UK has set challenging targets to tackle climate change, starting with the goal of achieving an 80% reduction in carbon dioxide emissions by 2050, with an intermediate goal of 26% by 2020 compared to 1990 levels. With about 37% of the UK's CO_2 emissions coming from buildings[10] it is vital that we learn from our buildings in use, and use the findings to feed back into our design, construction and delivery.

The Innovate UK programme had four primary aims:

• to gain real-world performance data from recently completed buildings
• to enable the industry to learn more about the factors and variables that influence performance
• to embed a culture of building performance evaluation in the construction industry
• to generate a knowledge base of building performance case studies.

Under the Innovate UK programme, a total of 53 domestic projects encompassing 350 dwellings, and 48 non-domestic projects incorporating 55 separate buildings were successful in receiving BPE funding. These projects came from across a wide selection of typologies throughout the UK. Such a large and detailed programme of building performance studies has rarely been carried out, with few predecessors being publicly available and widely circulated (the PROBE Studies being a notable exception).[11]

Project teams were led by architects, engineers, clients, consultants and contractors. All project teams consented to their buildings' performances being made transparent and, as such, subject to scrutiny. In addition the project teams carried out much of the evaluation and analysis required themselves.

Successful applicants were fully funded to carry out either six-month early-occupancy or two-year in-use studies in order to gather data and assess their buildings' performances with respect to:

- operational energy use and the associated CO_2 emissions
- thermal comfort
- occupant satisfaction
- reliability, maintenance and maintainability
- usability of controls and building management systems (BMS)
- low- and zero-carbon technology.

In order to support the participants and improve the quality and consistency of output, a panel of Expert Evaluators was formed. Projects were split between individual evaluators, who oversaw each study from start to finish.

Common themes from the programme

Innovate UK Expert Evaluators assessed the findings across the programme.[12] This included comparing key data such as measured and Part L (Building Regulations on energy use) predicted annual CO_2 emissions, as well as identifying where more qualitative findings occur on several projects. A number of common themes have emerged, summarised below.

Energy consumption is often much higher than design calculations suggest. Standard Assessment Procedure (SAP) and Simplified Building Energy Model (SBEM) are not meant to accurately predict energy in operation. However, the scale of disparity (actual emissions were 1.7–9 times the Building Regulations emissions rate, with an average of 3.7 times higher across the non-domestic projects within the programme)[13] is significant (see Figure 01). The failure of compliance tools to account for the complexity of human behaviour and the imperfect reality of an occupied building accounts for only some of this difference. Much of the gap is a result of failings across the entire building process, from initial design, to construction, through to operation and maintenance.

Low-energy regulations and incentives can influence system complexity. Many of the projects involved in the programme were constructed with low-carbon ambitions, whether motivated by mandatory planning conditions (e.g. BREEAM or Code for Sustainable Homes ratings), financial incentives or voluntary factors from progressive clients. These low-carbon design targets are

linked to compliance tools; frequently the tool is misused for design purposes, which leads to unnecessary complexity. For example in one project, a ground-source heat pump (GSHP) was deemed to create a significant enough CO_2 saving in SBEM that including it would trigger a financial incentive that allowed it to be installed for free. The GSHP was integrated into a design already including biomass boilers, gas boilers and mechanical ventilation with heat recovery (MVHR). Subsequently the building has experienced high energy use that is partly a result of uncertainty over the complex control strategy for the building's multiple systems.

Lack of post-occupancy data means buildings may not be equipped to operate efficiently. There was difficulty in undertaking a large number of non-domestic BPE studies due to inadequate data: missing building log books, incomplete operation and maintenance (O&M) manuals, and omitted commissioning certificates. However, the greatest difficulty arose from the quality of sub-metered energy data. Insufficient metering, un-commissioned and low-quality meters, and inaccurate or absent logging systems proved to be commonplace. Unfortunately, the standard of sub-metering affected the programme; a number of projects had to be modified or requested time extensions in order to rectify metering systems. Once corrected, the metering and monitoring systems did provide the data needed to measure performance, identify energy waste and begin to optimise a building's performance. However there remains a significant shortfall in the sub-metering being delivered, which creates barriers to improvement within individual buildings.

Innovation requires care and attention pre-and-post construction.
A number of the projects incorporated innovative building systems such as earth tubes, automated natural ventilation controls, night cooling, hot water heat recovery and others. Such systems offer potential for improved performance but also carry a certain amount of risk to inexperienced design teams, contractors and clients. It is important to consider the commissioning and maintenance requirements of such systems as well as the detail of how they will integrate with more standard building features. For example, in one project an automated natural night ventilation system created an unexpected maintenance burden because of the large amount of mechanical actuators. In another, the night ventilation strategy was deactivated as a result of loose office paper setting off security alarms. This was an unforeseen impact that could have been avoided with a different initial design of the security system.

RATIO OF ACTUAL CO$_2$ EMISSIONS/m²/yr TO BER ESTIMATE 01

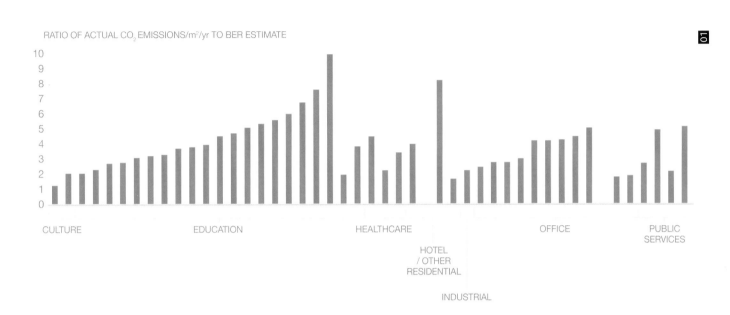

Handover and commissioning is a necessity, not a luxury. Commissioning was given as a common reason when tracing the route of an in-use problem back to its source. Examples included presence-controlled lighting that rarely turned off, CHP engines that rarely turned on, sub-meters reading zero and MVHR systems that failed to supply sufficient fresh air to new dwellings. The simple solution to these types of problems is to ensure that commissioning is carried out properly; the reality of the situation is that a client's rush to occupy often prevails. With an overrun in construction, a squeezed or compromised commissioning and handover period seems like the only workable solution. The programme has shown that such a decision can have significant consequences on operational energy, utility cost and occupant comfort that stay with a building for years to come, far beyond practical completion. This occurs even in instances where BREEAM credits for seasonal commissioning have been awarded. The importance of this period of calibration and fine-tuning both pre-completion and in early occupancy cannot be overstated, yet this phase of the project is so often hurried or ignored altogether.

Provide users with controls that are useful and intuitive. Controls take many forms in buildings, from automated weather compensation and complex building management systems (BMS) to common rocker light switches and simple window handles. Inevitably, as buildings integrate often-unavoidable technology and innovation in the quest for CO_2 savings, controls become complex. Poorly designed control strategies can lead to high energy use and poor comfort. This was particularly the case with BMS where, in many cases, they were not used in operation due to faults, limited handover and absent user manuals. A small number of simple controls seems to be the most successful strategy. Intuitive interfaces that focus on the most common use of the control, rather than trying to provide for every eventuality, are also important.

Building fabric is getting better but there is more to do. As part of the programme, pre-completion domestic projects were required to carry out airtightness tests, infra-red thermography and co-heating tests. The results of these projects suggest that the thermal performance of building fabric has improved with the inclusion of maximum U-value and airtightness standards within Part L of the Building Regulations. However in many cases, the results of the on-site testing fell short of the standards they set out to achieve. In particular, significant thermal bridges were clear on some projects, and unintended air leakage paths on others. Many of the issues found could be alleviated and high thermal performance standards achieved through the use of clear and comprehensive drawings and the presence of an experienced site manager.

Overheating is a significant risk that is not being addressed effectively. Thermal comfort monitoring was a mandatory part of the programme for buildings in operation. The monitoring results indicate that overheating is commonplace and most evident in domestic properties, with a variety of design and operational factors contributing to this effect. The design of glazing, natural ventilation, shading, MVHR, closed communal corridors and heating systems all need to be considered holistically in order to address overheating. The heightened risk of overheating in UK homes has also been highlighted in research carried out by Zero Carbon Hub, and is summarised by Gething in Chapter 3.[14] Overheating is a problem that will get worse with the effects of climate change and must therefore be treated as seriously as fabric heat loss has been previously.

Lessons for carrying out BPE

The BPE studies within the programme are unlikely to be replicated at the same level of detail in the future without similar external funding. However, the benefits of a study can be repeated, through integrating BPE tasks into design and construction programmes, distributing responsibilities among typical project team members, and prioritising the BPE techniques that are most useful to the team – and, more importantly, to the occupants – so that feedback on performance of the building can be gathered in use.

Fabric performance techniques such as airtightness, smoke pen tests and infra-red thermography are most useful when staged at the point in construction when fixing faults would be least expensive. This is particularly important when inexperienced project teams aim for best-practice fabric standards such as those within Passivhaus.

Checks and verification of the accuracy of metering and monitoring equipment must occur prior to contractors and the relevant subcontractor leaving the site. Metered data is the primary basis for optimising a building in use, and without it building or facilities managers have no hope of achieving the design targets for the building.

Data overload when analysing large data sets is difficult to avoid, and therefore a progression of analysis should be followed, from high-level through to fine detail. Evaluators should begin with annual utility data for benchmarking against industry standards such as CIBSE TM46[15] before assessing monthly, then weekly and finally daily energy profiles. Profiles for unexplainable or inefficient behaviour should be assessed before digging deeper into each issue identified. Detailed analysis such as correlation with user profiles and BMS data or further on-site testing should be used for individual problem solving rather than from the outset of a BPE study. The same is true when considering comfort and occupant satisfaction. A high-level occupant satisfaction survey can help to identify areas of a building with comfort problems prior to carrying out detailed temperature, humidity and air-quality monitoring.

BPE requires the collation of qualitative data and not just the recording of quantitative data. Qualitative information obtained through interviewing occupants and project team members is invaluable in understanding why

problems identified through the study have occurred. Informal conversations with occupants and, in particular, building managers, can help to identify any performance problems with a building far more quickly than data analysis in a spreadsheet. When conducting such interviews the interviewer should be independent from the design or construction team. Interviewees are then more likely to be honest and outspoken, and the evaluator's judgements will not be influenced by the history of the project and its relationships.

A crucial factor in implementing the changes that come out of BPE studies in non-domestic buildings is the level of engagement of the building manager or facilities management team. The most successful studies were those in which the building managers were active in the BPE study themselves, and where a willingness or incentive exists to enact change and improve comfort or reduce energy use. If BMS are impenetrable or handover is lacking, this task becomes significantly more difficult and the tendency is for settings to be altered to guard against failure. Systems that require more sensitive adjustment in early operation, such as biomass boilers or an automated natural ventilation system, may be switched off. When this happens, the expected design CO_2 savings disappear. When carrying out a BPE study it is important to get the building manager on board, as they will have greater insight into how the building is actually operated as opposed to how it was designed to operate.

The future of BPE

The programme has amalgamated the data captured into a central and accessible format which is available online through the Building Data Exchange.[16] By being freely accessible the platform allows meta-analysis by interested parties looking for robust evidence and data, stimulates the crossover of digital technology into the built environment and facilitates opportunities for data-driven innovation.

Since the Innovate UK BPE programme began in May 2010, there have been significant changes across the building industry, which may encourage greater uptake of BPE in the future.

These industry initiatives should encourage the uptake of BPE:

- The RIBA Plan of Work 2013 has been unveiled, with the new Stages 0 and 7, which will encourage project teams to review feedback from previous projects and carry out POE activities respectively.[17]
- Government Soft Landings has been introduced, which will ensure that public buildings follow a framework that focuses on the operational outcome of each building with clear requirements for improvements in handover processes, commissioning and elements of BPE.[18] The original BSRIA Soft Landings[19] is also becoming more widely used and is now referenced in Part L2A 2013.[20]
- CarbonBuzz was launched in June 2013. The free online platform will encourage project teams to share energy data and building information in order to create better benchmarks and highlight the performance gap.[21]
- Performance in-use targets such as pursuing a Display Energy Certificate (DEC) 'A' rating are becoming more common, particularly in the public sector. In-use targets act as a useful way to focus design and construction teams on operational outcomes rather than design aspirations.[22]
- CIBSE launched TM54 in September 2013. The publication provides users with clear guidance on how to evaluate operational energy use more accurately at the design stage.[23]
- The updated BREEAM 2014 includes a number of credits that directly relate to BPE activities and should encourage their uptake in the future.[24]

However, it is up to the traditional design and construction teams to drive a culture of feedback so this becomes the norm rather than the exception. After all, an industry that does not learn from its end product is blind to true innovation.

There have been multiple positive and negative findings from each and every project, but one consistent comment from all who took part is noticeable: there is both a need and a desire for all to carry out more BPE in the future.

ESSAY 3

Bill Gething, University of the West of England

Low-energy buildings — delivering theory in practice

There has been growing evidence that, in practice, the energy performance of recent buildings has fallen short of expectations, with potential consequences for their occupants, the reputation of the construction industry and the effectiveness of UK carbon policies to deliver emissions targets. A recent pan-industry initiative by the Zero Carbon Hub has reviewed the evidence for this performance gap in housing, and has carried out new research to establish the factors that contribute to it and to suggest how these might be addressed. The chapter highlights some of the key issues identified across the entire supply chain, from building design to the development and supply of products, materials and systems that go into them, through procurement and construction to handover.

The Post Occupancy Review of Building Engineering (PROBE) studies carried out between 1995 and 2002[25] were a groundbreaking initiative, but it would probably be fair to say that their direct influence was limited to like-minded designers, rather than reaching the industry mainstream. Since then, with post-occupancy studies being the exception rather than the rule, industry awareness of the performance gap has been patchy at best, and serious attempts to close it have remained the preserve of enthusiasts.

In more recent years, energy efficiency standards have become increasingly challenging, driven by government expectations that the built environment could be a prime source of carbon savings to enable it to meet the requirements of the Climate Change Act. Consequently there has been a period of unprecedented change in construction practice, as the industry has struggled to get to grips with rapid revisions to thermal performance regulations aimed at delivering these carbon savings. Given the pace of change, it is perhaps unsurprising that unintended consequences have emerged along with increasing evidence that energy performance in practice all too frequently falls short of expectations.

For policymakers, the growing realisation that the performance gap could be significant and pervasive lifted the issue from a minority interest to a matter of national policy concern, in the face of a real danger that the built environment sector will not deliver the carbon savings anticipated. For the construction industry, while some elements still questioned the evidence for the gap, there were growing concerns that the issue needed to be addressed seriously to demonstrate that it was complying with legal minimum standards and was delivering the high-performing product that its customers had the right to expect.

Zero Carbon Hub research

In order to address these concerns, in 2013 the Zero Carbon Hub assembled a pan-industry initiative to carry out the first comprehensive review of evidence on the size and significance of the gap, to explore potential reasons for it and to set out proposals to address the issues identified. Although the work specifically related to the house-building sector, the principles have relevance across all building types, and to refurbishment as well as new build.

The programme (Closing the Gap between Design and As-built Performance) gathered inputs from all parts of the industry and looked at potential factors that might contribute to the gap right across the process, from site acquisition, through design, to statutory approvals, procurement, site practice and commissioning. A structured review of the issues identified was carried

out, examining the strength of evidence and potential impact of each issue in published and unpublished reports. It also instigated new research work, including a house-building process review of sites of a range of sizes, types and construction approaches offered by members of the industry. The operation of the regulatory energy assessment tool, the Standard Assessment Procedure (SAP), was also examined through audits of assessments and questionnaires to SAP assessors and their accreditation organisations. The process review was particularly illuminating, involving site visits to inspect construction practice, interviews with site staff and a study of design information used.

The review highlighted some 15 issues as a priority for action, and a further 17 issues as a priority for further research to develop evidence on the scope and magnitude of their impact, plus 12 issues of lower potential impact but for which a watching brief should be retained.[26]

Possibly the most important overall conclusion was that there are factors that contribute to the gap throughout the process and across all the parties involved. This is a pan-industry issue that we all need to address.

Early-stage design

Right at the start of the project, designers and their developer clients need to be aware that early-stage design decisions can not only increase the difficulty of achieving a low-energy design in absolute terms, but can also increase the likelihood of a performance gap opening up.

One of the issues highlighted was the potential for early-stage energy modelling tools to be used to inform and support concept design work, to optimise the fundamentals of a project for low-energy performance. At present, if any analysis is carried out it tends to be done using SAP, even though this was never intended as a design tool. Perhaps because of its relatively unfriendly interface and somewhat impenetrable outputs, more often than not this is used as a retrospective specialist input rather than an iterative tool for designers. There are alternatives – such as the Passivhaus Planning Package (PHPP), used to design and assess Passivhaus projects. Perhaps because of its reputation for accuracy in practice and its spreadsheet format with instant user feedback, this package is popular despite the potentially daunting amount of information it requires. The recent availability of a three-dimensional modelling interface for it has further increased its appeal to designers. This approach has been followed in other early-stage modelling tools that aim to integrate energy modelling into designers' familiar working practices.

01

AS-BUILT PERFORMANCE - PRIORITY FOR ACTION

CONCEPT DESIGN & PLANNING

P2 — Limited understanding of impact of early design decisions on energy performance

DETAILED DESIGN

D1 — Inadequate understanding and knowledge within detailed design team

D2 — Lack of integrated design between fabric, services & renewables

EM8 — Issues around use of U-value and thermal bridging calculation procedures

EM7 — Concern over competency of SAP assessors

PROCUREMENT

PR2 — Inadequate consideration of skills and competency at labour procurement

CONSTRUCTION & COMMISSIONING

C5 — Product substitution on site without consideration of energy performance

C15 — Poor installation of fabric

C9 — Poor installation or commissioning of services

C13 — Lack of site team energy performance knowledge & skills

C6 — Lack of adequate energy performance related QA on site

VERIFICATION & TESTING

T3 — Concern over consistency of some test methodologies & interpretation of data

EM4 — As-Built SAP not reflective of actual build

V2 — Lack of robust energy performance related verification, reliance on third party information

V5 — Lack of clarity over documentary evidence for Part L & Part F compliance

Key

P Planning
D Detailed design
EM Energy modelling
PR Procurement
C Construction
T Testing
V Verification

CROSS-CUTTING THEMES

KNOWLEDGE & SKILLS

RESPONSIBILITY

COMMUNICATION

01 Priority actions from ZCH performance gap evidence review
02 Priority research from ZCH performance gap evidence review

27

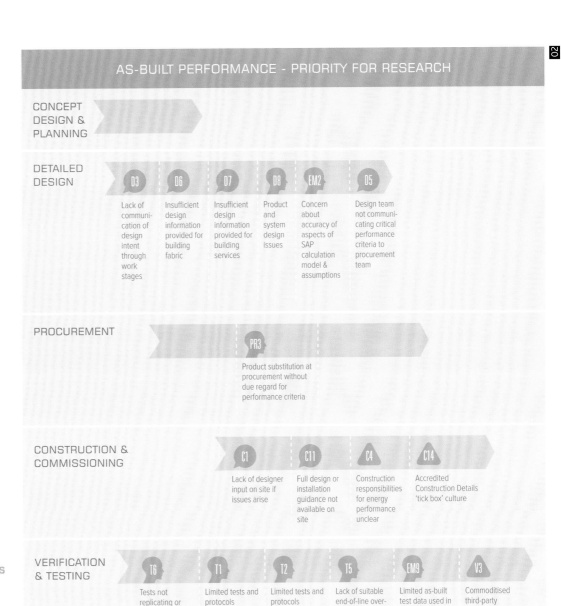

AS-BUILT PERFORMANCE - PRIORITY FOR RESEARCH

CONCEPT DESIGN & PLANNING

DETAILED DESIGN

D3	D6	D7	D8	EM2	D5
Lack of communication of design intent through work stages	Insufficient design information provided for building fabric	Insufficient design information provided for building services	Product and system design issues	Concern about accuracy of aspects of SAP calculation model & assumptions	Design team not communicating critical performance criteria to procurement team

PROCUREMENT

PR3
Product substitution at procurement without due regard for performance criteria

CONSTRUCTION & COMMISSIONING

C1	C11	C4	C14
Lack of designer input on site if issues arise	Full design or installation guidance not available on site	Construction responsibilities for energy performance unclear	Accredited Construction Details 'tick box' culture

VERIFICATION & TESTING

T6	T1	T2	T5	EM9	V3
Tests not replicating or accurately taking into account dynamic effects	Limited tests and protocols available for in-situ fabric performance	Limited tests and protocols available for in situ services performance	Lack of suitable end-of-line overall performance test	Limited as-built test data used in SAP calculations	Commoditised third-party verification schemes not independent

CROSS-CUTTING THEMES

 KNOWLEDGE & SKILLS

 RESPONSIBILITY

 COMMUNICATION

The different assessment methodologies used by compliance tools can have significant impacts in themselves. Designers familiar with PHPP will be aware of the impact that a building's form factor (the ratio between the building envelope area and occupied floorspace) and orientation can make on the ease with which a building can achieve the Passivhaus standard. However, the methodology used to assess compliance with UK thermal regulations sidelines the inherent thermal benefits of compactness. The proposed building is compared with a reference building of the same size and shape, but constructed to a specific notional specification. As a consequence, there is little incentive for designers to aim for forms that are inherently energy efficient.

Keep it simple

Compact forms also tend to limit complexity. The more complex the envelope of a building, the greater the likelihood of introducing cold bridges as a result of balancing structural and thermal detailing challenges when trying to resolve interfaces between elements. Taking insulated timber construction as an example, standard assumptions are often made about the thermal performance of an element based on a 'typical' make-up, which ignore the need for additional structure to deal with 'atypical' openings or structural complexity. In the past, when insulation levels were lower, the overall effect on thermal performance might have been relatively small. However, with increasingly high standards, it becomes correspondingly more important to maintain the thermal continuity of the envelope; any cold bridges can have a significant effect.

Designers, developers and those producing planning guidance need to be aware of the energy consequences of their concept ideas, and recognise that the balance between aesthetic freedom and thermal performance is changing. It can no longer be assumed that any building that receives planning permission will be able to meet thermal performance standards that have traditionally been addressed a later stage in the design process.

This is not to say that all homes should be designed as bald cubes or unrelenting blocks. It is possible to design around most detailing challenges; however, this requires time, skill and forethought. Leaving problems to be sorted out on site is almost guaranteed to increase the performance gap.

Low-energy/carbon performance depends on a high level of integration between building form, fabric and services. Integration starts by developing an overarching strategy at a very early stage in the design that flows from and

affects key decisions on site layout and building form. For example, to optimise the contribution from photovoltaics, orientation, roof form and overshadowing within the site and around it all need to be considered. This might sound obvious, but examples emerged in the search for evidence of expensive PV arrays with significantly suboptimal orientation or overshadowing (but this had been frequently ignored in estimations of projected output).

Some increasingly common technologies such as mechanical ventilation with heat recovery (MVHR) also come with space planning implications to consider from the outset of developing design proposals; which cannot be 'found' later in the design process. The central ventilation units are not small, and space needs to be allocated in the planning of the home so they can be installed, connected and maintained easily. There are numerous examples where the central unit has been installed in a roof space, for example. It might be out of sight, but it is also subject to significant temperature and humidity fluctuations, and has very poor access.

Even if installed perfectly in the first place, if filters are not cleaned and the unit is not regularly maintained, performance will degrade over time. In terms of construction detailing, running ducts in the roof space also adds complexity and risk as there must be numerous penetrations through the thermal and airtight envelope of the building, every one of which increases the potential for the performance gap to open up. Within the home, space for ductwork needs to be designed in from the outset. Ducts are large and runs must be efficiently laid out if the performance of the system is not to be compromised and the performance gap correspondingly widened. All too frequently duct runs were left to be sorted out on site, resulting in unsightly afterthought bulkheads and/ or tortuous routes. Sometimes the ductwork was constricted as a consequence of substituting rigid for flexible ducting for cheapness or to get over a routing problem.

The need for integration of concept design with detailed design, buildability and user experience, as shown by the MVHR example above, is not well supported by current construction and development practice. Often the design and construction process is broken up into separate packages. Continuity of intent from concept through detailed design to construction is almost impossible to maintain. In the reverse direction, feedback loops from issues encountered along the chain by subsequent designers, the procurement and construction team or users are contorted or non-existent. Building information management (BIM) is currently trumpeted as the integrating framework that should allow a more seamless transfer of information to get

over this fragmented approach. However, it remains to be seen whether the more subtle aspects of design intent can be heard through the noise of mass information transmission. The current focus of BIM also appears to be on managing information flow in one direction – from design to construction – with considerably less emphasis on feeding back experience in the other direction. This is particularly the case where there is no contractual incentive to make use of that information even if it is available.

Work on site

On site, there is a corresponding lack of understanding at a supervisory and individual trade level on the level of integration and extra care required to achieve low-energy performance in practice. This is not helped by a similar fragmentation in how projects are contracted and managed. Delivery tends to be prioritised in order of cost, time and finished appearance, with little emphasis on the minutiae of achieving thermal continuity, airtightness, logical service runs and timely commissioning. In the past these aspects might have been covered up and forgotten, but they are vital to deliver high performance.

Energy performance now needs to be similarly prioritised by site supervisory staff. In order to do this effectively, they need to have an overall understanding of how the work of individual trades can support the achievement of optimum thermal performance. Individual trades need to understand (and price for) what they need to do themselves so as not to create a potential performance gap. They must also understand how their work can adversely affect the ease with which other trades can achieve the same aim. There are many examples in which following trades have unthinkingly damaged perfectly good work by others. This often goes unnoticed and, even if picked up in time, a satisfactory repair can be difficult, disruptive and costly. The problem is exacerbated by employing cheap, poorly trained labour and by out-of-sequence working, resorted to in order to maintain progress but with potentially severe consequences for the performance gap.

New products – delivering the promise of innovation

The step-change that has occurred in the last few years in the name of low-energy construction has enabled the development of numerous new products and systems that take advantage of new technologies or aim to solve technical challenges. In the absence of authoritative impartial guidance that used

to be provided by the Building Research Establishment, the only source of information for the industry on how these products should be used is from the suppliers themselves.

Unfortunately, claims made for the performance of new products are often over-optimistic and, where they are able to deliver in theory, installation, testing and commissioning instructions are inadequate. There may also be a lack of information about the interface with the rest of the system of which the product is designed to be a part. Even if products are designed as a complete system, in the market-driven construction industry there is the tendency to pick and choose elements of a system on price, breaking the chain of design responsibility and opening up another opportunity for a performance gap.

Product substitution

More generally, product substitution is another potential contributor to the performance gap. Its effects occur in numerous ways. Costs are always uppermost in a contractor's mind, and buyers are typically incentivised to find the best deal for a component or material. If the buyer is not aware of or simply disregards the energy consequences of substituting a specified product with a cheaper, inferior alternative, performance will inevitably be affected. Similarly, on site it is not unknown for similar-looking products or materials to be substituted for the correct materials. This can happen inadvertently – through ignorance or the difficulty of identification – or deliberately, to save money or get over a supply problem. At a more fundamental level, the quest for the cheapest deal can affect strategic decisions such as the choice of construction method, between timber frame and conventional cavity masonry construction, for example. The decision can sometimes be delayed until too late in the process to allow time for resolution of design problems before work starts on site.

In theory, the consequences of changes like these should be picked up when preparing the as-built SAP, and any compensating measures carried out so that the building still complies with thermal regulations. However, there was considerable evidence that the preparation of as-built SAP is sometimes for appearance only, with little incentive or opportunity for updating the calculation to account for any changes made during construction.

Verification and testing

The power of tests that identify construction shortcomings is well illustrated by the success of airtightness testing. This is being increasingly adopted by leading contractors to identify problems at a point in the construction process at which they can be properly rectified – ideally by the people who caused the problems in the first place. This is preferable to submitting to testing as a retrospective regulatory imposition. A test at the end of a project provides few options to do anything to improve matters, other than resort to chasing problems with a mastic gun.

Airtightness testing is an example of a relatively cheap, practical procedure that clearly highlights failures so that all involved can understand what has gone wrong. It would also appear that, as the industry becomes more familiar with the process and the difficulties of retrospectively making good, the test is encouraging trades to take greater care to avoid problems in subsequent tests. That said, testing procedures have sometimes been found to be questionable, and it is important that testing firms are monitored to ensure that tests are fair and accurate.

Infra-red photography similarly illustrates problems; however, it can only really be used as a retrospective check because rectification is often very intrusive and costly. It is, however, being adopted by leading housebuilders to identify weaknesses and to develop effective and robust solutions to persistent detailing challenges.

Other tests, such as co-heating tests, are of huge value as research tools. They have been instrumental in the discovery of previously unnoticed systemic failures such as thermal bypassing via cavity construction party walls, as identified by a team from Leeds Beckett University at Stamford Brook.[27] However, they are too specialist, time-consuming and disruptive to be used for routine checking.

One of the challenges that emerged from the Zero Carbon Hub work was to develop tests that would enable developers to demonstrate robustly that the performance of completed homes matched their designed performance. Such a test, if achievable, would have very far-reaching consequences for the industry.

An energy-literate industry

The overarching challenge identified by the Zero Carbon Hub was to develop an 'energy-literate' industry that understands the importance of addressing the performance gap across the supply chain, the overarching principles of how to do so and how individual actions contribute to achieving this. This is a challenge of collaboration across the process, where problems are designed out, firms are appointed who understand how to deliver low-energy performance in practice, and trades make sure their work does not start to open up the gap, or impact on the work of others. The Hub made a first step along this road with the production of the *Builders' Book: An illustrated guide to building energy efficient homes.*[28] The book highlights, with drawings and photographs of examples, the kinds of things that can go wrong on site – and how to address them through better design or construction practice. This is the kind of initiative needed to provide additional training and continuing professional development for existing members of the industry, and it also changes in the way we educate and train new entrants to develop a truly energy-literate industry.

ESSAY 4

Simon Bradbury, Plymouth University

Designing low-energy buildings

Architects and designers are uniquely placed to take a central role in addressing the performance gap and delivering low-energy buildings. However, currently there are only a limited number of practices that have the expertise and are participating in post occupancy evaluation (POE) of their own projects. A recent survey suggested that only 3% of architecture practices undertake POE on their own housing projects.[29] Therefore the profession is not able to feed back and build virtuous circles of learning.[30] This chapter outlines why architects and designers are well placed to take this lead, and how they can develop their own processes of design and feedback.

TABLE 01

ISSUES UNDER DISCUSSION	REASONS FOR DESIGN CHANGES
1 Outline specification and plans issued by architect	
2 Standard Assessment Procedure compliance	Energy performance
3 Lifetime homes, winter garden size, window specification, bathroom size	Accessibility, airtightness, visual appearance
4 Homes and Communities Agency funding and unit sizes	Funding
5 Scheme Development Standards compliance, Lifetime Homes compliance, Homes and communities Agency funding	Funding, accessibilty
6 Building fabric specification (Window, building envelope, wall, floor, doors)	Energy performance
7 Ventilation system specification	Health of occupants, maintenance
8 Planning application submitted	
9 Construction system choice, window supplier	Construction sequence, thermal performance, air tightness, cost
10 Scheme Development Standards compliance, winter garden size, roof design, Planning drawing compliance	Funding, external appearance, construction sequence
11 Planning drawings compliance, Secured by Design compliance	Cost, energy performance, security, external appearance
12 Scheme Development Standards compliance	Funding
13 Ground floor slab construction	Health and safety, sequencing of construction
14 Lifetime Homes compliance	Accessibility, funding
15 Roof design, airtightness membrane installation	Airtightness
16 Services design, airtightness membrane installation	Airtightness, sequencing
17 Building fabric specification	Thermal bridges
18 Building regulations application submitted	
19 Building fabric specification	Thermal bridges
20 Roof design, insulation specification	Condensation, airtightness
21 Services design	Sequencing
22 Standard Assessment Procedure compliance	Energy performance
23 Services design, airtightness barrier location	Airtightness, sequencing
24 Start on site	
25 Rooflight specification	Energy performance
26 MVHR unit specification	Energy performance
27 Building fabric specification, airtightness membrane installation	Airtightness (1st pressure test)
28 Building fabric specification, airtightness membrane installation	Airtightness (addition of parge coat)
29 Building fabric specification, airtightness membrane installation	Airtightness (repaired roof membrane)
30 Building fabric specification, Standard Assessment Procedure compliance	Airtightness (completion of building)
31 End of construction period	
32 Building fabric specification, Standard Assessment Procedure compliance	Airtightness, thermal bridges, thermal performance (co-heating test result)

Developing skills and knowledge

The first challenge faced by architects is developing the skills and knowledge necessary for energy modelling. Energy modelling is not typically an activity undertaken by architects because of the way it is procured. It is usually done by an independent consultant who will be primarily concerned with ensuring compliance with Building Regulations – and not with informing design decisions, optimising performance or developing accurate predictions of final energy use. This separation of function results in architects and designers not being directly aware of the consequences of design changes on energy performance – or, worse still, being hostage to compliance models late in the design process.

If you look at energy performance in buildings it changes throughout the design process as a result of variations to the form and specification of a developing project. This is clearly illustrated in Figure 01, which shows how the energy performance of a house changed from initial design to occupation. The graph plots the change in the heat loss parameter (HLP), – loss divided by floor area – with each change explained in Table 01.[31] The graph also illustrates the changes in HLP derived from the regulatory model – the Standard Assessment Procedure (SAP). It is evident that there is significant variation in the design performance, particularly in the early design stages, relative to the as-built performance. It is also clear that there is a large discrepancy between the regulatory model (SAP) and the design performance throughout the project.

01

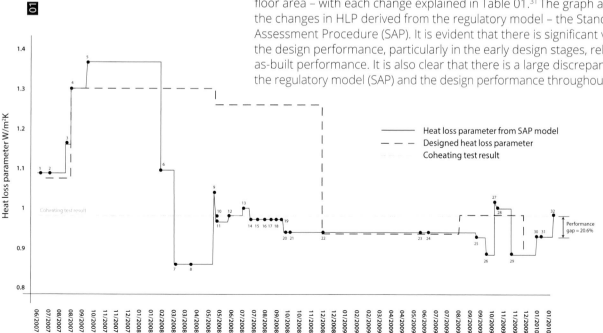

Although this is only one project, the changes that have taken place in the design process are not unusual (for example cost, design coordination and compliance with regulations). This is because many design decisions impact on issues such as geometry, airtightness, M&E systems or the thermal performance of the fabric. Energy performance should therefore be seen as one of many other considerations (social, economic and regulatory) that shape the design of a building. This means that in order to manage the energy performance through the design process it is necessary to be able to update the energy model alongside variations in design, and not have a 'gap' between the design and energy model as in this example.

The separation of energy modelling from the design process therefore removes the ability to easily negotiate energy performance in the context of other issues. This is made more problematic when the model being used is a regulatory compliance model such as SAP, which is neither a design tool nor intuitive to use, and whose outputs are difficult to connect with design decisions.

Integrating energy modelling into the early design process, when decisions about massing, orientation and fabric are made, is particularly important. In Essay 3 Gething highlighted the importance of the early design stage in minimising the performance gap. The opportunity for architects is to develop capacity to undertake energy modelling as part of early design decisions, to allow for the optimisation of the building. This will also allow for a more integrated understanding of performance, as the complexity of projects develops over time. It will also support a collaborative relationship with the design team, engineers and contractors to ensure that early principles are carried through.

Many architecture practices have been drawn to use the Passivhaus Planning Package (PHPP), a spreadsheet tool for designing Passivhaus projects, as one way to develop this capacity. Despite its complexity the tool allows designers to understand the impact of decisions on performance. The recently launched three-dimensional plug-in to SketchUp further enhances this tool, by allowing architects to integrate energy performance into their normal workflows. This tool, along with others, offers significant potential for architects to engage with low-energy design early in the design process. It also helps to build an appreciation of the many other factors, such as services, thermal bridging and airtightness, that influence the delivery of a low-energy building and help to minimise the performance gap.

Managing the design process

In addition to developing skills and knowledge it is also important to be aware of a number of common areas where decisions in the design process are likely to impact on performance.

Changes to the **design brief** are common, particularly in the early design stages when different overall design strategies are being considered. However, attention should be given to how this affects the compactness of the building form and orientation. For example, the PHPP encourages designers to focus on a compact form and good solar orientation, which contributes significantly to the ability to design a building that achieves Passivhaus standard. Compact building form and careful orientation go a long way to reducing total energy consumption of buildings.

Cost control and **value engineering** can have a significant impact on performance. The changes can vary from the more obvious, such as product substitutions, to a lower-performing thermal element (e.g. window or insulation material), to the less-obvious such as changes in geometry or specification of different M&E systems. This happens throughout the design and construction of a project, but can be particularly difficult to manage once a building is on site. It is important that architects are aware of which changes will impact on energy performance, and that these are communicated between the design team, contractor and client to enable the impact of any changes to be understood as part of any value-engineering process.

Specification and design of construction **systems and products**, particularly where they are complex or involve off-site manufacturing, can impact on design performance and contribute to the performance gap. Problems can arise when a system or product performance is based on a typical condition, and not on the specific design proposal. For example, the thermal performance of timber panel systems may be based on an assumed amount of timber content and not on the actual design solution, leading to unexpected changes to the performance late in the design process. Worse still, these changes may not be recognised until after construction. In addition, there needs to be careful consideration of the design of junctions between systems to ensure continuity of airtightness and thermal performance, as well as sequencing of construction. It is important therefore to work with suppliers to ensure that the assumptions about the performance of a system are robust, and that they are updated as the design develops.

Sequencing and design coordination must be considered early in the design process. This may include strategies to effectively install insulation and airtightness membranes, or the installation of services and penetrations through the thermal envelope. It is important to consider when, where and how services will be installed during the construction process. All too often, particularly in house building, this is left to decisions made on site. This can affect the efficiency of systems such as mechanical ventilation with heat recovery (MVHR), and also the airtightness of the building fabric. Other common issues relate to thermal bridges and airtightness at junctions, which can be affected by the sequencing of construction or tolerances of different building materials.

Regulations and standards, including those that are not related to energy, can also impact on performance. For example the incorporation of accessibility or fire regulations may change the geometry of a building, affecting its compactness or complexity. Alternatively planning constraints on overlooking or rights to light may impact on solar gain. Many of these regulations are requirements, and therefore consequential design changes may be needed, such as increasing thermal performance in other areas, to compensate for any negative impact that results from their incorporation.

The first steps to BPE

Developing a better understanding within a practice of energy performance and the issues that impact on it is often the first step to undertaking BPE. If you have an appreciation of the issues that impact on energy, it is easier to look for these in a completed project. However, undertaking BPE can still be a challenge for an architect who has not done it previously.

In this context, developing a range of partnerships with universities offers some opportunities. The Standing Conference of Heads of Schools of Architecture in 2015 was specifically about incorporating building performance evaluation into the curriculum and, with the RIBA soon to be updating its validation criteria, this presents a good opportunity to rethink how young architects engage with the evaluation of buildings.[32]

There are already a number of courses, particularly at postgraduate level, on which students learn about and undertake BPE.[33] Although further consideration needs to be given to how to integrate BPE into undergraduate teaching, and particularly into the design studio, these courses may present opportunities for practice. For example, having a number of undergraduate

students study a completed project may offer valuable insights both for students and practices.

There are many examples of this being done on individual buildings, where students monitor energy and interview occupants and the design team. Getting students to engage in BPE will create future practitioners with the interest and understanding to undertake this work. This of course calls for both university and practice to develop more collaborative models of teaching, which is indeed in line with current thinking on the future of education.[34]

Student projects do not need to be limited to studying individual buildings; they could evaluate other aspects of practice. One example is the work of the Plymouth University students who undertook daylight analysis of 900 award-winning housing schemes using a tool called LightUp. They were able to show that many projects were not meeting regulatory guidance for minimum daylight in homes. This revealed a systemic problem in regulation and practice, but also supported students in designing their own studio projects with a much more sophisticated approach to daylight.

These initial partnerships through teaching offer the potential to develop into more significant research collaborations of the sort described in the following two chapters, and exemplified by some of the case studies in this book. However collaboration between academia and practice is also valuable in that it ensures a level of independence in the evaluation of projects and, importantly, the obligation and mechanisms to disseminate findings.

Building collaborative models between teaching, research and practice therefore presents a clear opportunity for practice and academia, in an environment of increasingly competitive research funding and in a profession that needs to build a stronger evidence base that demonstrates the value of architects.[35]

Conclusions

Increasingly, practices that are engaged in low-energy buildings are building project teams that have an integrated understanding of the issues related to energy and are working across projects to improve their own practice. (Many of these practices are included as case studies in this book.) It is clear that where this is the case, lessons are being learned and fed back into the design process. However, much work is needed to encourage this across industry.

Where practices are learning from their own projects they will increasingly be able to work with clients to support them in mitigating the risk of under-

performance by managing the process of design. In these instances the management of the energy performance of buildings could be viewed in a similar way to the management of the risk of overspend. In the early design stages, where there is significant uncertainty about the design of the project, the potential risk of under-performance will be high, along with the variation in the predicted performance. However, as the project is developed the variation of the predicted energy performance would reduce, as well as the risk of a performance gap. Figure 02 is a diagram of how this might be understood, illustrating each stage of the design and construction of a building. This approach should enable a more critical understanding of how to manage energy performance in buildings, while recognising that it is not an exact science.

Finally, developing a culture of feedback on projects should also be about broadening the issues and methods we use to evaluate buildings. In this book the focus is on energy in the context of social and technical challenges, and on how to close the performance gap. However, evidence is needed across a range of other areas – and architects, in collaboration with academia, have the potential to uncover this.

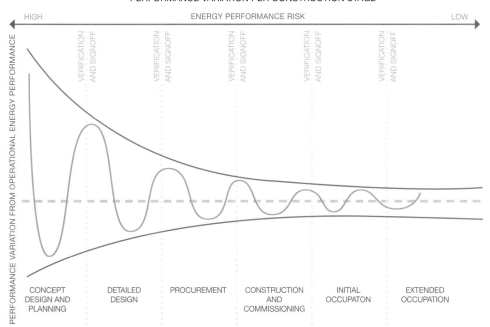

02

PERFORMANCE VARIATION PER CONSTRUCTION STAGE

HIGH ENERGY PERFORMANCE RISK LOW

VERIFICATION AND SIGNOFF

PERFORMANCE VARIATION FROM OPERATIONAL ENERGY PERFORMANCE

CONCEPT DESIGN AND PLANNING DETAILED DESIGN PROCUREMENT CONSTRUCTION AND COMMISSIONING INITIAL OCCUPATON EXTENDED OCCUPATION

Building performance evaluation – where to start?

1 Build internal capacity

Architects should build internal capacity to enable a better understanding of energy issues in the context of design. This will also enable them to work collaboratively with those producing the building energy models from the outset of projects, and to work with clients and contractors to integrate this through the design of a project.

2 Keep it simple

Do not be over-ambitious with complex buildings and monitoring processes. Low-energy buildings are becoming increasingly technically complex, and systems and building complexity have been shown to have an impact on the reliability of performance (see Essay 2). It is also not necessary to embark on complex evaluation processes; simple questionnaires and walk-rounds are a good start to uncover many issues.

3 Learn from your own projects

The practices in this book have all started in one way or another by looking at their own projects as a source of learning – including, in many cases, the monitoring of their own offices. This might also involve developing or improving existing project feedback systems. These initial exercises offer a low-risk way of testing and learning about new technologies and processes.

4 Seek partnerships

In the longer term, partnerships with academia, other architects and consultants offer the greatest potential to access additional resources, and also collectively address the issues you are interested in. These could start in a relatively small way on a single project and then grow over time.

5 Publish your findings

Although the findings that emerge from your own projects will be of benefit directly to your future work, practices that have engaged in BPE have found that publishing their findings provides them with credibility among clients and in the wider profession.

ESSAY 5

Mark Lumley, Architype

Learning through practice

Architype has developed a consistent approach to design, energy modelling and project management that has produced a series of exemplar schools. Each project within this substantial body of work has built on lessons from its predecessor. The practice has a fundamental belief in the rigorous study of the schools in use, which is helped by a continuing dialogue with contractors, managers, staff and students. This approach, coupled with the exacting demands of the Passivhaus model, is outlined in a critical review of recent work.

Introduction

Architype has been developing its own approach to the making of 'sustainable and humanistic' buildings over a period of several decades. Stimulated by an early interest in timber construction and work with community groups on self-build projects using the Segal method, the practice combines a passion for technical knowledge with a real concern for the experience of building users and for the efficiency of buildings in use. The practice's working methods have been guided by research through knowledge partnerships and research grants, and by revisiting, observing and measuring their buildings after handover.

This essay explains how five schools[36] built for Wolverhampton City Council between 2006 and 2013 provided an opportunity to reflect on good practice and develop lessons learned through a post-occupancy evaluation (POE) feedback loop.

Delivering five buildings with the same client gave rise to a unique set of opportunities:

* the ability to maintain the same design and consultancy team for all five schools and build them with the same contractor (with the exception of Willows Primary & SEN School), building enough confidence to push the design parameters

* procurement at a time when the political climate facilitated proper investment in education infrastructure; Wolverhampton City Council maintained a strong vision for improving its school estate in some of the city's most deprived areas

* securing a number of research grants that allowed the practice to employ qualified research assistants to undertake detailed post-occupancy assessment.

This delivery process was improved using an extended Soft Landings[37] programme on three of the schools, which helped make a positive difference to the occupants, and enabled understanding of how the schools performed in real life, not just as propositions.

A strong feedback loop
– the importance of post-occupancy monitoring

The principle of a strong feedback loop was embedded after the first funded study was undertaken, by a full-time researcher in a Knowledge Transfer Partnership (KTP) with Oxford Brookes University between 2006 and 2007.

Despite both the first two Wolverhampton schools scoring highly for user satisfaction in a BUS study, a number of problems were identified: CO_2 occasionally reaching higher levels than anticipated in some classes, despite a well-designed natural ventilation strategy; issues relating to the operability (particularly BMS protocols) of windows; and some minor failings in the building envelope relating to thermal bridging and airtightness. The poor energy performance of appliances and fittings, particularly in school kitchens, was also noted. Sub-metering systems were not installed properly, which prevented accurate monitoring of energy use, and there was unsatisfactory commissioning of mechanical and electrical systems generally, often driven by a need to occupy a building as soon as possible.

These initial findings provoked strong reactions in the design team. On the whole this generation of buildings was carefully designed, with expert input from a team of environmental specialists. The schools won design awards and, judging from staff comments, were much loved and enjoyed by their users. Having got so many things right, the design team were justifiably sensitive but resolved to learn from 'positive criticism'.

Subsequently Architype successfully applied for grants from the Technology Strategy Board (now Innovate UK) to carry out further POE studies on two projects. This helped develop in-house skills for carrying out post-occupancy investigations, in particular with the suite of tools promoted by Innovate UK.

Passivhaus and the follow-on schools

During this period of detailed analysis Architype also started to investigate Passivhaus, in part to gain a better understanding of building physics but also to provide discipline to their intuitive concern for orientation, form factors, eliminating cold bridges, and achieving high degrees of airtightness and much higher U-values. It also forced a review of the impact of 'unregulated energy', excluded from Building Regulations, and regard for the performance of all the equipment and appliances going into the building, to meet the Passivhaus Primary Energy target.[38]

Having successfully delivered St Luke's and the Willows primary schools, Architype took on two further primary schools, Oak Meadow and Bushbury Hill, and proposed Passivhaus as the energy and comfort standard. Passivhaus seemed to address most of the key areas around building performance that had proven challenging over the previous years – in particular providing a strategy to tackle ventilation heat losses through the use of mechanical ventilation with heat recovery (MVHR), which is prescribed by Passivhaus.

The predictive and calculation skills specific to the Passivhaus Planning Package (PHPP) required some learning and support from specialists,[39] but the knowledge accumulated through the research studies and the improving technical skills gave Architype a head start.

Significant markers

Achieving Passivhaus certification required further technical improvements, including learning to detail with minimal cold bridges and to achieve high levels of airtightness. Areas of high energy consumption were addressed, for instance the poorly performing kitchens revealed by the KTP study. (These were solved in part by the use of more efficient appliances and electric hobs instead of gas.) IT usage and other electrical consumption were reduced, in particular lighting and its controls. The air supply and extraction were better integrated with the building fabric, and orientation and shading for control of solar gain were also critical factors. The client, design and contractor teams worked well, and there was no need for complex incentives with a common focus on the goal of Passivhaus certification.

The delivery of the first two Passivhaus schools was achieved to a fast programme and came in on budget. Despite some teething problems the schools performed well, and both picked up awards – one a regional RIBA award, the other a national Passivhaus award.

Second-generation Passivhaus and continued learning

Wilkinson Primary School (see Case Study 6) was the last to be completed, in November 2013. This second-generation Passivhaus school benefited from the experiences of the previous projects, with some dramatic simplifications to the building envelope, services and controls (compare, for instance, the section drawings in the case studies).

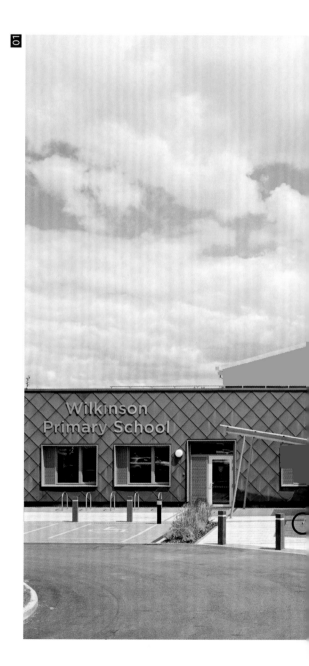

01

For the second-generation school there was more engagement with the users, who were given the operational support necessary to run a Passivhaus building. Guidance was also given to the client on the appropriate level of skills required to run the building management system (BMS) and for general operation of the building. Many design decisions were intended to simplify operation – for instance reducing the number of high-level automatic actuators in order to reduce maintenance and improve reliability. However, the building's different seasonal operation required some understanding on the part of users, and some participation for proper running and optimal comfort (this is discussed in Case Study 6). Improvements like this were also applied retrospectively to the earlier Passivhaus schools.

Handover, commissioning and further engagement

In all the schools the team ran workshops in which they brought school representatives, the head teacher and maintenance staff together with members of the design team, usually the mechanical and electrical engineers, a Passivhaus consultant, contractors and controls installers. Convened as part of a defects resolution process, these meetings aimed to get the right people in the room together to get a reliable account of problems, and find a way to move forward with solutions. The impact of these has been positive, though careful management of technical discussions and reporting is needed to enable useful progress. The group sessions were particularly productive, with vigorous discussion and shared solutions emerging from people who might otherwise have been blaming each other in private and trying to evade responsibility.

The early projects all suffered from reduced commissioning and, faced with deadlines imposed by the school calendar, were handed over earlier than the design team would have liked. Following handover, there were protracted periods of trying to get everything operating properly, particularly the now-familiar problems with operational protocols for BMS. The perseverance and diligence required to get things right at handover should be noted by any architect and client trying to agree the scope of RIBA Stage 7 activities.

Conclusions

A further KTP study, this time with Coventry University, has been completed, leading to the appointment of a part-time research/POE post within the practice. This study provides a comparison of performance across the five Wolverhampton schools, along with a 1970s school not designed by Architype. Classrooms from each were monitored for CO_2 levels, temperature and humidity, and questionnaires were issued to pupils and staff at different points in the year to gain further understanding of the different age perceptions of comfort, and occupants' ability to affect their immediate environment or comfort level. The findings are powerfully represented by graphs (Figures 02–05), which show clear steps of improvement through the different generations of schools with regards to classroom CO_2 levels and temperature stability.

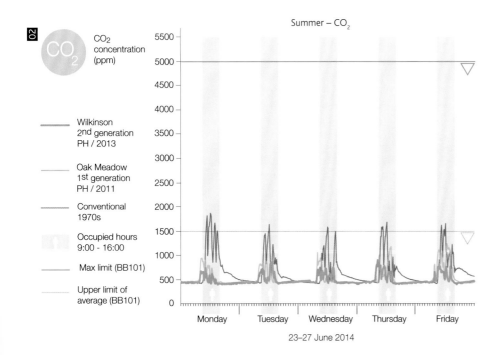

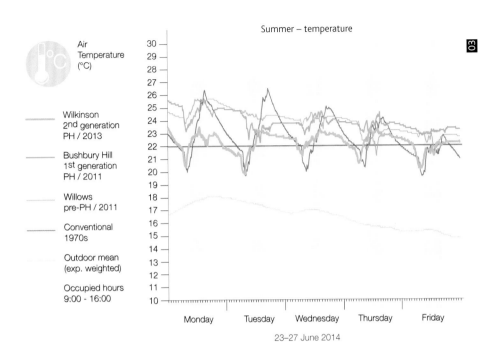

Summer – temperature

Air
Temperature
(°C)

Wilkinson
2nd generation
PH / 2013

Bushbury Hill
1st generation
PH / 2011

Willows
pre-PH / 2011

Conventional
1970s

Outdoor mean
(exp. weighted)

Occupied hours
9:00 - 16:00

Monday Tuesday Wednesday Thursday Friday

23–27 June 2014

In practice now Architype routinely includes post-occupancy activities to ensure that buildings work as intended – the practice is determined to address the performance gap. A more ambitious target, to be achieved within the next decade, is to be able to provide a guarantee for its buildings' performance.

Architype's commitment to stay involved with projects long after their handover is recognised by clients, who have respect for a practice that does not walk away from problems. From a commercial point of view this credibility with clients has had benefits: being offered follow-on work, or receiving the positive references that are essential for winning new work.

Architects who are reluctant to engage with post-completion problems frequently mention concerns over liability, but Architype's experience has been quite the opposite. When notified, insurers have generally encouraged a proactive approach to dealing with the issues. That is, to get any problems with the building solved in a cooperative manner, to prevent escalation and to avoid conflicts and being drawn into time-consuming disputes.

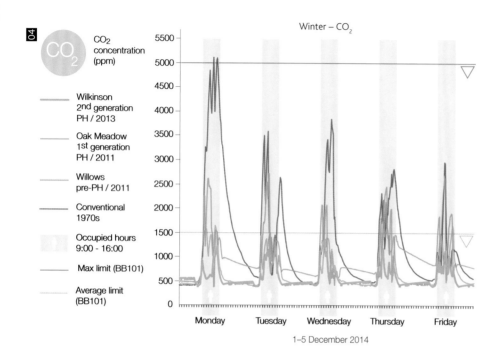

04 CO_2 concentration (ppm)

— Wilkinson 2nd generation PH / 2013

— Oak Meadow 1st generation PH / 2011

— Willows pre-PH / 2011

— Conventional 1970s

Occupied hours 9:00 - 16:00

— Max limit (BB101)

Average limit (BB101)

Winter – CO_2

1–5 December 2014

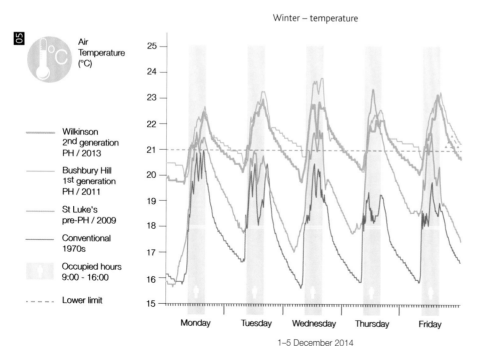

05 Air Temperature (°C)

— Wilkinson 2nd generation PH / 2013

— Bushbury Hill 1st generation PH / 2011

— St Luke's pre-PH / 2009

— Conventional 1970s

Occupied hours 9:00 - 16:00

- - - Lower limit

Winter – temperature

1–5 December 2014

Ten Elements of a New Professionalism

The theme of cooperation and collaboration runs consistently through Architype's work, and the practice's approach is well aligned with many of the principles in the Ten Elements of a New Professionalism promoted by the Usable Buildings Trust[40] and the Edge, the campaigning built-environment think tank that commissioned the 'Collaboration for Change' report.[41]

1 Be a steward of the community, its resources, and the planet. Take a broad view.

2 Do the right thing, beyond your obligation to whoever pays your fee.

3 Develop trusting relationships, with open and honest collaboration.

4 Bridge between design, project implementation and use. Concentrate on the outcomes.

5 Don't walk away. Provide follow-through and aftercare.

6 Evaluate and reflect upon the performance in use of your work. Feed back the findings.

7 Learn from your actions and admit your mistakes. Share your understanding openly.

8 Bring together practice, industry, education, research and policy making.

9 Challenge assumptions and standards. Be honest about what you don't know.

10 Understand contexts and constraints. Create lasting value. Keep options open for the future.[42]

ESSAY 6

Dr Judit Kimpian, AHR Architects Ltd

The architect's role in energy efficiency

At the time of writing this chapter, the planet has just experienced another hottest year on record. As the reality of climate change is dawning on most, architects are increasingly aware of their responsibility to mitigate its impacts and reduce greenhouse gas emissions. With buildings responsible for more than 40% of carbon emissions, architects should have a major role in transforming the energy performance of the building stock.

Energy use and architecture

Expertise in energy-efficient construction is often largely considered by architects as a specialism 'bolted on' to education and professional practice.[43] In the wider construction industry, the energy consumption of buildings is often perceived as presenting a technological challenge, with the architect's role confined to the specification of the building envelope.

Paradoxically, architectural design is one of the most important factors in energy efficiency. Demand for energy is driven by occupant needs for well-being and productivity in buildings. We use energy to power mechanical and electrical systems that enhance a building's functionality beyond what its fabric, configuration and materiality are capable of providing passively. Catering for occupant needs without the active consumption of energy is therefore key to reducing demand.

Architects, whose design focus is occupant experience, should be leading the campaign for greater energy efficiency. Instead, the profession is becoming increasingly sidelined in one of the fastest-growing market segments of the construction sector. Architectural chambers from across Europe are reporting that the words 'design' and 'architecture' are not usually included in the scope of works for energy efficiency. Feedback from the 30-plus members of the Architects' Council of Europe, representing more than half a million architects in the EU, is that the role of the architect is increasingly undermined by a legislative framework that has been seduced by technological fixes.[44]

AHR has invested in energy-efficiency research since 2006 to support the work of architectural teams across the practice who found it increasingly challenging to design for long-term adaptability, resilience and occupant comfort.

An initial survey of architects inside and outside the practice[45] showed the following:

- that the construction sector's imperative was to comply with Building Regulations only
- that there was a lack of robust data that could underpin the definition of well-performing buildings and related benchmarks
- that passive design features were routinely 'value engineered' to make way for mechanical means of providing occupant comfort

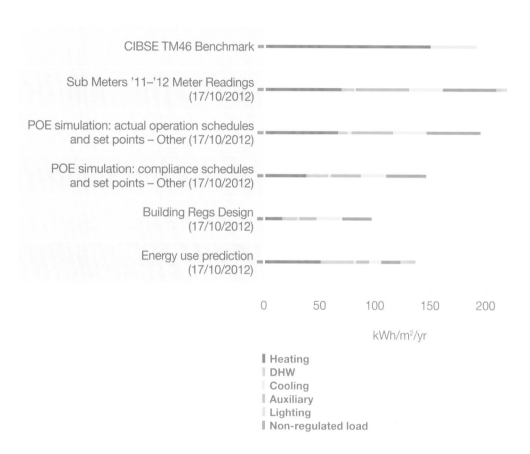

01

CIBSE TM46 Benchmark

Sub Meters '11–'12 Meter Readings
(17/10/2012)

POE simulation: actual operation schedules
and set points – Other (17/10/2012)

POE simulation: compliance schedules
and set points – Other (17/10/2012)

Building Regs Design
(17/10/2012)

Energy use prediction
(17/10/2012)

0 50 100 150 200

kWh/m²/yr

▮ Heating
▮ DHW
▮ Cooling
▮ Auxiliary
▮ Lighting
▮ Non-regulated load

- that energy models and performance calculations were not shared across project partners
- that professional-indemnity insurers actively discouraged practices from collecting feedback from buildings in use
- that the legislative framework did not require the prediction, tracking and validation of the operational energy consumption of a building.

To address these findings, the R&D team at AHR set up a number of focused research projects.

The first one of these was the RIBA/CIBSE CarbonBuzz platform,[46] gathering crowd-sourced energy-use data for benchmarking buildings from design to operation. CarbonBuzz addresses the chronic lack of performance data, gathering a large enough sample to evidence the sizeable gap between the expected and achieved performance of buildings. To understand the specific barriers to better energy performance, the practice secured projects both in Innovate UK's Design for Future Climate (DfFC) and building performance evaluation (BPE) programmes. Building on the lessons learned from these studies, AHR completed the UK's first design project to successfully implement an energy performance contract targeting operational energy use, at Keynsham Civic Centre (Figure 02).

Buildings in operation – the energy performance gap

The UK led the way in Europe when it implemented the Energy Performance of Buildings Directive (EPBD), requiring public buildings to report and benchmark annual energy consumption. A new focus on operational performance began to emerge, with many leading commercial organisations voluntarily benchmarking their buildings based on CIBSE's TM46[47] guidance, which underpins the national Display Energy Certification programme. In the wake of this initiative a number of groundbreaking research programmes[48-52] have led to an EU-wide debate on the methods used to account for building carbon emissions and the gap between the expected and achieved performance of buildings.

An important outcome of Innovate UK's recently completed BPE study was that overall there was no discernible relationship between the CO_2 emission figure calculated for regulatory purposes and actual emissions, with dwellings emitting on average 2.6 times[53] that of the compliance figure, while the CO_2 emissions from non-domestic buildings were 3.8 times that.[54]

Compliance calculations only consider energy consumed by fixed building services (heating, hot water, ventilation, cooling and lighting), under fixed hours of use and intensity. They do not account for the energy used by occupants for plug-in appliances or equipment. To be able to compare like-for-like, compliance calculations need to be adjusted to reflect actual operating conditions and to include plug-loads.

A recent study of education buildings,[55] which compares a forecast of operational energy use (as opposed to a compliance calculation) with measured

02

data, shows an average of 1.5 times higher operational energy use than forecast. The variation in the size of the performance gap between different studies is due in part to the lack of clarity on whether compliance calculations or energy use forecasts are used as a design-stage baseline.
A 2012 report by the RIBA/CIBSE energy benchmarking platform CarbonBuzz, which compared energy forecasts with actual energy use across the education and office sectors, showed on average a factor increase of 1.5 times for heat and 1.8 times for electricity consumption.[56] These latter estimates of the scale of unexpected energy use are likely to be more robust and are still alarmingly high.

There is a growing consensus among the participants of the CarbonBuzz programme that the more complex a building in terms of heating, ventilation and air-conditioning (HVAC), the greater the risk of excessive energy use.[57] Low- and zero-carbon technologies, specified to reduce carbon emissions, are often not used or are under-utilised. 'Smart' controls are proving to be unmanageable for installers and operators, and 'smart' metering equipment installed to monitor energy consumption ends up mostly deficient, making diagnostics extremely costly. The more automation there is in a building, the greater the likelihood of technical malfunction, excessive energy use and poor occupant satisfaction.[58]

This does not appear to be a one-off occurrence. Most non-domestic buildings studied under the Innovate UK BPE programme experienced problems with their BMS.[59]

AHR's Research and Development team carrying out the detailed evaluations of seven buildings estimated the cost of unused, under-utilised mechanical equipment[60] to amount to between 2% and 5% of capital cost for a typical education building. If this small sample is representative, over £100 million of the government's past ten years' £5 billion investment in schools may have been poorly invested.

Omitting the validation of operational performance from Building Regulations has also meant that any issues with energy consumption, usability and indoor environmental quality go unnoticed. In turn, investment and design effort are not focused on improving occupants' experience of a building, but on meeting theoretical performance criteria only.

Implications for architecture – passive design

Looking in more detail at AHR's study of five education and two office buildings under Innovate UK's BPE programme, a clear link between simplicity and energy use emerged. Smaller, less complex buildings, or buildings relying largely on passive measures for ventilation, cooling and daylighting, showed smaller performance gaps and substantially lower energy consumption (Figure 03).

Providing comfortable indoor environments passively through a building's configuration is part of the essential toolkit of the architect. By considering floor-to-floor heights, circulation and buffer zones, spatial adjacencies, the placement of thermal mass and openings in the building fabric, we are able to mediate daylight, fresh air and energy use. These are not just indoor environmental design features. They provide opportunities to express the

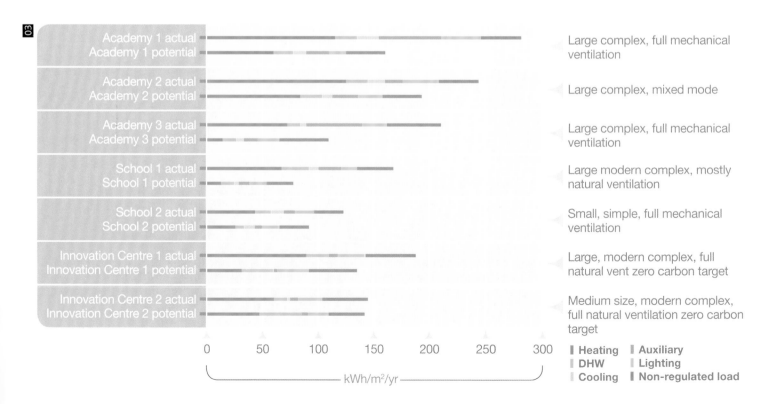

03

Academy 1 actual / Academy 1 potential	Large complex, full mechanical ventilation
Academy 2 actual / Academy 2 potential	Large complex, mixed mode
Academy 3 actual / Academy 3 potential	Large complex, full mechanical ventilation
School 1 actual / School 1 potential	Large modern complex, mostly natural ventilation
School 2 actual / School 2 potential	Small, simple, full mechanical ventilation
Innovation Centre 1 actual / Innovation Centre 1 potential	Large, modern complex, full natural vent zero carbon target
Innovation Centre 2 actual / Innovation Centre 2 potential	Medium size, modern complex, full natural ventilation zero carbon target

0 50 100 150 200 250 300

kWh/m²/yr

▌Heating ▌Auxiliary
▌DHW ▌Lighting
▌Cooling ▌Non-regulated load

individual character of a building and meet the needs of its occupants. Yet many features that improve passive performance are commonly cut back early or compromised during 'value engineering', where mechanical services are increasingly selected to provide 'flexible' indoor environmental control.

Complex systems are not just complicated to design, coordinate, install and operate, but often fall into disrepair due to their high maintenance costs, putting occupants' health at risk. At the start of a project a routine evaluation of the likely whole-life impacts of energy-efficiency solutions is needed to support a more robust approach. Passive measures have an important role in reducing energy demand regardless of the systems used to enhance thermal comfort and air quality. Importantly, where an investment model does not cater for the higher capital and installation costs or the long-term maintenance and operating costs associated with automated systems, passive measures seem to present much greater value.

04

Summary (overall variables)

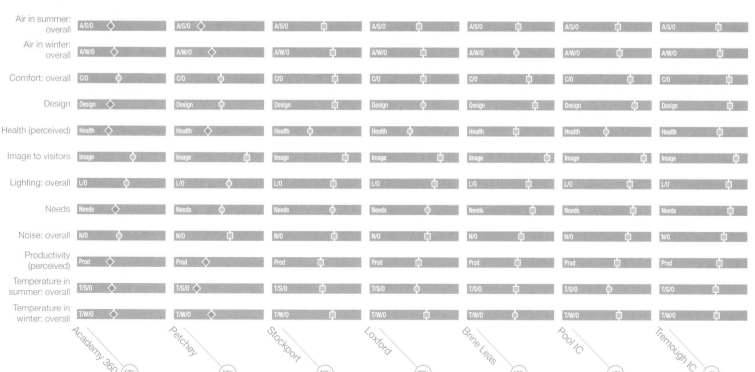

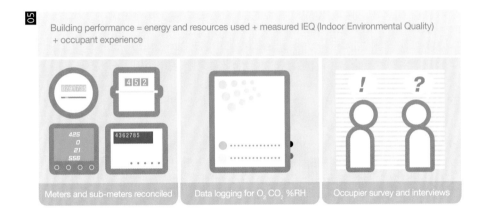

05 Building performance = energy and resources used + measured IEQ (Indoor Environmental Quality) + occupant experience

Meters and sub-meters reconciled

Data logging for O_2 CO_2 %RH

Occupier survey and interviews

From energy use to building performance

In the course of the BPEs carried out by AHR, the R&D team faced questions about the intense focus on energy performance. After all, in architectural terms, a well-performing building is one in which minimal energy and resources are required to provide a comfortable, safe, healthy and productive environment for occupants. By the end of the study a more holistic view of energy efficiency had emerged, one that tackled all three pillars of building performance: **resources used** for achieved **environmental quality** indicators and **occupant satisfaction** (Figure 05).

Performance can be measured by collating metered parameters with qualitative feedback from occupants. These typically include daylight, temperature, CO_2, relative humidity and pollutant levels. The recently developed WELL Building Standard[61] sets out a broader group of indicators for occupant health and indoor environmental quality. Qualitative feedback is usually gained through surveys, such as the BUS (Building Use Studies) developed by the Usable Buildings Trust,[62] or others.

Studying all three pillars of building performance proved to be challenging. The reconciliation of forecast and achieved energy use – including gaining an understanding of where, when and how energy is used in a building – was in itself an arduous process. The prediction and validation of the achieved indoor environmental quality (IEQ) was still firmly in the realm of academic research.

However, the systematic gathering of feedback from buildings in use must be a priority for architects. Our research shows that a building's design and functionality can have a greater impact on occupant perception of comfort than the actual measured temperature and air quality. We also found that when occupants are satisfied with a building's design and it meets their needs they demonstrate an increased comfort range for temperature and air quality.[63]

Two case studies from AHR's BPE portfolio, Academy 360 and Stockport Academy, illustrate that occupants can have drastically different perceptions of very similar measured temperature and CO_2 levels. The two buildings were in the same region, with the fundamental difference being occupant satisfaction with design and functionality. Where occupants were less satisfied with these, their perception of physical comfort was significantly lower than the benchmark. In the building where occupants were happy with design and usability, physical comfort was rated higher than the benchmark. Architecture clearly had a major role to play in occupants' perception of comfort and well-being (Figures 06–07).

The issue of user perception is especially pertinent in the context of active versus passive controls for thermal comfort and air quality. There is growing regulatory and industry pressure to narrow the criteria for comfort and

well-being in offices and schools, pushing more designs towards active HVAC solutions. The feedback from BPEs indicates that this often leads to higher energy consumption and a risk of compromised building resilience (e.g. air-handling units not working, and non-operable windows). Conversely, it may be more beneficial to invest in architectural quality to provide greater flexibility and adaptability and to meet the evolving needs of occupants.

More data is needed to statistically demonstrate the key factors influencing energy efficiency as well as the relationship between design and measured versus perceived internal environmental quality. Researchers require significantly more feedback from buildings and occupants to do this.

The role of feedback in legislation

It is considered anathema in any design profession to miss out on feedback from a product's performance in use. Yet in architecture, the use phase has only been re-incorporated into the RIBA Plan of Work since 2013, and there are no recognised standards or scopes of work for what should be undertaken. Architects cite the lack of fees and concerns over liability as the main reasons for not engaging beyond completion. However, architects have much to gain from pushing for the measurement and verification of building performance. Evidence shows that where there is a requirement to target operational building performance, there is inherently more design emphasis on the way in which occupants will interact with the completed buildings. AHR found that feedback from BPEs engaged the wider practice and created an appetite for finding ways of improving building performance.

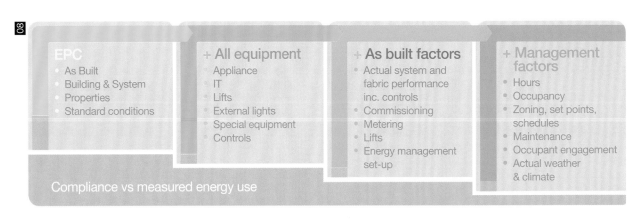

08

EPC	+ All equipment	+ As built factors	+ Management factors
• As Built	• Appliance	• Actual system and	• Hours
• Building & System	• IT	fabric performance	• Occupancy
• Properties	• Lifts	inc. controls	• Zoning, set points,
• Standard conditions	• External lights	• Commissioning	schedules
	• Special equipment	• Metering	• Maintenance
	• Controls	• Lifts	• Occupant engagement
		• Energy management	• Actual weather
		set-up	& climate

Compliance vs measured energy use

On projects where the BPE team were involved prior to completion, such as Tremough Innovation Centre, there were already significant benefits in terms of commissioning and handover (Figure 09).[64]

Another advantage of planning for feedback early on was that it reduced the cost of a building evaluation. AHR found that where the gathering of operational data was built into the project framework, the time and cost required to carry out an evaluation could be reduced by more than 70%.

Evaluating a building in use requires a building log book, comprising a building user manual, information on design intent, a prediction of detailed energy use and the assumptions behind this. This provides a baseline for operational energy that can be used for benchmarking and diagnostic purposes. Although a requirement for compliance with Building Regulations, this information has been found missing on an overwhelming number of projects participating in Innovate UK's BPE programme.

Incorporating the evaluation and reporting of building performance early on creates a vested interest for all project parties to collaborate and prepare information relating to energy consumption. As a consequence, associated responsibilities for monitoring are assigned, meters are correctly installed and commissioned, and project log books and building manuals are completed – as are operation and maintenance (O&M) manuals. Starting a BPE immediately after completion has been found to raise the chances of a building project being completed as designed.

Embedding such feedback into the existing framework of legislation is technically possible for non-domestic buildings[65] – the main hurdle to overcome is to adjust reporting metrics so that design-stage calculations can become comparable to measured energy use. At EU level there is work being done to address this as part of the Energy Performance of Buildings Directive, recast also as the EU-wide Voluntary Certification programme, which will allow building energy use to be compared across national boundaries.

National governments and the wider construction sector are beginning to recognise that mandating disclosure may actually ease the legislative burden while improving performance cost-effectively. For those making the leap, the rewards are there to be reaped. Shifting focus away from box-ticking towards effective means of improving actual building performance can raise productivity across the supply chain and deliver value for money for investors and operators alike. It seems that the business case for investing in energy efficiency has been there all along – it is just a question of looking at the right data to see it.[66]

The realisation that energy-performance contracting of design projects can promote architectural quality is beginning to change architects' take on energy legislation. It has already provided an impetus for organisations such as the Architects' Council of Europe to campaign for the disclosure of building performance data to be incorporated into new updates of EU energy legislation, such as the Energy Performance of Buildings Directive that drives Building Regulations in all EU member states.

The challenge for the built-environment sector is to improve well-being and productivity in buildings while lowering energy and resource use. Performance data and feedback needs to become ubiquitous if we are to meet this aim. Whatever the ultimate solution, the good news is that targeting building performance in use is great for building occupants, for architecture and for the climate.

Disclosure – a driver for excellence

AHR, together with Max Fordham engineers, has piloted an approach based on analysing feedback and performance data for Keynsham Civic Centre (KCC) and One Stop Shop, a major regeneration project for Bath & North East Somerset Council. To achieve greater certainty in reducing running costs, the client set a requirement for an operational Display Energy Certificate (DEC) rating of 'A' from the outset. Building on feedback gathered from BPEs, the team embedded the measurement, verification and disclosure of operational energy-use data into the contractual framework for the project.

Aspects of the design that contributed to the achievement of performance targets, including occupancy scenarios and operating conditions, were recorded in an Energy Risk Register that was updated at key project stages, along with detailed energy-use forecasts. Shifting the focus from compliance to actual performance allowed the architectural design to work harder to support occupant well-being, building usability and long-term resilience. Since its completion in 2015 the project has received major national design awards, including a British Council for Offices Award, and is already showing leading performance among UK offices.

KCC is the first project in the country to take this approach, supported by the Soft Landings framework.[67] However, other reporting frameworks that have been implemented globally also demonstrate real improvements in energy performance. The common thread between these is the emphasis they place on the measurement, verification and disclosure of performance in use.

10

11

12

ESSAY 7

Bill Bordass, Usable Buildings Trust

Energy performance

It is over 40 years since the first oil crisis in 1973–74, and a quarter of a century since the Rio Earth Summit in 1992 put anthropogenic CO_2 emissions firmly on the map. By now, one might have expected the UK to have a firm grip on reducing the energy use and carbon emissions from its buildings, particularly new and refurbished ones where architects and other building professionals are deeply involved. While low energy is just one of many attributes of a sustainable building, it is also fundamental given the importance of energy security and the threat of climate change. Our work in the 1990s[68] also showed that while low-energy buildings were not necessarily also comfortable, well designed, well procured and well managed, buildings could indeed manage to be all of these things.

Performance gaps

So how good are we at producing low-energy buildings? Not very: today there are often large differences between intended and actual performance, with some new buildings even having higher annual carbon emissions than their much older predecessors. Fortunately, as the evidence builds, there is a growing realisation that these performance gaps really do exist. However, there is some confusion among the construction industry and government as to what to do about this, with committees threatening to make things unnecessarily complicated and bureaucratic.

Case study evidence of these performance gaps has been around for many years, including in some publications by the author more than a decade ago.[69, 70] However, it has tended to be ignored, or dismissed as anecdotal. Why? Because neither government nor the building professions has regarded building performance in use as a legitimate knowledge domain, as has been argued by past RIBA president Frank Duffy.[71] Consequently, on matters of building performance in use, the government tends to turn to the construction industry … but the industry doesn't know, because it is appointed to design, build and alter buildings, not to see what really happens after they are completed, and to feed back the experience into its designs and processes.

We have been making the categorical error that building performance is about construction and regulation, rather than the result of a much wider range of influences as buildings are occupied and evolve through time. This thinking is reflected in the titles of government reports and initiatives, including the Egan Report 'Rethinking Construction' (1998), the Fairclough Report 'Rethinking Construction Innovation and Research' (2002) and the naming of the Green Construction Board (2011).

The Fairclough Report[72] was commissioned:

- to prepare for the expiry of the government's Framework Agreement with the Building Research Establishment (BRE), five years after the regrettable privatisation of BRE in 1997: another manifestation of a market mantra that fails to appreciate the public-interest dimension of good building performance
- in response to the continuing dismemberment of the former Environment Department following the 2001 General Election, with its responsibility for construction sponsorship being transferred to the Department of Trade and Industry

The report saw building performance largely as a matter for regulation, not something that goes far wider. However, it did identify four aspects of government interest to support building research: as a regulator, a sponsor, a client and a policymaker – 'for issues that go wider than the construction industry' – here mentioning climate change, energy efficiency and unforeseen circumstances.

In spite of this, it still seems difficult to wrest building performance away from construction – and to get joined-up government thinking and action in the area. One shaft of light has been Innovate UK's sponsorship of a programme of about 100 building performance evaluations, several of which have provided material for this book. Sadly, the programme ended in 2014. To avoid a rush of unintended consequences, there needs to be a constant flow of performance feedback information and insights in the public interest, and to support the radical improvements that policy requires.

Building professionals and building performance

Where does this leave the building professional? To protect society's wider interests, professionals have a responsibility to do 'the right thing', going beyond the obligation to whoever pays their fee. The idea of professionalism may seem dated, because over recent decades the social and political culture has tended to see the professions as just another branch of business. However, the challenges of sustainability now bring professional obligations into sharp focus, with the common interest now on a global scale. As Malcolm Bull[73] puts it: climate change does not tempt us to be less moral than we might otherwise be; it invites us to be more moral than we could ever have imagined.

A milestone in the history of building performance was the book of the same name[74] by the Building Performance Research Unit at the University of Strathclyde, published in 1972. However, history has shown this to be more an epitaph than a manifesto. In the same year, Stage M – Feedback was removed from RIBA's document 'Architect's Appointment', on the grounds that the service could not readily be quantified and clients were unwilling to pay for it. Sadly, this also applied to government clients – though at the time government departments still had their building professionals, their works departments and their research units (not to mention the Building Research Establishment) and were doing a lot to close the feedback loop, implicitly and explicitly. In the ensuing decades, government tended to outsource, privatise or abandon these activities, but neither industry nor the building professions saw fit to put alternative feedback systems in place.

Without such feedback, how can building professionals know that they are doing the right thing? Frank Duffy[75] has said: 'Plentiful data about design performance are out there, in the field … Our shame is that we do not make anything like enough use of it.'

Because such follow-through and feedback has not been routine, many people say it can't be afforded. I say we can't afford not to. Professional institutions already require their members to understand and practise sustainable development, so surely this must include understanding the outcomes of their own activities? If you call yourself a building professional, get to understand how your buildings really work in use.

Towards better-performing buildings

Keep things simple and do them well

Studies in the 1990s, including the Probe studies of published post-occupancy evaluations (POEs) reviewed in a special issue of *Building Research & Information*,[76] revealed that unmanageable complication was the enemy of good performance, a finding now echoed in the results of Innovate UK's building performance evaluation programme.[77] It showed that many things that one would hope to take for granted (e.g. the thermal integrity of the fabric and the functionality of controls – both manual and automated) often leave a lot to be desired. The buildings that worked best tended to be both relatively straightforward in their design and to have received attention to detail – in design, during construction, and before and after handover. Another important ingredient of good performance was an individual (or, better still, several individuals) committed to getting a good result: process is no substitute for leadership!

Robust or fragile buildings?

With dedicated input, complicated buildings could also work well if sufficient effort was put into both their procurement and their operational management, from briefing through design and construction and into operation. The best of these often had a dedicated client representative who provided leadership and insight right through the process. However, as time passed, it became clear that complex buildings that had worked well in their early life could nevertheless prove fragile in the face of organisational changes, for example when facilities-management budgets were reduced in the face of economic

difficulties, or when skills were lost when in-house facilities management was outsourced. Better to be simpler and more robust, particularly for public buildings. Sadly, over the past decade, buildings and the related legislative requirements have gone in the opposite direction, becoming ever more complicated, not least many recently constructed schools: expensive to build, expensive to occupy and often with large performance gaps in terms of energy and carbon. This is because theory tends to favour the more complicated solution over the simpler one, while performance in use stresses the importance of making things robust, usable and manageable.

Improve the process

Not only is the concept of completing work, handing it over and going away not fit for purpose for today's buildings, the whole procurement process needs re-examining. The golden thread from design intent to reality must be maintained throughout the process; at present it is often severed as a project moves from stage to stage, sometimes with an almost complete change in 'players'. Should it be any surprise that performance gaps open up and that innovations do not hit their targets?

The Soft Landings framework[78] has been developed to give more emphasis on outcomes, and to reinforce any existing process at five critical stages:

- inception and briefing
- managing expectations during design and construction
- preparation for handover
- initial aftercare
- longer-term aftercare – typically for three years after handover.

The approach works best if one or more members of the project team adopt the role of Soft Landings champions, who can help to maintain the focus on outcomes and support and challenge other team members.

Count everything

Designers tend not to be very good at predicting actual energy performance in use. The architect too often asks the computer modeller or building services engineer: does it meet the regulations? If the answer is yes, the design proceeds; if not, options are reviewed and changes are made – often adding complication, because this makes the sums work better though often not the buildings themselves. The results of the calculations can be difficult to

understand, and focus on so-called 'regulated loads', representing the energy end uses covered by the Building Regulations – i.e. heating, hot water, cooling, ventilation and fixed interior lighting. The numbers may look good, but the assumptions can be questionable. Not only does the energy used by these loads tend to be severely underestimated, but they can also be just the tip of the iceberg – particularly in non-domestic buildings, where the occupier's equipment and management can dominate. Unfortunately, building designers often think this has nothing to do with them, while in practice if the priorities are communicated clearly and early, there can be not only an influential dialogue but designers may make the building and its systems better able to be controlled and managed effectively in relation to likely patterns of use.

Focus on performance in use

In 2001, in *Flying Blind*[79] the author argued that building performance needed to be made visible to spur people into action, and saw opportunities within the EU's proposed energy certificates. This led to the development of Display Energy Certificates (DECs), based on actual energy use, which came into force in England and Wales in October 2008, but only for public sector buildings over 1,000m².

While DECs have helped to expose the performance gaps, they have been a disappointment for three main reasons:

- The government seems to regard them as a bureaucratic procedure, not an evolving window on performance and the anchor for a variety of policy measures.

- DECs have not been extended to commercial buildings, in spite of getting into the Energy Bill 2011, with strong support from the building and property industries and the CBI. At the last minute they were removed from the Energy Act by the Treasury, reportedly owing to concern about the benchmarks and pressure from major retailers who did not want to sell A-rated appliances from D-rated buildings.

- Extraordinarily, in view of their importance in terms of clarity of communication and furthering policy objectives, there has been absolutely no government investment in benchmarking for a decade.

The unfortunate history of DECs is described in 'Mandating Transparency about Building Energy Performance in Use', in *Building Research & Information*.[80]

The bizarre consequence is that for all the policy interest in improving building energy and carbon performance, we still lack clarity on the key objective: how are buildings actually performing? While this could act as a rallying point for all the players involved, we instead continue to fly blind in a bureaucratic fog. One positive development is CarbonBuzz[81] – a platform developed with support from the Technology Strategy Board, RIBA and CIBSE, on which people can deposit and share their design and in-use energy data and which provides support in identifying contributors to the performance gaps. However, we still need proper government support with coordination and benchmarking.

Whatever happens, building designers need to get much more familiar with how their buildings work in use. Only then will we understand what we need to do to get them to perform better. A promising development is Commitment Agreements as used in Australia, where a developer and their design team undertake to provide a building that performs in accordance with its design predictions. This has been a great success for landlords' services in rented offices ('base buildings' – something very close to 'regulated loads'). The Usable Buildings trust is currently part of a team that is exploring the feasibility of adapting this system for the UK and the EU,[82] including a series of pilot projects.

Case studies

The case studies in this book have all undergone BPE and show both the design intentions and how they worked on completion. They are grouped according to building type – offices, public buildings, schools and homes – allowing for some cross-comparison between similar projects, but also to show the different evaluation methods and challenges across building types.

The case studies are drawn from the Innovate UK programme as well as other projects that have undergone BPE. Wherever possible the performance information is presented in a consistent format. However, all of the performance information needs to be viewed in context and qualified or explained to some degree, including information on building location, occupancy, weather and the length and detail of monitoring. These variable factors are difficult to encapsulate in short studies, so where possible references to full research reports are given.

The write-up of the case studies is structured to introduce the overall ambition of each project with a specific focus on the environmental aspects of design, followed by a summary of findings from the post-occupancy evaluation. Individual teams evaluated each project; in the majority of cases this was done independently of the design team, and this is identified in the project credits.

A number of different factors were evaluated, and these differ in each building type – however, these typically included an assessment of the building fabric, monitoring of energy use and environmental conditions (indoor and outdoor), review of installation and commissioning of building services and technologies including maintenance and management procedures, review of operation and usability of systems and controls, and finally an assessment of occupant satisfaction. In some case studies, such as the two school projects (Case Studies 5 and 6), ventilation was also monitored.

Evaluation was carried out through building walk-through surveys; interviews with facilities managers, occupants and staff; and a review of documentation. In addition a range of more structured methods was also used.

BUS (Building Use Studies)[83]

This is a survey method used to evaluate occupant satisfaction that was developed during the original PROBE studies in the 1990s. It is a structured questionnaire that looks at 45 variables including thermal comfort, ventilation, indoor air quality, lighting, personal control, noise, space, design, image and needs.

Infra-red thermographic survey

This involves using a thermal-imaging camera to identify variation in the surface temperature of the building. This enables the team to identify areas of thermal bridging, changes in insulation or areas of air leakage. This is a helpful method to identify possible areas of weakness in the thermal fabric (see Case Study 4) or to study the effects of thermal mass (see Case Study 1) but would normally need to be correlated with other data from meters, air infiltration tests or user surveys to enable understanding of the findings.

Co-heating tests[84]

This is a method of determining a building's heat loss coefficient (HLC), calculated by plotting the heat input into a building against the difference in temperature between inside and outside. Used on dwellings it enables the comparison of the as-built HLC with the design HLC generated by the Standard Assessment Procedure (SAP). There has been some criticism of the effectiveness of this method to accurately predict heat loss, particularly where there is significant solar gain into properties.[85] In addition it has been noted that widespread application of this method in all housing projects would be problematic due to the length of the test. However in housing, where there is significant variation in user energy consumption, it offers a helpful starting point alongside other methods to understand the robustness of the building fabric relative to design predictions. Further detail on this method can be found in the housing case studies (Case Studies 8–10).

Air leakage test

This involves fitting a temporary airtight screen to a door in the building with a fan mounted to it, and closing off extraction vents, trickle vents and traps. A pressure difference is created between the inside and outside of the building of 50Pa, and the rate of airflow through the fan is measured over a range of different pressures between inside and outside. This enables an overall air permeability rate to be determined for the building. This can be combined with smoke pen tests and thermal imaging to identify air leakage paths in the fabric of the building.

TM22 BPE methodology [86]

Technical Memorandum 22 Energy Assessment and Reporting Methodology (TM22) is a CIBSE-developed spreadsheet and accompanying guide for assessing energy performance in buildings. The tool can be used in different ways dependent on the level and quality of metered energy data that you have available. Simple energy benchmarking assessments can be made where metered mains utility data is to hand. If sub-metered energy data is available, energy profiling can be used to determine and compare energy for separate end uses (e.g. lighting, cooling, small power, ventilation, etc.). Additionally, if TM22 is used to build up energy profiles during the design process the TM22 model can be used in early occupancy to verify design predictions and identify energy waste in order to optimise a building's energy performance in use.

Each of these methods on its own only offers a partial understanding of the building and how it is being used. Some are relatively simple to undertake; others require significant investment of time and resources. The case studies use a range of different methods to give an overall picture of the building, and have been written up to illustrate the key findings of value for designers and clients.

CASE STUDY 1

The Woodland Trust HQ
Grantham

The Woodland Trust HQ is an open-plan office that reflects the Trust's mission through an innovative approach and simple building design that provides reasonable occupant satisfaction with modest energy use.

Client	The Woodland Trust
Architect	Feilden Clegg Bradley Studios
Structural engineer	Atelier One
Services engineer	Max Fordham
Landscape architect	Grant Associates
Project manager	Buro Four
Quantity surveyor	Ridge
Main contractor	Bowmer & Kirkland
Post-completion testing	William Bordass Associates with Max Fordham and Archimetrics

Overview

The Woodland Trust Headquarters is a new office in Grantham, a few hundred metres from its previous rented building. The building was designed to be low cost, to a budget that reflected rental values in the surrounding area, yet high quality, delivering low environmental impact in construction and use.

Key to the brief and design of this project was incorporating the lessons learned by the architects and engineers from the post-occupancy evaluation (POE) of the National Trust Headquarters, Heelis, which was completed in 2007 by the same team. The mantra used was to 'keep it simple, do it well' and to concentrate on getting the basics right with a shallow plan, natural ventilation and simple detailing. This included using task lighting and keeping controls simple, with energy-efficient Information and communications technology and 'thin clients'. Thin clients means that computer terminals are not used to run software but rather that this is done centrally through the network. The designers had also been involved in the initial Soft Landings research in 2002–3 and applied elements of this approach, including early appointment of a facilities manager and a commitment to follow through with continued POE.

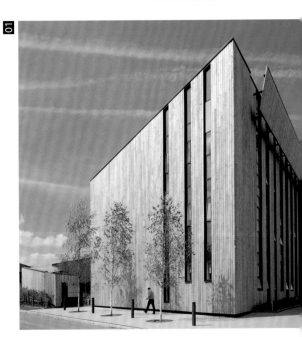

01

01 External view: baffle on north elevation to assist stack and cross-ventilation
02 Context plan
03 Ground-floor plan
04 First-floor plan
05 Second-floor plan

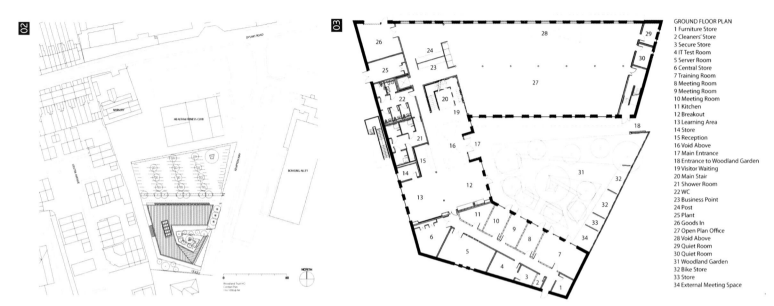

02

03

GROUND FLOOR PLAN
1 Furniture Store
2 Cleaners' Store
3 Secure Store
4 IT Test Room
5 Server Room
6 Central Store
7 Training Room
8 Meeting Room
9 Meeting Room
10 Meeting Room
11 Kitchen
12 Breakout
13 Learning Area
14 Store
15 Reception
16 Void Above
17 Main Entrance
18 Entrance to Woodland Garden
19 Visitor Waiting
20 Main Stair
21 Shower Room
22 WC
23 Business Point
24 Post
25 Plant
26 Goods In
27 Open Plan Office
28 Void Above
29 Quiet Room
30 Quiet Room
31 Woodland Garden
32 Bike Store
33 Store
34 External Meeting Space

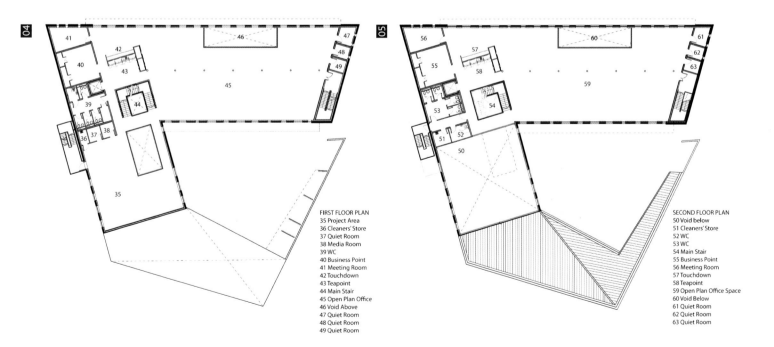

04

05

FIRST FLOOR PLAN
35 Project Area
36 Cleaners' Store
37 Quiet Room
38 Media Room
39 WC
40 Business Point
41 Meeting Room
42 Touchdown
43 Teapoint
44 Main Stair
45 Open Plan Office
46 Void Above
47 Quiet Room
48 Quiet Room
49 Quiet Room

SECOND FLOOR PLAN
50 Void below
51 Cleaners' Store
52 WC
53 WC
54 Main Stair
55 Open Plan Office
56 Meeting Room
57 Touchdown
58 Teapoint
59 Open Plan Office Space
60 Void Below
61 Quiet Room
62 Quiet Room
63 Quiet Room

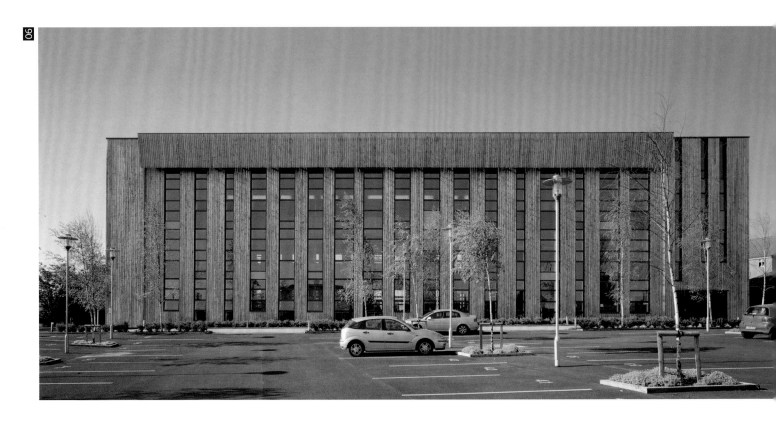

The structure consists entirely of cross-laminated timber (CLT) with no structural frame apart from a row of columns and beams up the centre of the three-storey office section (Figure 09). The timber was then wrapped externally in a thick wood-fibre thermal jacket and finished with larch cladding (Figure 06).

This simple and frugal approach allowed the building to be procured for £1,800/m², demonstrating value for money while expressing the core values of the Woodland Trust.

The CLT did not have sufficient thermal mass to limit peak temperatures. Therefore a particular innovation in the project was to supplement this by means of 'concrete radiators' bolted to the underside of the structural timber deck. These also stiffened the deck, reducing the depth of timber required.

06 External view
07 Thermogram: radiant cooling of ceiling planks
08 Concept drawing: spiralling form encloses sheltered garden

85

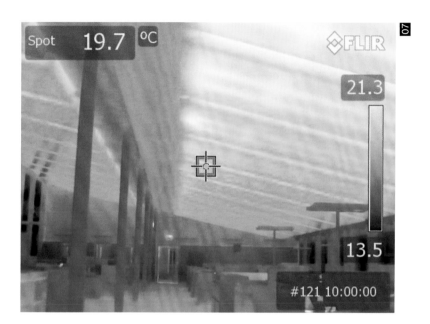

Design approach

The form of the building was inspired by an unfurling fern – an ascending spiral that rises from ground level to three storeys high (Figure 08). This creates a courtyard or 'woodland glade' that acts as an entrance and breakout space while also allowing sun into the office space over the low roofs to the south and east. The angle of the roof also allows for the future installation of photovoltaic panels.

The building has a 15m-deep floor plan with 4m floor-to-floor height, allowing for excellent levels of natural daylight. On the south façade light shelves are used to reflect light on to the ceiling soffits, while storage and service rooms are located on the west façade to avoid the need for external shading on this elevation. Rooflights over the main staircase allow direct sunlight into the circulation areas of the building, to animate the space.

The building elevations take their inspiration from silver birch woodlands with three-storey vertical strips of windows to the north, and south elevations separated by vertical timber cladding. The windows incorporate grey and silver-grey spandrel panels in reference to the bark of silver birches.

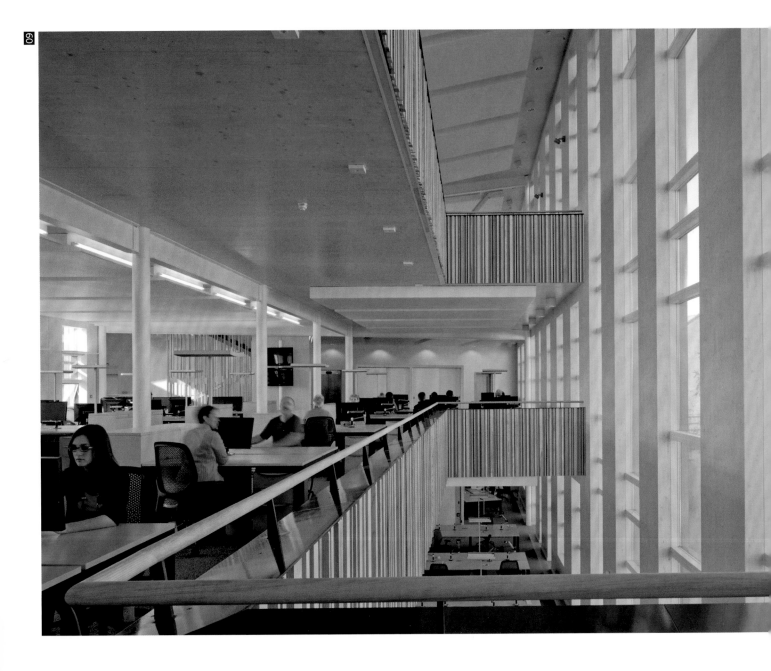

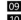

Environmental design

Key lessons from Heelis incorporated in the project included simple construction and detailing, use of natural ventilation and thermal mass, the use of task/ambient lighting and careful IT design.

The CLT construction of the building's floors, walls and roofs enabled the simple design and construction of the thermal envelope, with no structural members or panel frames to create weak spots or thermal bridging. The use of timber also significantly reduced the embodied carbon dioxide, which was 400 tonnes less than in an equivalent concrete structure. In addition, the timber also sequesters 500 tonnes of CO_2. The designers estimated that the total embodied carbon savings would be equivalent to ten years of operational energy use. The actuality is five years, because the design estimate was for 'regulated loads' only (heating, hot water, ventilation and lighting).

Learning from Heelis led to the decision to introduce more user control to supplement the already good levels of natural daylight in the building, rather than relying on a centrally controlled ceiling system. This included time-controlled ambient lighting in the middle of the office space, time-controlled wall-wash lighting around the edges of the space and task lighting at work stations, using floorstanding uplighters and downlighters between the desks (Figure 09).

The natural ventilation and cooling strategy uses a combination of motorised windows operated by the building management system (BMS), with a local override on each floor, and windows that users can control. Air circulation through the building is then enhanced by voids between floors at the main stairs, reception area and atrium spaces. To assist stack and cross-ventilation, a baffle was fitted at the peak of the monopitch roof to place the upper motorised windows on the north elevation under a negative pressure, whatever the wind direction (Figures 01 and 10).

The natural ventilation and concrete radiators work together to help improve thermal stability by absorbing heat in the day and then either removing it at night through cross-ventilation or retaining it for the next day.

The Woodland Trust had a desire to use a 'thin client' system, which had a number of advantages in terms of data security, archiving and reducing heat gains in offices. It also allows staff to work from any workstation in or out of the office.

The server room design included direct cooling from four units that cooled the equipment cabinets and one unit that provided ventilation from outside for free cooling. It was hoped this could be used for much of the year. This was changed to a single cooling system as part of the value engineering process.

Monitoring and post-occupancy feedback[87]

The BUS (Building Use Studies) methodology survey indicated that occupants were satisfied generally, with the building scoring in the top quintile of the BUS reference data set. However a number of specific issues were reported about ventilation, air quality and overheating, relating largely to the automated control of the windows.

In winter, occupants reported problems with draughts from both the manual and the automated windows. This resulted in them being open less and the facilities manager increasing the setting for automated CO_2 control, which led to complaints of poor air quality. In 2012 the facilities manger began to open some windows away from workstations manually, and in 2013–14 further changes allowed the motorised windows to be opened slightly. This reduced complaints about air quality. However, some problems remain because the windows do not open uniformly.

In the first two years, there were complaints of overheating, although the summers were relatively mild. Although the concrete radiators reduced peak temperatures through thermal inertia, the control systems did not operate as intended. Three main reasons were found for this:

- On sunny days, in spite of being in the shade, the external sensor detected an elevated average external air temperature so did not open the windows, thinking it was too hot outside. The sensor was moved in 2013.
- The concrete radiators took the longest to cool overnight, owing to their high thermal capacity. Meanwhile all other internal elements, including the furniture and the air in the building could be cold when staff came in, leading to complaints. The solution was to terminate night cooling two hours in advance of occupancy to allow temperatures to equalise.
- The control logic was too complicated and was simplified.

The night cooling is now much more effective, but it took a considerable amount of time to diagnose the problems and tune up the system. In most buildings, this never happens.

The lighting strategy proved very successful, with most staff happy to work at light levels well below published standards. The task lights provided at workstations were used economically, with only 20% of the fittings typically in operation.

The overall electrical energy use of the building is similar to design predictions. However there were a number of problems with the BMS that made it difficult to use for data logging in order to undertake the POE. This included the calibration of sensors, the metering system not being compatible with the thin client system and difficulties in transferring data to the office of the design engineers.

The overall electrical energy use hides a number of more interesting findings. The lighting consumption was nearly half of the design prediction, and this was accompanied by high user satisfaction, showing the success of high levels of daylight and user-controlled task lighting.

However, the savings in lighting and in other areas were offset by higher-than-expected electricity use in the server room and in cooling the server room. The causes included more processing in the server room with a thin client system, the 'value engineering' of server room cooling into a single system, and what in hindsight may have been over-specification of server room equipment. In the event the single cooling system proved unreliable and the client has had to add a back-up system with wall-mounted comfort cooling units.

The gas consumption in the building was below the design estimates even though the building was monitored in a relatively cold year. This was due to well-designed fabric and high build quality and some under-ventilation in winter, as discussed above.

The CLT panels performed well thermally with minimal cold bridging. The air permeability was 2.44m³/m²/hr at 50Pa – less than 25% of the level required by Building Regulations. Although shrinkage cracks (up to 5mm) were visible between the CLT panels, these have not been shown to produce significant air and heat leakage, as the panels were sealed externally with airtight tape. This shows the importance of a simple thermal envelope design in delivering robust thermal performance.

Conclusions

The building achieved relatively high user satisfaction, with overall energy use very similar to predictions. Significant savings were made in lighting energy use, but the IT systems and server room cooling used much more than originally estimated, accounting for 80% of annual electricity consumption. To create truly low-energy office buildings, there needs to be a dedicated effort to reduce the energy use of ICT services. Appointment of a specialist ICT energy-efficiency consultant is recommended to assist with briefing and specification and for review during selection, installation, commissioning and operation.

The building tested an innovative approach to thermal mass in timber buildings through the design of concrete radiators, and successfully delivered a naturally ventilated building. However this was only achieved through a significant amount of work with the client on completion to optimise controls, despite a relatively simple building.

Areas where expectations fell short included those where over-complicated approaches were adopted and not fully understood. As the facilities manager noted: 'The Woodland Trust is lucky to have less complication than most. It is difficult enough to cope with the complication we have got.'

This reinforces the need for simply designed buildings, for an understanding of how the building will be used and run by the occupier, and for adopting a Soft Landings approach to manage expectations during design, construction and commissioning – and to follow through after handover into fine-tuning and formatting.

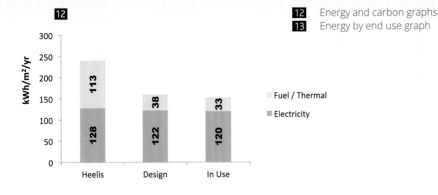

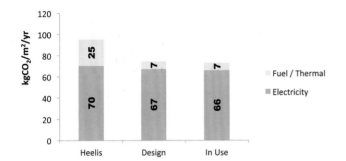

Title Woodland Trust Headquarters
Location Grantham, Lincolnshire
Completion date October 2010

The Woodland Trust HQ performed very close to overall design predictions (see energy and carbon graph, Figure 12) and significantly better than the project used to benchmark the design, Heelis. However this overall performance does not illustrate the successes in some areas and challenges in others. The building energy demand by end use graph (Figure 13) shows that the savings made by the internal lighting strategy, ICT equipment and hot water were offset by the increase in energy use by the problems encountered with the server room.

The data for the graphs was adapted from information in Pete Burgon and Bill Bordass, (2014) 'Woodland Trust HQ, Building Performance Evaluation: Final Report', Innovate UK. Design data was taken from outputs from the Building Regulation model plus estimates of other electricity needs at the time. Actual data for ICT equipment and small power have been combined to allow comparison with design data.

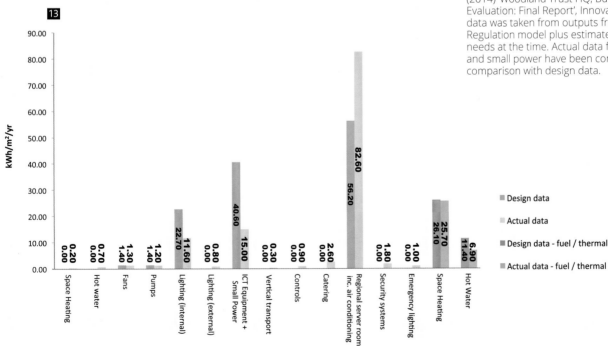

CASE STUDY 2

Greenfields House
Braintree

A three-storey landmark head office commissioned by a not-for-profit Community Gateway housing organisation, Greenfields House combines office functions with space for community meetings in a building that reflects Greenfields' innovative, resident-based approach to social housing.

Client	Greenfields Community Housing
Architect	Studio Partington
Structural engineer	Integral Engineering Design
Services engineer	Michael Popper Associates
Main contractor	ISG Jackson
Post completion testing	AECOM, UCL, Studio Partington

Overview

Greenfields Community Housing took over Braintree Council's homes in November 2007 following a tenant and leaseholder ballot. The building brings all of the organisation's activities together in a productive working environment combined with social and exhibition spaces and a community hub. The brief for the project was developed by a working group that included residents, resident board members, staff and the designers.

Design approach

Located on a sloping brownfield site on the edge of an existing retail park, the new building consists of three storeys of narrow-plan office floors and a timber-clad public hub that shares the entrance and reception space with the office (Figures 01–03).

01 Entrance hall with artwork mounted on acoustic panels
02 Internal view: double-height entrance lobby
03 External view of main entrance: 'Every aspect of this beautiful building screams non-bureaucratic, non-standard, non top-down and everything about "people and community". I helped change the group's mind on the choice of brick; who am I? A tenant, what do I know? Every time I pass the building I smile … empowerment.' (Leigh Jones, tenant representative)

The building is organised to allow its exhibition and public meeting areas to be used outside of normal business hours, reflecting Greenfields' aim to promote health, education and well-being and provide more than just housing services (Figure 04).

The working group championed the project's aims and challenged the designers on the detailed aspects of the brief and the environmental strategies needed to deliver a flexible and comfortable environment.

The group expressed a strong preference for windows that could be opened, a degree of control and self-management of the internal environment, and a studio-like atmosphere in the office spaces. The light and airy internal atmosphere is appreciated by staff, and any lingering associations with their local-authority origins have been dispelled.

Environmental design

The building has a highly efficient envelope, high thermal mass provided by an exposed concrete frame, and good natural daylighting. Three ground-source heat pumps provide all the heating and cooling for the offices, reducing the energy use. Passive design measures reduced the need for cooling, which is only provided to IT rooms and community rooms where the occupancy can be high.

In winter fresh air is introduced by a displacement system through the office floor plenum. The air is pre-heated by an extensive underground labyrinth and a heat exchanger within the air-handling unit. In the summer unwanted heat can be purged in periods of hot weather by using a night-time ventilation system that pulls fresh air across the exposed concrete surfaces. High-level ventilators, operated automatically by the building management system (BMS) allow air to pass above cellular offices. This arrangement ensures that the cross-ventilation and purge ventilation will be effective even if the office space is divided into a more cellular arrangement. Only one of the three heat pumps needed to be reversible to provide cooling, and this was sized with the intention to future-proof the building against a warmer climate (Figure 05).

04 Internal view: foyer to community hub ('my space') with art inspired by residents
05 Heating diagram: grant funding for heat pumps led to a decision to make the building all electric

97

Rainwater harvesting

Office spaces heated by perimeter trench heaters connected to Ground Source Heat Pump.

Fresh air supplied to spaces through floor plenum.

Exposed concrete slabs store heat and re-release back into the space to reduce heating load

Supply air is pre-heated by being drawn through underground thermal labyrinth.

Air handling unit

Stale air from office is extracted by air handling unit. A heat recovery unit extracts the heat from the stale air to help heat the incoming air supply

Rainwater harvesting task collects rainwater from roof for flushing WCs

Ground-source Heat Pump meets the entire heating load of the building

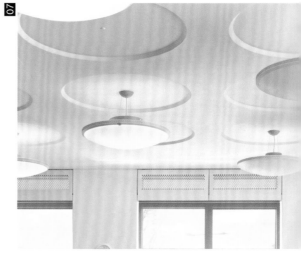

The building's exposed concrete soffits act as a visual feature of the office space, as well as playing a role in its passive thermal systems. Circular recesses 1,200mm wide and 25mm deep were formed in the concrete using plywood discs with chamfered edges. Large circular pendant lights are suspended from the centres of these recesses, complementing the design by subtly accentuating the recesses, and fulfilling the need to have direct and reflected light in the office environment (Figures 06 and 07).

06 Ceiling coffers under construction
07 Circular ceiling recesses: note uplighting, deisgned to accentuate chamfer on coffers
08 External view
09 Thermal image: heat loss around high-level actuators (highlighted red) – probably caused by service wear of actuator mechanism (not returning vent against air seals)

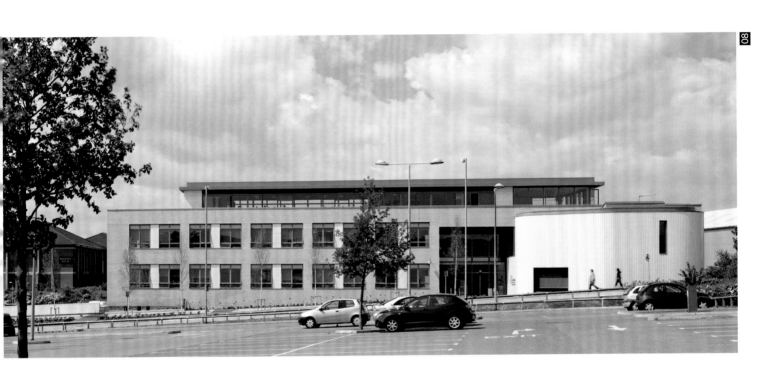

08

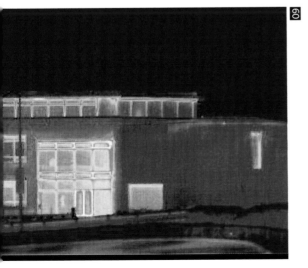

09

Monitoring and post-occupancy feedback[88]

The BUS (Building Use Studies) methodology survey was undertaken in the summer of 2012 and energy monitoring continued through 2013 and 2014, though hampered at first, as with many of the Innovate UK building performance evaluation (BPE) studies (as discussed in Essay 2), with difficulties setting up the building's sub-metering to give informative readings.

Overall the performance evaluation confirmed that the first design objective, to make an efficient building fabric, had been successful. The heating demand for the building was less than predicted in the Part L design calculations and the overall energy use was close to the predictions, representing a considerable achievement.

Somewhat surprisingly the users frequently remarked that the building was too warm, even in the winter months. Thermal imaging work confirmed that the insulation had been installed consistently well, but small infiltration losses were noted around the high-level window vents (see Figures 08 and 09) to

the top floor and in a concealed location behind the main staircase. The stair walls have several layers of construction, and heat losses could be through the voids behind the plasterboard (a thermal bypass) or directly by a thermal bridge. The cause was not pursued, as tracing this relatively minor loss would have involved some intrusive and disruptive investigation. The losses observed around the opening vents could either be because of deterioration of the casement weather seals, or more likely because the automatic actuators are not returning the windows to the closed position firmly against these seals. The high winter temperatures were managed with adjustments to the heating controls and reprogramming of thermostats in different areas.

Although the passive elements were generally performing to a high standard the BPE study raised more serious questions about the efficacy of the controls and the accuracy of information being reported to the user's management team. The handover of the completed building was rushed because of the termination of a lease on Greenfields' previous offices. Individual elements of the services were commissioned and signed off by subcontractors, but it seems that the commissioning of the overall controls and the description of their operation was compromised. Added to this, some false savings were made in the 'value engineering' processes during the two-stage tender. The functionality of the BMS was reduced, and the computer interface reporting sub-meter outputs and the status of the different services components was removed. With a relatively inexperienced facilities management team and with little convenient access to the BMS, Greenfields were effectively flying blind in the first year of operation. A proposed Soft Landings approach to handover was also abandoned, as the finish date began to override other aspects of completion.

Frustratingly for the monitoring team the BUS user survey did not coincide with the measurement and data collection process, so it was not possible to confirm anecdotal evidence of overheating by measurement. However, some very important feedback emerged from the occupiers' survey, confirming misunderstandings about the building operation and revealing some deficiencies in the 'trial and error' approach to system optimisation. An example was the intended summer ventilation regime. The building's mechanical ventilation system, which supplies tempered air through floor displacement grilles, is supplemented by automatic high-level vents and low-level user-operated vents. The automatic vents are also part of a night-time cooling strategy and are controlled by the BMS to open when external night-time temperatures are lower than internal temperatures. Some of the users

10

10 'Doorknobs' is a five-metre-high artwork made up of 864 porcelain doorknobs fired with images, each one depicting a detail from the memories of a local resident. Displayed prominently in the welcoming foyer of the building, the artwork is one of a number commissioned from local artists.

had been advised not to open low-level vents themselves, as these would interfere with the operation of the automated systems, disabling a simple local temperature and ventilation control.

The night-purge system also experienced teething problems similar to those encountered at the Woodland Trust (see Case Study 1), with erratic control of the night vents in high winds or when it was raining. The system was shut down by the BMS or manually overridden whenever blowing paper triggered a movement detector or alarm. Weather sensors would take a long time to reset after the cessation of rainfall, restricting the intended air movement.

Other changes made by the client were implemented hastily by the building's management, and with the benefit of hindsight could have been better thought through with help from the designers. The decision to install anti-glare film across all windows, even though the glare problems were only localised, led to an increased use of artificial lighting in the office spaces, contrary to the designers' intention to maximise daylighting.

Many staff considered the artificial lighting to be too bright. Lighting levels have been reduced in some areas by de-lamping luminaires. Such over-specification is not uncommon. The design aimed to achieve a 'maintained' illuminance of 600 lumens per m^2 – an industry norm, promoted in the main by funding institutions.

Another intervention was the introduction of a dedicated split DX-type cooling unit to the comms room. The reversible ground-coupled heat pump dedicated to cooling the room had periodically cut out, jeopardising Greenfields' operations. The replacement is both energy and carbon intensive, but as the monitoring team also failed to identify the fault (thought again to be a controls issue) this intervention seems justified. These two changes and the introduction of an air-curtain over the entrance doors have increased the overall energy usage, and carbon emissions, which are already high because of the all-electric heating systems.

Conclusions

Overall the lessons from Greenfields show that seemingly simple mixed-mode buildings still need well-designed and manageable controls. Savings to the control system and BMS proved to be false economies. In addition misunderstandings about how to operate the building, especially where seasonal changes require different behaviours, were caused by the hurried handover.

This project showed that the simple BUS user survey, supplemented by effective sub-metering, revealed many areas for improvement. This demonstrates that expensive monitoring is not necessarily essential to help get the best out of building performance.

Overall the client, designers and construction team did well to deliver a building that performs close to the expected design performance. With a low heating demand the decision to use heat pumps (subsidised through the Low Carbon Building Programme) may be justified, though the pumps and their controls require specialist and expensive maintenance.

Each member of Greenfields Community Housing's residents and employees values their new 'home', as they all played a part in its conception, design and completion. The building has been very well looked after since its occupation in 2009 (Figures 11–12).

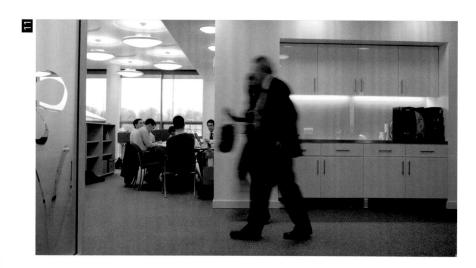

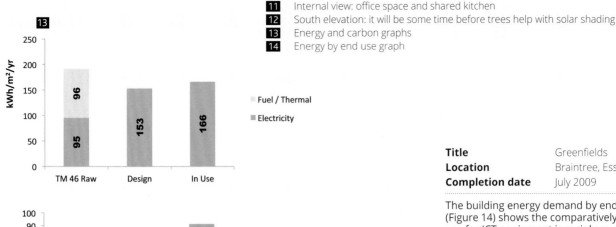

11 Internal view: office space and shared kitchen
12 South elevation: it will be some time before trees help with solar shading
13 Energy and carbon graphs
14 Energy by end use graph

103

Title Greenfields
Location Braintree, Essex
Completion date July 2009

The building energy demand by end use graph (Figure 14) shows the comparatively high energy use for ICT equipment is mainly caused by the reliance on a split-system DX air-conditioning unit for continuous cooling of the IT room. Although one ground-sourced heat pump was originally designed to work in cooling mode the operation was not reliable enough for the ICT providers. Reasons for the increased energy use for lighting are discussed in Essay 1.

The energy and carbon graph (Figure 13) shows how CO_2 as a measure of performance can be misleading. When the overall energy use is considered the building performs well against the benchmark, however as the building only used electricity the CO_2 emissions are much higher than the benchmark.

Graphs were produced from data adapted from Richard Partington Architects (2014),'Greenfields Community Housing Headquarters, Building Performance Evaluation, Final Report', Innovate UK. Design data was taken from outputs from the Building Regulation model plus estimates of energy use for non-regulated energy loads based on a survey of installed equipment. This enabled an identification of gaps in performance related to the regulated loads, however it also explains why for many of the areas the design use is similar to the actual use.

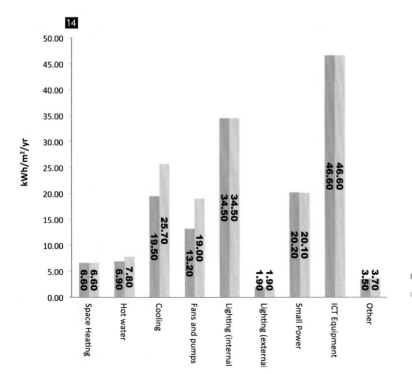

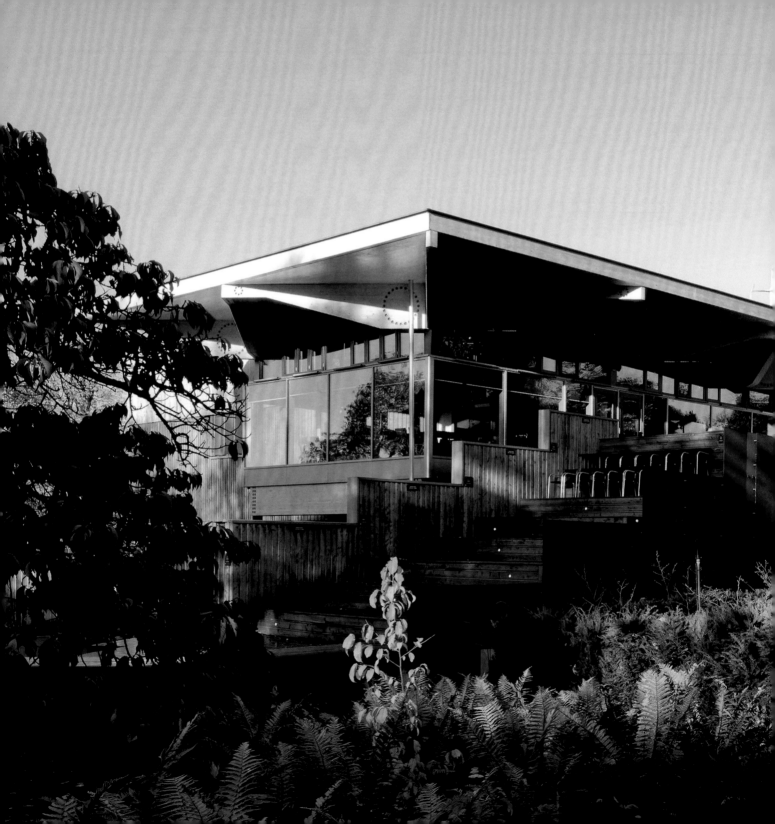

CASE STUDY 3

John Hope Gateway
Royal Botanic Garden Edinburgh

The John Hope Gateway introduces visitors to the important scientific work of the Royal Botanic Garden Edinburgh, and to the garden itself. It is a place full of living experiments, with cuttings and seeds collected from plants grown in the garden; plants observed, studied and recorded; and a visiting public engaged with this expertise.

Client	Royal Botanic Garden
Architect	Cullinan Studio
Structural engineer	Buro Happold
Services engineer	Max Fordham
Landscape architect	Gross Max
Project manager	EC Harris
Quantity surveyor	Davis Langdon
Main contractor	Xircon Construction
Post-completion testing	Max Fordham
Author of chapter	Roddy Langmuir

Overview

The John Hope Gateway is a new-build visitor centre housing permanent and temporary exhibitions, a restaurant, outdoor café, shop, education spaces, a media studio, flexible spaces for events and a biodiversity garden.

The Royal Botanic Garden Edinburgh (RBGE) is a world leader in the education and study of science, conservation and horticulture. Allied to its scientific purpose is the mission to explore, explain and conserve the world of plants for a better future. The John Hope Gateway builds on this legacy and provides a new public face to the Garden. As well as providing visitor facilities, it explains RBGE's history, significance and range of work undertaken around the world. With a beautiful city-centre location, a unique mix of events, educational experience and centuries of expertise, the Gateway is the prime facility in Scotland for engaging the public about biodiversity and climate change.

The design takes its cue from the contours, paths and trees of the mature landscape of the Garden. It replaced buildings and paths at the west entrance, and juxtaposes built spaces with the mature arboretum all around. It had to

01

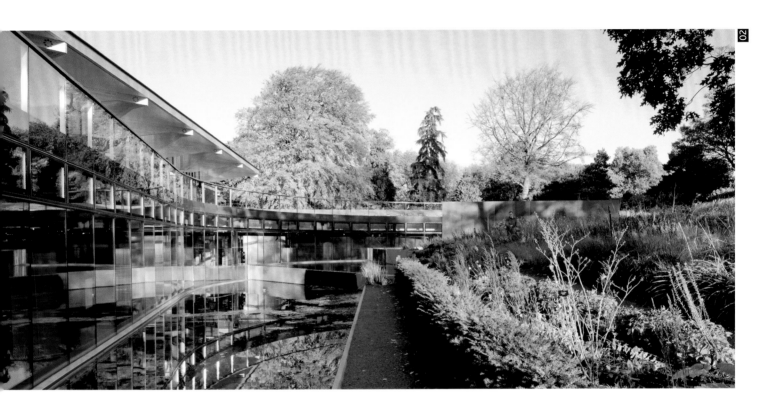

minimise disturbance and open up new views. Rather than simply build an 'object' in the landscape, the aim was to create a 'lens' through which the plant world around it would be brought into focus.

RBGE looked to the John Hope Gateway to put across its messages about environmental sustainability, not just in its exhibitions but also through the design and fabric of the building itself.

Design approach

The entrance to the Gateway sits at an important crossing; the long axis through Inverleith Park leading up to the Inverleith House gallery, and the perimeter circular path around the Garden. Views into the Garden are framed by slate walls and the oversailing timber roof, while inside routes and views radiate outwards into the landscape.

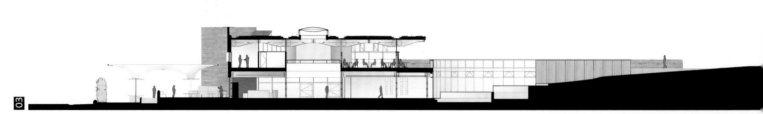

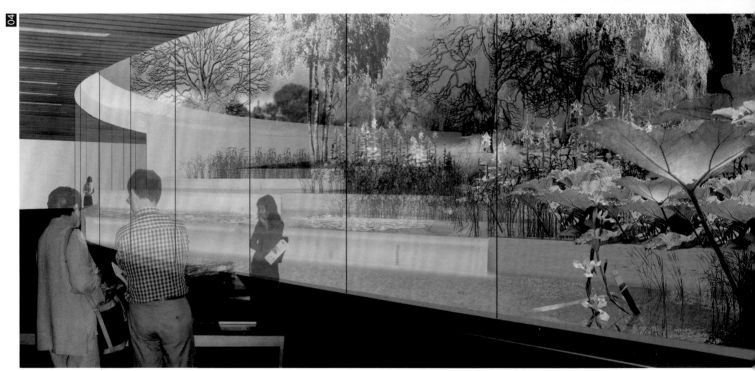

Through a 60m curved glass wall you can see the new biodiversity garden. With plant species critical to biodiversity, it forms a living extension of the exhibition spaces. It can also be explored outside along a zigzag path, or seen from the external terraces on the upper floor (Figure 03).

Walls are Caithness stone off-cuts from the slabs that line Edinburgh's streets, and the cladding is Scottish larch. The structure is engineered timber, and the cross-laminated roof panels and glulam beams float over the whole building as a single horizontal plane on pencil-thin steel columns. The roof is extended to create sheltered spaces. Its deep overhangs provide protection from rain and wind, so you can be outside to see and smell the garden whatever the weather.

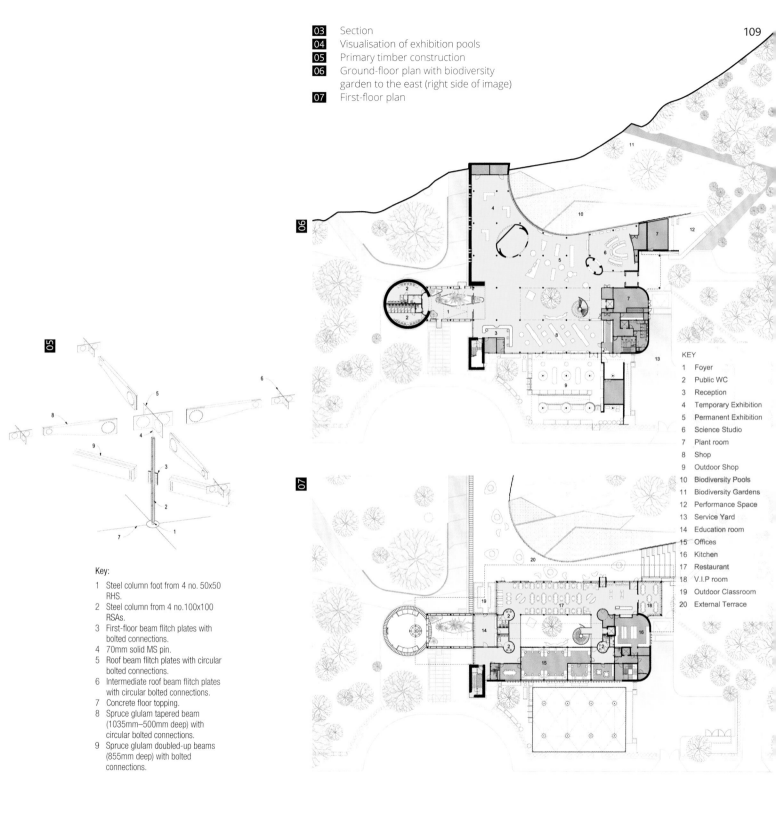

06

07

KEY

1 Foyer
2 Public WC
3 Reception
4 Temporary Exhibition
5 Permanent Exhibition
6 Science Studio
7 Plant room
8 Shop
9 Outdoor Shop
10 Biodiversity Pools
11 Biodiversity Gardens
12 Performance Space
13 Service Yard
14 Education room
15 Offices
16 Kitchen
17 Restaurant
18 V.I.P room
19 Outdoor Classroom
20 External Terrace

Key:

1 Steel column foot from 4 no. 50x50
 RHS.
2 Steel column from 4 no.100x100
 RSAs.
3 First-floor beam flitch plates with
 bolted connections.
4 70mm solid MS pin.
5 Roof beam flitch plates with circular
 bolted connections.
6 Intermediate roof beam flitch plates
 with circular bolted connections.
7 Concrete floor topping.
8 Spruce glulam tapered beam
 (1035mm–500mm deep) with
 circular bolted connections.
9 Spruce glulam doubled-up beams
 (855mm deep) with bolted
 connections.

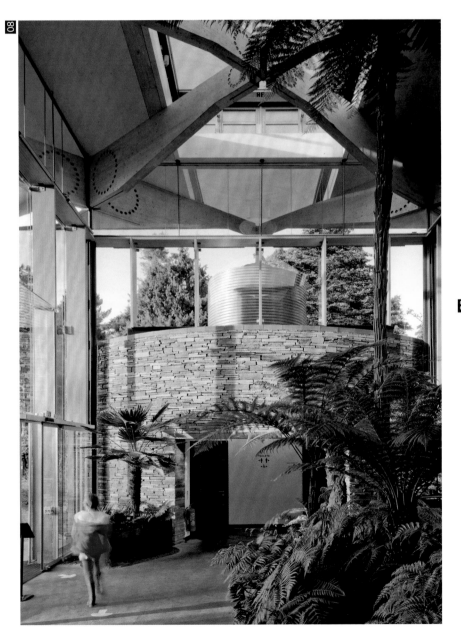

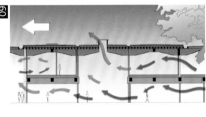

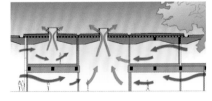

08 Internal view
09 Ventilation diagrams: central atrium space and roof ventilators aid
 natural wind-driven and stack ventilation
10 Ground-floor plan: daylight factors

111

Environmental design

The Gateway has been designed to demonstrate sustainability features through its exhibition content and by its construction. Environmental solutions include rainwater harvesting, a biomass boiler, solar thermal panels, roof-mounted photovoltaic (PV) panels and a wind turbine, a potent symbol of the environmental ethos of the Gateway.

The articulation of renewable systems and materials is an extension of the public mission of RBGE and its objective of promoting sustainable techniques. For example, rainwater collection follows a journey from roof, to tank, to WC cisterns – a journey that is on full display to the public (Figure 08).

Careful orientation, good daylighting, natural ventilation and high insulation levels all contribute to the building's energy efficiency, while strong, durable, locally sourced natural materials guarantee a long life for the Gateway. It achieved an Energy Performance Certificate (EPC) with the highest ('A') rating (Figures 09 and 10).

A BREEAM assessment was not carried out. Instead the design team worked closely together to deliver a sustainable, low-energy, minimum-waste design with many demonstrable environmental features.

In order to ensure that the design team and client aspirations were aligned, the Design Quality Indicator (DQI) toolkit was used to map both the client's and the design team's attitudes in the early stages of the project. This was the first project to use DQI as an online tool.

Monitoring and post-occupancy feedback

The John Hope Gateway was the first largely government-funded project in Scotland to be procured following the highly publicised financial overruns of the Scottish Parliament. For this reason, despite the technical sophistication of the renewable techniques to be deployed and the demands of a refined detail design, the project was procured through a design and build contract, perceived as presenting 'least risk' to final capital cost.

However, in the context of a global and national recession, the main contractor went into receivership before completing the project. Complete commissioning of the mechanical and electrical systems did not happen, and it was not possible to assemble operation and maintenance manuals in the normal way.

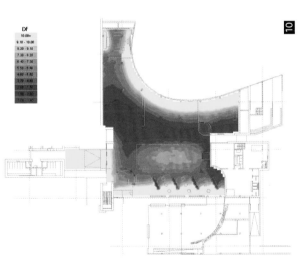

DF
10.00+
9.10 - 10.00
8.20 - 9.10
7.30 - 8.20
6.40 - 7.30
5.50 - 6.40
4.60 - 5.50
3.70 - 4.60
2.80 - 3.70
1.90 - 2.80
1.00 - 1.90

10

Design and build contracts place more responsibility on the contractor, and therefore decisions on construction specification and installation are often managed without the knowledge or direct involvement of the design team. When contractors default, as happened in this case, clients are left without comprehensive installation, maintenance and monitoring information.

The Building Management System automatically reads all meters: gas, electricity and water. Max Fordham collated and analysed data during the testing and commisioning and extended remedial works. The Garden's Facilities Management team would ideally monitor the meter readings on a monthly basis.

However RGBE do not have the capacity to employ a dedicated operator to check the efficiency of the systems on a daily basis, so when faulty building systems need attention, there can be a delay before such issues are identified. Owners or tenants of a building which uses solar and thermal energy - with PVs, wind turbines or biomass boilers – need to keep a close eye on these systems to ensure correct operation and speedy repairs. This fact needs to be impressed on clients considering the use of these complex renewable electrical and heating systems. The robustness of the PV panels has shown them to be an ideal renewable technology for a building with a limited maintenance staff, however the wind turbine has proved very problematic, requiring frequent maintenance and now is permanently out of action. Accurate energy predictions were made more difficult as the supplier was not able to provide data on the performance of the turbine that included the energy used to power up the turbine when it started.

The client has also had difficulty dealing with the lighting control system. Only the specialist contractor can alter or maintain the system, and this means that the RBGE electricians or other contractors are unable to fix lighting problems that occur. The use of a more traditional lighting control system that gave the client the ability to maintain it with in-house staff would have been more manageable.

A below-ground biomass silo was a problem, as the construction was poor and did not follow the design drawings. The resulting leaks have caused the woodchips to absorb water. This water ingress has also resulted in failures in the equipment, which has meant the building no longer operates the biomass boiler. In future it would be appropriate to use an internally lined silo that holds the woodchips away from the floor and walls, to ensure that any water from leaks does not come into contact with them.

11 Internal view: restaurant
12 Internal view: night. The venue is a popular choice for hospitality events

113

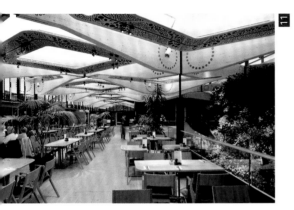

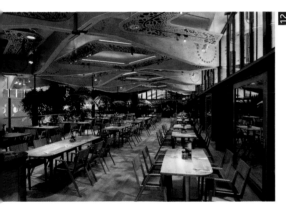

The placement of egg-sized pebbles within the gutters to the sedum roof resulted in birds picking them up and dropping them, assuming they were eggs they could smash. One PV panel and several of the solar thermal tubes have been replaced after being hit. Chicken wire has since been installed over the stones to stop birds from picking them up.

The building relies on cross ventilation and thermal mass to maintain internal comfort conditions. This works in much of the building, however there are ongoing problems with overheating on the west-facing first floor.

Transformational lighting for evening hospitality events means that the changeover from day to evening is quick and effective. It has helped make the John Hope Gateway into a sustainable business, with hospitality income supporting the activities of the institution (Figures 11 and 12).

The potential of an exposed glulam and cross-laminated structure for major public projects (beyond domestic/schools) has been demonstrated, helping to promote renewable materials for larger construction projects in the UK. This has been well received by visitors and experts alike (Figure 13).

BMS data has been analysed and is detailed in the building energy graph. The data does not include information from any of the renewable technologies as there was either no data available (for the PV and solar thermal panels) or they are no longer operational (the biomass boiler and wind turbine). When the core building carbon emissions (those included in an EPC calculation, which exclude unregulated loads) are compared to a typical building, the John Hope Gateway building performs exceptionally well against the typical building, emitting 70% less carbon. However the total carbon emitted by the building (which includes unregulated loads) is much closer to that emitted by a typical building. This was due to the unexpected success of the building, with large numbers of visitors enjoying the facilities, increasing the catering use. Other areas such as display lighting were higher than the benchmarks. Overall this shows the importance of working with users to understand how to minimise energy use.

Conclusions

At the time of writing it is seven years since the completion and opening of the John Hope Gateway as a public building. It has been an enormous success – very popular with its visiting public, hosting a dynamic exhibition programme, and with a thriving catering and hospitality offer that sees the Gateway fully booked six months ahead.

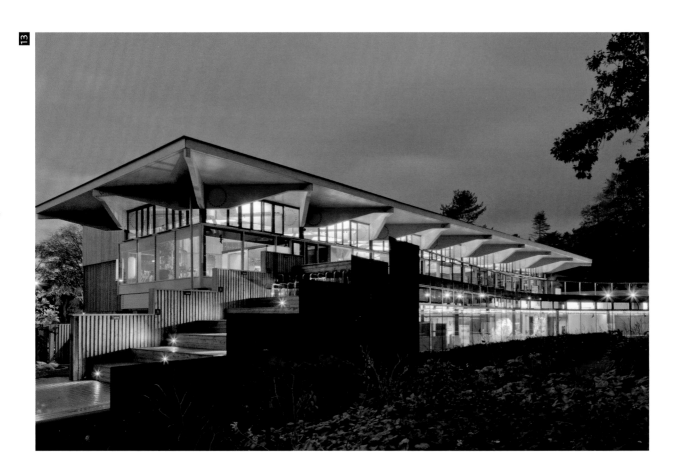

This success is important, both in meeting the RBGE mission and in helping to fund the organisation as government grants are cut back. The high footfall has also 'stressed' the building, and this along with latent problems from its challenging beginnings, have meant the building has proved difficult to operate, particularly the multiple renewable technologies.

As is the case with many institutions the original briefing and estate management team have moved on, and at the time of writing the new team have set about a thorough review of the building and its environmental systems with the original design team. This will be an important opportunity to recalibrate the building systems and to assess those that have truly earned their keep.

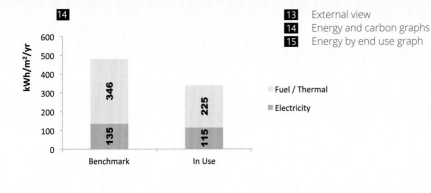

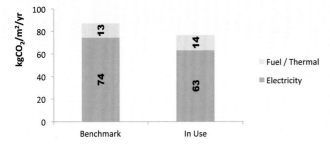

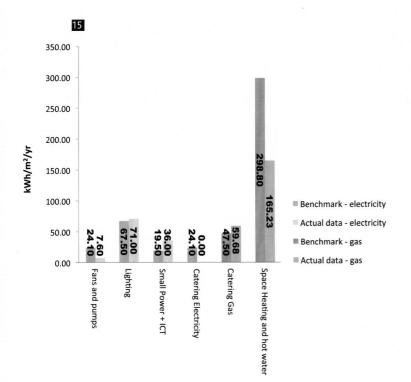

Title John Hope Gateway
Location Royal Botanic Garden Edinburgh, Arboretum Way, Edinburgh, EH3 5NZ

Completion date July 2009

The graphs compare in-use energy with the benchmarks set out at the start of the project. As there were no appropriate existing benchmarks for a building this diverse, they were calculated using a number of assumptions and area-weighted energy benchmarks for specific building types (i.e. Energy Consumption Guides, such as 'Econ-19' – Energy use in offices, were used along with similar ones for exhibition, education and catering spaces). These figures were then used to set design targets for the building provide a check point and guide the design. The aim agreed with the client/funding bodies was to achieve best practice level (i.e a balance between expense and performance appropriate for a publicly funded project). The graphs shows that the building performs well in comparison to benchmarks for regulated energy loads, specifically heating, hot water and fans and pumps. However in non-regulated energy the building is less successful, the two largest contributors are the increased catering energy/carbon emission due to the very successful restaurant and the display lighting.

The in-use energy data was based on utility bills from March 2010 to April 2011. The breakdown was estimated on information gathered from the BMS between January 2011 and August 2011. Data for PV, wind and solar thermal was not available, but may have contributed to reducing the overall electricity utility bill.

CASE STUDY 4

Crawley Library
Crawley

Crawley Library is a new civic building that is well liked by its occupants and has a good internal environment (air quality and daylighting factors). Although energy use exceeded the ambitious targets (Energy Performance Certificate/EPC rating 'A') in the first Display Energy Certificate/DEC (rating 'D'), the building still outperforms best practice.

Client	West Sussex County Council
Architect	Penoyre & Prasad
Services engineer	Ramboll
Quantity surveyor	Ramboll
Main contractor	BAM
Post-completion testing	Low Carbon Building Group, Oxford Institute for Sustainable Development, Oxford Brookes University
Author of chapter	Rajat Gupta

Overview

Crawley Library is a major new civic building housing a range of county council services including a central library, register office, and administrative and social services accommodation.

The brief asked for a landmark sustainable building. Careful orientation of the building, a stepped façade and high-performance coated glass minimise solar gains, while the generous north-lit atrium floods the library with natural daylight. Efficient lighting controls with motion detection and daylight zoning maximise efficiency and reduce internal heat gains.

An assisted natural ventilation system combined with extensive thermal mass and night-time cooling is designed to provide a stable internal environment for the library and open-plan offices. The design is supplemented by renewable technologies such as a biomass boiler and a solar thermal system.

01

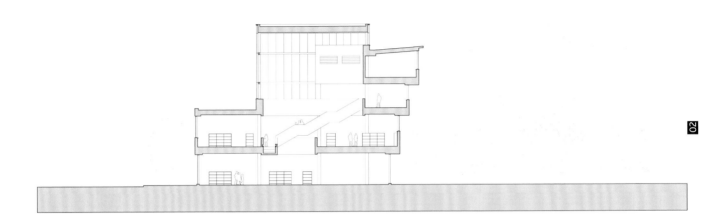

02

03 The library building is occupied from Monday to Friday, 8am–5pm. The library areas are also open on Saturdays from 9am to 7pm. Occupancy varies significantly during the day. It is estimated that about 1,000 people visit the library on weekdays while approximately 75–100 people work in the offices.

Design approach

A core design driver was to provide the client with a long-term, loose-fit building with robust structural and environmental strategies to allow for flexible layouts and future adaptability.

Accessed off a new square, the building is arranged over three floors around a central atrium. Above the library is the council's social services open-plan office space. The adjacent two-storey registry office has a separate entrance, also off the square. The ground-floor elevations to the public library areas are heavily glazed to showcase the facilities and welcome visitors. A café opens out on to the public square south of the building. The first-floor ceremony rooms have an external terrace that can be used for photography and outdoor gatherings. The gross internal floor area is 4,468m², with the library taking up 2,678m².

Environmental design

The building is designed to be energy efficient with a low heat demand. Through structured sustainability workshops with the client, options were reviewed with respect to renewables, Building Regulations Part L and wider sustainability targets. The technical targets set were:

- BREEAM Very Good and EPC 'A' rating
- carbon emissions 30% better than Part L 2006
- at least 20% to 30% renewable energy contribution
- an air leakage index of 5m³/h.m² @ 50Pa
- low water usage.

04

The resulting building was designed with good levels of insulation, airtightness measures, high ceilings, extensive thermal mass, stratification and natural cross-ventilation and stack ventilation measures, good glazing and solar protection measures (Figure 04) and proposals on an IT procurement strategy. To ensure a low heat demand U-values were better than those specified in Part L of the Building Regulations.

A primary biomass boiler with a condensing gas boiler back-up heats the building. Hot water is provided by a solar thermal array, with central gas-fired calorifiers as back-up. A chilled-water cooling system using an air-cooled chiller serves a series of air-handling units, and fan-coil units provide primary cooling through a section of the building. The remainder of the building has an assisted natural ventilation/mixed-mode system that introduces tempered fresh air into the library spaces and open-plan office through floor plenums. In summer, windows on actuators provide additional ventilation. The plenums also provide a route for secure night-time cooling to pre-cool the building structure for the following day and prevent overheating.

A core design driver was to support flexible layouts within the library, making it possible to accommodate future change. Services and the IT network are built into library-wide raised flooring designed to loadings that allow all book stacks and furniture to be rearranged.

Good daylighting is achieved with solar-control glass shaded by cantilevered south-facing floors to control solar gains (Figures 02 and 05). The majority of the lighting was designed to operate on photometric control along with occupancy sensors in the library. A building management system (BMS) was installed to help the facilities manager run the building efficiently and monitor sub-metered energy consumption.

Monitoring and post-occupancy feedback[89]

The monitoring and post-occupancy evaluation of the building was undertaken as part of Innovate UK's building performance evaluation (BPE) programme.

A review of the installed systems showed that the heating and cooling strategies did not appear to be functioning according to the initial design intent, due to inadequate commissioning and maintenance contracts. The biomass boiler had encountered breakdowns due to the low quality of biomass fuel. Maintenance provided did not address the problems effectively as the system kept failing, remaining out of operation for nearly two years. As a result, the system was perceived by the facilities-management team as unreliable and difficult to maintain. Similarly the chilled-water cooling system and the solar thermal panels were also not functioning properly, but little was done to resolve these issues. In addition to this, there was no feedback mechanism set up in the building to report the aforementioned building issues to the management.

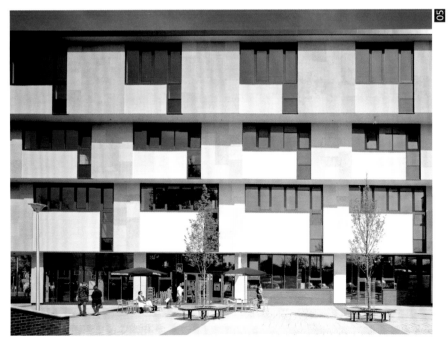

Poor maintenance and management issues are particularly evident in the case of the BMS. The system had not been optimised, and some BMS sensors had not been well calibrated. These problems resulted in the poor performance of the heating and cooling systems. After continuous efforts by the BPE team, actions were taken to address these issues, but without a maintenance contract in place many of them are likely to reappear. A review of the usability of controls revealed that controls for lights, blinds and fire alarms were intuitive and easy to use.

Despite the problems with the BMS the internal temperatures were found to fluctuate only between 20°C and 25°C in most of the rooms during much of the monitored period, indicating a robust environmental strategy able to sustain comfortable thermal conditions. Relative humidity was found to range between 25% and 60%. The highest CO_2 concentrations were recorded during the winter season when the building was mechanically ventilated; however, CO_2 concentration remained below 1,000ppm in all spaces.

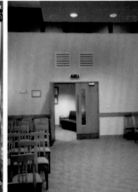

Occupant feedback was recorded through Building User Studies (BUS) questionnaires, semi-structured interviews and walkthroughs. The survey revealed that the staff members had a positive opinion of the building, with modern design and high levels of natural light the most appreciated elements. There were, however, some negative perceptions of the ventilation, summer thermal conditions and indoor air quality, with a lack of occupant control over the windows and ventilation in the open-plan office aggravating the issue.

The BPE study revealed that despite the measured airtightness of the building fabric being 4.88m³/h.m²@ 50Pa, the thermographic survey showed air leakage around windows and cold bridges at the wall/ceiling junction in a number of rooms (Figures 06 and 07). Thermograms also revealed heating and cooling being left on in some unoccupied spaces, indicating poor control of the systems.

The energy supplied to the library was monitored for a one-year period. During this period, 157,563kWh of gas and 468,640kWh of electricity were consumed, which resulted in total emissions of 275,028kgCO$_2$/m²/yr. The actual energy consumption was 44% more than the design estimate (9% more in gas use and 44% more in electricity use).[90] The library's annual energy consumption and the resulting carbon emissions per unit of floor area were compared to CIBSE TM46 and DEC benchmarks. In terms of gas consumption, Crawley Library performed significantly better than the benchmarks. However, the library used more electricity than both benchmarks.

06 Thermogram: heating of unoccupied spaces suggesting poor control of services 123
07 Thermogram: air leakage around windows and at the wall/ceiling junction
08 Ground-floor plan
09 Internal view

KEY

1 entrance foyer
2 coffee bar
3 enquiries
4 express collection
5 children's library
6 audio visual
7 "head space"
8 large print & spoken word
9 reserve stock
10 loading and security
11 staff work
12 plant
13 interview rooms
14 waiting area
15 conference rooms

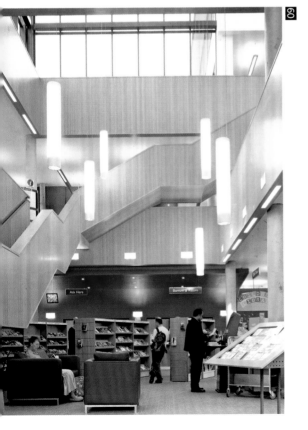

A breakdown of electricity use by end user showed that 31% of electricity was used for lighting, 18% by small-power equipment, 11% for cooling and 10% by the fans and pumps for ventilation. The library hub room, which contained a large server with its cooling system, was found to consume 9% of the total electricity and the café was responsible for a further 9%. Other 'unregulated' loads accounted for the remaining 12% of the total electricity.

While electricity use is more than twice the design target, a number of the increases came as a result of external factors outside design team control, namely café use (it is fitted out and run by an external operator, with actual use over six times the target), and small-power use (more than double the estimate in the target). Lighting load was 25% over the target, which could be reduced through the specification of the sensors and zoning. Overall, it should be noted that the electricity use compared to design target is not a dramatic increase relative to many other building-in-use studies.

Regular changes in facilities-management staff since handover mean that the environmental control strategy, BMS and sub-metering are not well understood by the facilities-management team, which is not able to monitor the energy performance to enable energy savings to be targeted. Lack of user guidance and understanding of the processes that take place in the building, together with minimal individual control over heating, ventilation and lighting, further undermine occupant comfort and lead to excessive energy use in the library and office spaces. As a result there is little engagement in managing the building and its performance. Going forward, in-depth training of the facilities-management team to use the BMS system, as well as proper maintenance of the biomass and solar thermal technologies, would improve control over the building systems and environmental conditions.

Conclusions

This project reveals the necessity of carefully reviewing with the client their capacity to manage the proposed technologies in the long term, and the importance of maintenance contracts, close monitoring and regular reviews of any 'new' technologies installed. This, alongside client-commissioned, easy-to-understand user guides and in addition to the requisite building manual, could help to ensure that users take full advantage of the design and technologies installed in the building.

Metering and sub-metering arrangements should be carefully designed and installed according to end uses and zones. It is important to ensure that sub-meters are calibrated and commissioned properly, and reconciled after handover in order to correct problems quickly and allow effective energy management.

Finally, the project illustrates how robust passive design measures and simple systems (such as the plenum ventilation system used in the library, and extensive thermal mass) are much more resilient than add-on technologies and can exceed best-practice energy targets in their own right as well as creating comfortable environments.

10

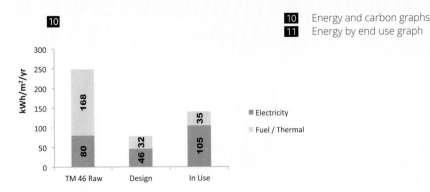

11

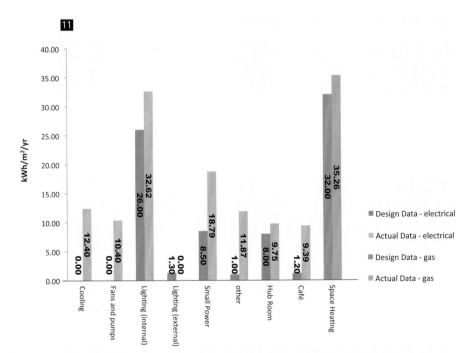

Title	Crawley Library
Location	Crawley
Completion date	December 2010

The fabric of the building performed close to predictions and is reflected small discrepancies in heating load for example. However the building used over twice the predicted electricity. Some of this related to unregulated loads associated with the café (run by a separate company) and small power equipment. However there were also problems with operation and management of heating and cooling systems and the library hub room which contained the server room with its cooling system used 9% of the total electrical load of the building.

The design prediction was estimated using BRUKL calculations (which follow Part L Regulations) and CIBSE TM54. BRUKL calculations do not account for all end uses and include only heating, hot water, cooling, fans and pumps and fixed internal lighting. Other end-uses such as small power, server rooms, lifts, catering and external lighting were added following the guidance provided in TM54, in order to compare actual energy use with a more accurate design estimate. The biomass system was out of order from April 2009 until Dec 2011 (before the BPE study) and also, due to the excessive amount of issues, heating was provided predominantly by the gas boiler. There was also limited information on the biomass boiler design performance and therefore a gas boiler has been assumed for the design target.

CASE STUDY 5

St Luke's Primary School
Wolverhampton

St Luke's was one of the early schools designed by Architype and has become recognised as an example of how good school design can improve teaching and learning and create safe, nurturing and well-loved environments for children. It was also the first Architype school to be evaluated through a structured research programme – the findings of which influenced later schools projects by the practice.

Client	Wolverhampton City Council and All Saints & Blakenhall Community Development Partnership
Architect	Architype
Structural engineer	Price & Myers
Services engineer	Ernest Griffiths
Landscape architect	Coe Design
Project manager	Smith Thomas Consulting
Quantity surveyor	Smith Thomas Consulting
Main contractor	Thomas Value Structural

01

Overview

The two-form-entry primary school, on a suburban site in Wolverhampton, was the first of series of schools for the same education authority designed by Architype. It was also the first school to be studied by the practice through a Knowledge Transfer Partnership with Oxford Brookes University. Lessons from St Luke's were applied to subsequent schools, which share an environmental strategy based on first principles: reducing heat and ventilation demand; exploiting natural daylight and ventilation; and optimising the building fabric through close attention to detailing, airtightness and thermal bridging. Although the school was the first primary to achieve a BREEAM Excellent rating, this has been done with a minimum of applied technologies; as *Ecotech* noted at the time, the building 'wears its eco-credentials lightly'.[91]

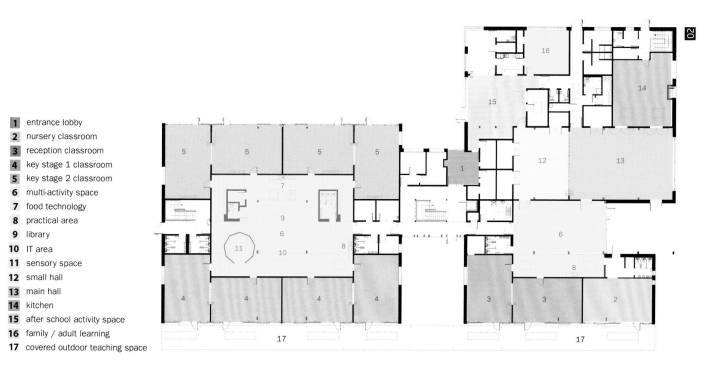

1 entrance lobby
2 nursery classroom
3 reception classroom
4 key stage 1 classroom
5 key stage 2 classroom
6 multi-activity space
7 food technology
8 practical area
9 library
10 IT area
11 sensory space
12 small hall
13 main hall
14 kitchen
15 after school activity space
16 family / adult learning
17 covered outdoor teaching space

Design approach

Classrooms are arranged to the north and south of two multi-purpose social 'hub' spaces. This led to a deep plan but eliminated corridors in response to a clear objective that emerged from the extensive consultations held with staff, governors and parents before design work commenced (Figure 02). The plan of the primary-school wing is reminiscent of a typical London 'board school': compact and efficient, but with the potential to ventilate and light the enclosed hub spaces directly from north lights and high-level ventilators (Figure 03). Single-storey classrooms for Key Stage 1 are arranged to the south, with the building rising to two storeys at the north. The section is the generator of the spatial design, and incorporates characteristics that would feature in Architype's future schools projects: north-lit common spaces; natural cross-ventilation to classrooms, achieved with ventilation stacks and clerestory vents; and large protecting overhangs to south-facing glazing.

Timber is used extensively for the structural frame, wall panels and external weathering materials. The roof is shingle clad and external walls combine UK-grown larch boarding with generous glazing set in timber frames and punctuated with subtle splashes of colour.

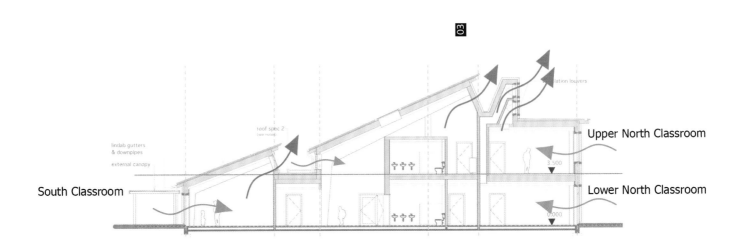

South Classroom

Upper North Classroom

Lower North Classroom

roof spec 2
(see note)

lindab gutters
& downpipes

external canopy

Environmental design

The design targeted very low U-values (0.12W/m²K wall, 0.09W/m²K roof, 0.14W/m²K floor) and high-performance double-glazed windows (1.1W/m²K). The target airtightness was also very low at 2.0m³/h.m²@ 50Pa, although not quite achieved in construction. These measures, combined with the compact building form, contribute to the very low predicted heating and hot water usage (24.7kWh/m²). The building is heated by biomass boilers (with gas back-up), which supply hot water and feed the underfloor heating throughout.

There are three strategies for ventilating the spaces. The south classrooms have low-level inlets from top-hung windows and sliding doors, and outlet via clerestory windows that are controlled by temperature sensors. The common hub uses clerestory vents to the north and south sides for inlet and outlet. The north classrooms have low-level inlets and use custom-designed stack ventilation, which for the ground-floor classrooms follows a rather contorted route to discharge on the roof. Opening vents at the top of the stacks are also temperature controlled (Figures 03-07).

Pupils and staff participate in energy-saving practices including a 'switch-off campaign' started by the school as part of its Eco-Schools project. Children inspect rooms for cleanliness and lights-off, and switches and controls are animated with posters and messages.

03 Section: ventilation and solar control: high-level ventilators
and clerestorey vents depend on reliable BMS control
04 External view
05 External view
06 Internal view: library / learning resources
07 External view

131

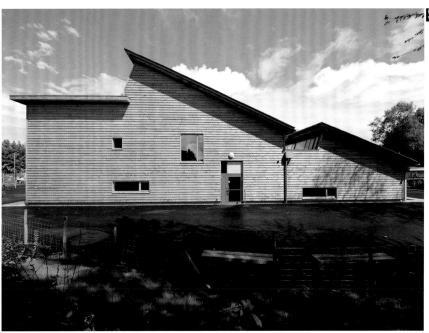

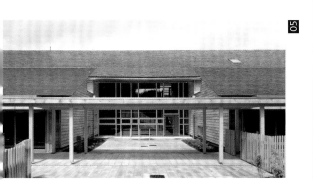

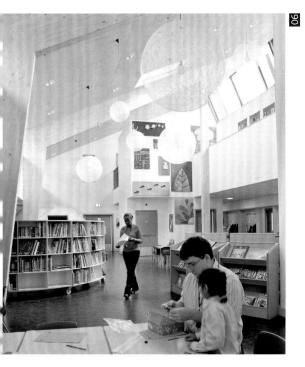

Monitoring and post-occupancy feedback

Building monitoring, by Oxford Brookes University, started approximately
six months after occupation, using temperature and humidity recording in
classrooms and hubs, various user surveys and energy walk-rounds, and Soft
Landings workshops and interventions. The programming and the operation
of the building management system (BMS), which was designed to control
natural and night-purge ventilation and the heating system, was also reviewed
when it became obvious that the reported energy use from sub-meters was
inconsistent with the readings from physical meters installed in plant rooms.

The user survey followed the standard Building User Studies (BUS) format
and was supplemented by investigations into the usability of controls and a
review of whether the BMS protocols were supporting or impeding the energy
management of the building. A daylighting survey was also undertaken to map
the lighting levels on a typical overcast day, with all lights off, on a 1m grid
across the floor.

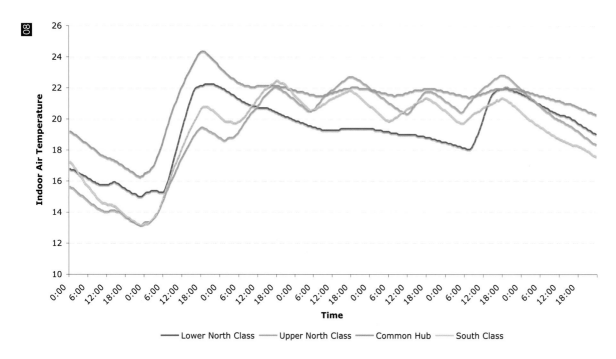

08

Indoor Air Temperature (y-axis)

Time (x-axis)

Legend: —— Lower North Class —— Upper North Class —— Common Hub —— South Class

A review of temperature and energy readings taken over the winter period showed that the building was being constantly heated to occupancy temperatures, even on weekends and holidays. A visible spike in heating energy use taken from the winter holiday week of 2010–11 (Figure 08) also shows that the system had compensated for the lack of internal gains from occupation and equipment, and consumed more heating energy out-of-hours than when occupied. Further investigation revealed that although the BMS could be set up for seven-day programming, it hadn't been commissioned correctly. There were also no schedules that allowed different operation over large blocks of time, for instance the winter holidays. This was a fundamental programming oversight that could not be corrected by the school's staff, as neither the council nor the equipment supplier provided training to allow the users to make advanced changes and adjustments to the system.

The energy usage recorded by the sub-meters and reported by the BMS was also shown to be extremely unreliable when compared with the mains meters used for billing. Biomass reporting was out by a factor of 10, due to a programming error on the interface, and electrical energy use was

08 St Luke's winter holiday week heating on continuously
09 Annual energy benchmarks. St Lukes is Primary School A on the graph
10 Internal view: classroom

133

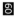

■ "Total Fossil Fuels, or Non-Electric" ■ Total Electric

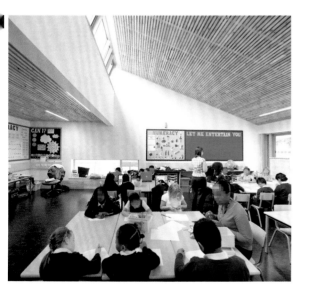

underestimated by approximately 50%. In the summary graph (Figure 09) the BMS and metered readings are benchmarked against best practice and typical schools (the survey data is from DfES studies in 2003 and 2004). The published Display Energy Certificate (DEC) issued by the local council used the physical metered readings and, despite the discrepancy with the BMS, established the school within the best 25% for heating energy consumption.

Generally internal lighting control worked well, with a three-zone system in the classrooms that allows levels to be adjusted separately in the zones furthest away from windows. The zoning worked well when interactive display boards were also positioned on the north wall in the deepest lighting zone. Despite the extensive shading on the south side glare was reported to be a problem, with sunlight reflected off the external ground surfaces interfering with the visibility of the interactive white boards. External lighting, however, was not as successfully controlled, with the school having to disable motion sensors following concerns about reduced security and because of the nuisance to neighbours. The external lighting outside occupied hours accounted for 65% of the total lighting energy used.

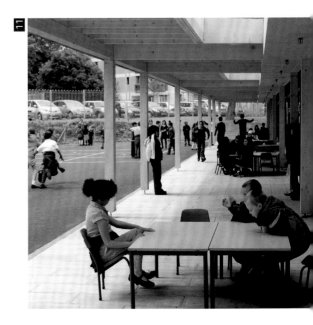

Generally the thermal conditions in the school are well controlled. The BUS survey revealed that summer conditions were comfortable, with respondents confirming that temperatures were very stable – a good result for a lightweight construction with relatively little thermal mass. Summer conditions showed average temperatures between 21.1°C and 22.3°C for the four main spaces, which is well within the CIBSE Guide A Summer Operative Temperature Range for a primary school (between 21°C and 23°C). None of the main spaces showed temperatures during core hours at or above 27°C.

Temperatures in the winter in the hub spaces were a little on the high side but were stable, resulting in some adjustment of the heating set points.

Conclusions

The comfort and air quality data collected confirmed the general perception in the school that the internal environment was extremely well controlled and healthy. Ventilation rates and air quality were good, though the simpler ventilation strategy in the south-facing classrooms (without stack ventilators) was more effective. However, the complex operation of the BMS and the high electrical usage (much of which was attributed to the external lighting) led to a simplification of the controls strategies in future projects.

Two linear thermal bridges, at the head of the curtain walling on the south side and at the base of the external walls (where blockwork construction was used to raise the timber frame above ground level), were improved on subsequent projects. Confidence in the fabric performance and the external wall detailing, verified by the testing and measurement at St Luke's, also led to more emphasis on the correct sizing of heating plant in future projects. Finally, the testing results gave Architype the confidence to advocate full-certified Passivhaus performance, rather than principles, in future projects (see Case Study 6).

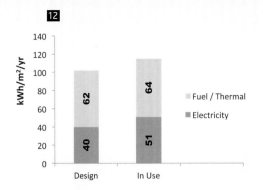

11 External view
12 Energy and carbon graphs
13 Energy by end use graph

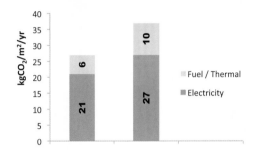

Title St Luke's School
Location Wolverhampton
Completion date June 2009

The energy and carbon graph shows a relatively small performance gap with regard to total energy but a larger gap for the CO_2 emissions. This is because the design estimate assumed the biomass boiler would use 80% of the load, with the gas boiler accounting for the rest. In practice the biomass boiler only accounted for 33% of the total load, hence the much higher than predicted CO_2 emissions.

The building energy demand by end use graph only illustrates the design prediction, and was estimated using guidance provided by CIBSE TM54. This was because there was no sub-meter data available.

Actual monthly usage data has been provided by Wolverhampton City Council. The annual usage has been metered across a full period between 2014 and 2015. The metered data is read directly from the meter for electricity and biomass, whereas the gas usage has been estimated from utility bills.

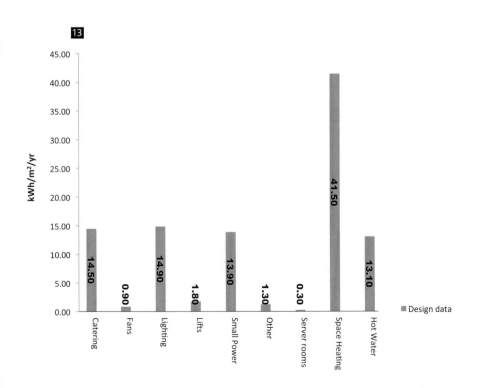

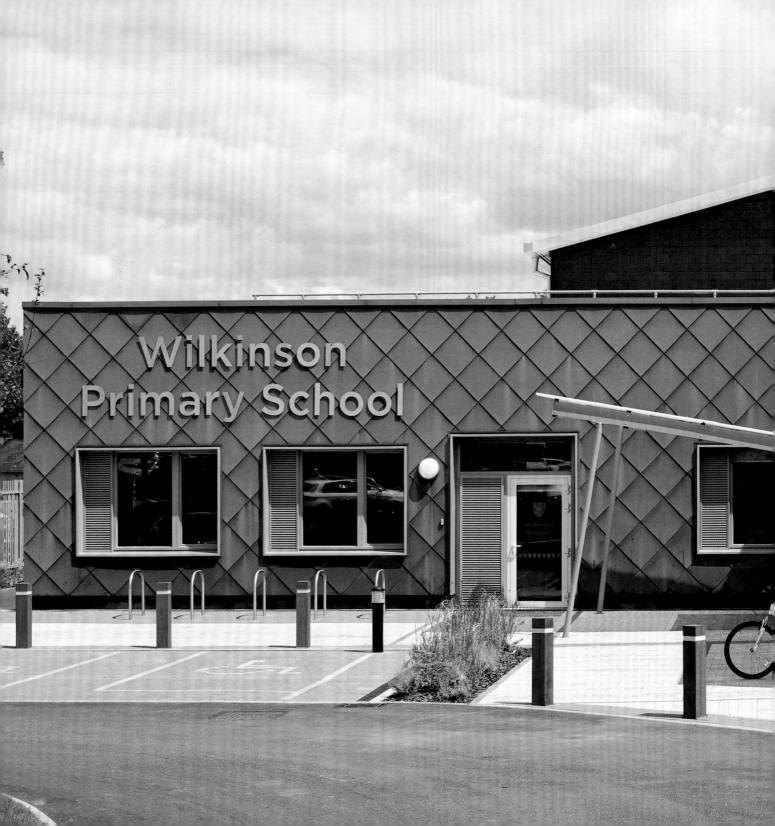

CASE STUDY 6

Wilkinson Primary School
Wolverhampton

Architype describes Wilkinson School as its second-generation Passivhaus school. The design builds on the lessons of previous projects, with the same client and construction team. Post-occupancy monitoring is showing that better comfort levels and even lower running costs have been achieved. Wilkinson won the Passivhaus Trust's Best Large Project Award for 2015.

Client	Wolverhampton City Council
Architect	Architype
Structural engineer	Price & Myers
Services engineer	E3 Consulting Engineers
Landscape architect	Coe Design
Project manager	Carillion and The Local Education Partnership
Quantity surveyor	Smith Thomas Consulting
Main contractor	Thomas Value Structural
Passivhaus consultant	Elemental Solutions
Passivhaus certifier	WARM

Overview

Wilkinson is a two-form-entry primary school for 430 pupils with a 30-place nursery and flexible space for community use out of hours. The new building replaced an existing school that had been badly damaged in an arson attack. The former ironworks site had archaeological remains dating back to the Industrial Revolution and the ground conditions, requiring potentially expensive remediation, restricted the building's outline to the footprint of the previous school. However, despite these constraints, the internal layout follows the principles established in the previous Wolverhampton projects of optimising daylight and good ventilation, and arranging classroom spaces around double-height flexible common areas, avoiding corridors wherever possible.

The Passivhaus standard was a requirement set by the client following the success of two previous Passivhaus schools (Oak Meadow and Bushbury Primary) that in turn had built on the learning from St Luke's (Case Study 5).

01

01 External view: Corten steel cladding tiles and eaves
02 External view: south elevation
03 External view

139

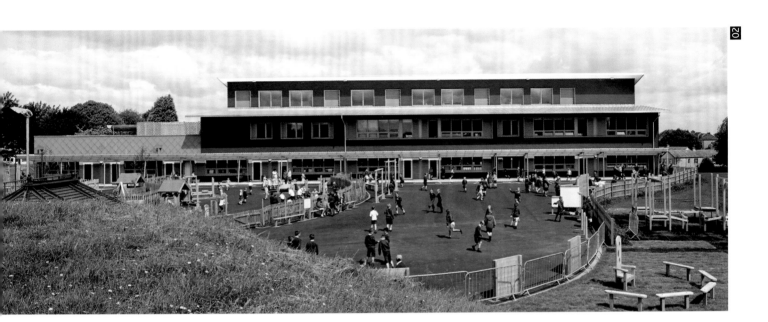

For Oak Meadow and Bushbury the client initially needed some persuading that Passivhaus was desirable, and agreed on the proviso that it wouldn't cost more to achieve. By the time Wilkinson was commissioned the comfort and reduced energy-consumption benefits of the first-generation schools had become obvious, both in their successful and well-liked learning environments and with evidence from post-occupancy evaluation studies and measurement.

Design approach

As with the previous projects the designers developed strong relationships with the teaching staff, the students and the neighbours, through workshops and briefing sessions. They were sensitive to the need to provide for safety and security, but also keen to achieve a delightful, airy and uplifting building for a new chapter in the school's history.

In contrast to St Luke's the building's section rises to the south (Figure 02), providing two floors of classrooms with south-facing windows and interactive whiteboards on the north classroom walls. Clerestory lighting above this south

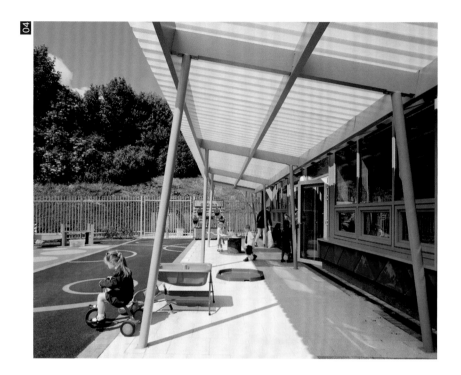

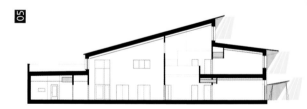

range of classrooms provides natural light to the double-height hub space. The south façade is characterised by the extensive horizontal projections of overhanging roofs and play canopies (Figure 04), carefully oriented to shade in summer sun but also to reflect low sun deeper into the plan in winter (Figure 05).

The main building is clad in dark grey polished clay tiles (Figure 06), while the single-storey nursery and community elements are clad in strikingly contrasting orange Corten tiles (Figure 07). Both materials are intended to reference the site's historical past but also provide an outwardly reassuring robustness and deliberately 'arson-resistant' facing. The structural frame and wall panelling are lightweight timber frame as in the previous projects, assembled with the tried-and-tested (and in many cases improved) junction details. Improved airtightness measures were developed through close working between the same consultants and contractors as had been used on the previous Wolverhampton Passivhaus schools.

04 External view: playground; shade also acts as reflector to increase
daylight penetration
05 Solar studies: low-level winter light penetrates deep into plan; high-level summer
sun shaded by overhangs and playground shade
06 External view: robust, contrasting materials
07 Canopies shade external play areas
08 Ventilation supply: tempered air supplied to classrooms
09 Ventilation exhaust through central hub space

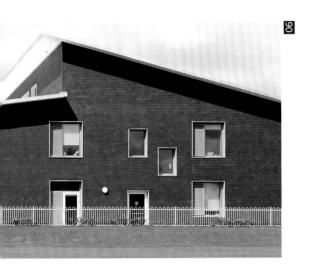

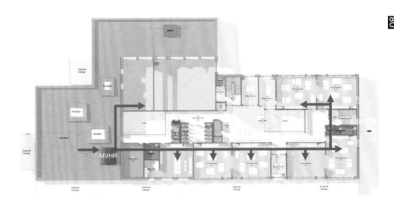

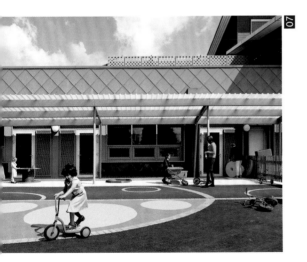

Environmental design

The classrooms are mechanically vented from centralised mechanical ventilation with heat recovery (MVHR) plant, allowing a supply of fresh warm air (Figure 08) in winter without the need to open external windows. In summer fresh air is supplied by the external window vents and louvred ventilation panels. Stale air is extracted through high-level grilles by the ventilation system (Figure 09). The use of mechanical ventilation reduces winter heating costs (through heat recovery) but also improves the night cooling operation in summer. Overall the building section and roof profile is simpler than St Luke's, which had complicated steps, clerestory vents and 'stack' ventilator shafts of varying effectiveness.

The operation of mixed-mode buildings generally requires some understanding by the users, who need to know when the building is in winter mode (mechanical ventilation, Figure 10) or summer mode (when windows can be opened, Figure 11). At Wilkinson information is provided through classroom-specific user guides, the Soft Landings support and explanatory posters and notices around the school.[92] After some running in it has proved simpler in practice to use the supply ventilation constantly during all occupied hours, ensuring that the correct background ventilation is always achieved. Although there is a very small additional running cost, the constant and controlled supply of fresh air regulates the accumulation of CO_2 and reduces the tendency to stuffiness in the classrooms (and the resulting poor attentiveness of students).

Overall the carefully designed and commissioned ventilation system provides good ventilation and better winter comfort than in a conventional classroom, where the air can stagnate quickly if windows are kept closed, or where uncomfortable draughts and unnecessary heat losses occur because windows are opened for fresh air. Wilkinson relies less on the building management system (BMS) than in previous projects for ventilation control: all of the classroom windows are manually opened, with only clerestory ventilators being automated. In the first-generation schools the BMS operation was found to be unreliable, with weather sensors behaving erratically and overriding manual controls (see also Case Study 2, where similar problems were encountered). This means that the summertime night purge (Figure 12) has to be enabled by manually opening the side-hung ventilators, whose louvres and grilles protect from rain and insects.

The Passivhaus standard dictated the exemplary performance of wall and roof elements, and the ultra-airtight construction was proven through site measurement (Building regulations air permeability, 0.66m³/h.m² @ 50Pa, Passivhaus, 0.34 ach @ 50 Pa). In calculating the overall heating loads, allowance was made for the higher density of occupation in UK schools, which average close to 5m² per pupil compared with 10m² in Germany.[93] The result of being able to use a higher internal heat gain figure was that the amount of south-facing glazing could be decreased, providing better temperature stability in summer than had been achieved in the first-generation schools. A single 90kW boiler provides all of the heating for the school. Hot water is provided by local electric water heaters, rather than a centralised system with its associated losses from storage and circulation pipework. Microbore copper is used between the heaters and outlets, reducing losses from 'dead legs' and eliminating the need for trace heating. Pipework volumes are below one litre, so there are no concerns with Legionella.

10 Classroom ventilation: winter mode – heated fresh air supplied and extracted mechanically
11 Classroom ventilation: summer mode – running the extract fans continuously maintains good air quality and supplements natural ventilatio
12 Classroom ventilation: night purge – secure ventilation from manually opened louvres and high-level extract
13 Energy use of Architype Schools compared with CIBSE benchmarks

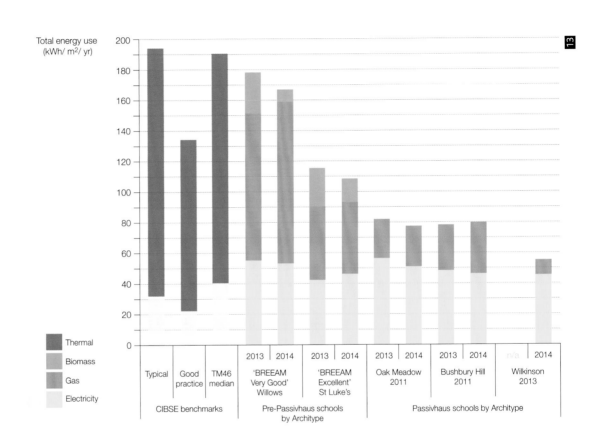

Monitoring and post-occupancy feedback

Building monitoring was undertaken by Architype in collaboration with Coventry University through its Knowledge Exchange and Enterprise Network (KEEN). Space heating can be accurately monitored, as the heat is from a single, dedicated energy source. Cooking is via induction hobs – another energy-saving improvement learned from the previous schools. Hot-water usage is monitored from a sub-meter and rigorous commissioning has ensured that sub-meter readings are more reliable than at St Luke's. The building was fine-tuned during the Soft Landings period.

Monitoring revealed that some teachers were not opening the windows when the ventilation system was off (in summer mode), so CO_2 levels were higher than anticipated. The operational protocol was subsequently changed and the ventilation was set to run continuously with the heat exchanger bypassed, but providing supply air throughout the summer (as is the norm in domestic Passivhaus projects). This removed the fallibilities in the system, or the need to communicate when to open windows and vents to keep CO_2 levels down when the seasonal change occurs.

Comfort and internal conditions are being monitored, and the first year's data shows very stable temperature conditions in classrooms and low levels of CO_2, improving on the already class-leading results from the first-generation schools.[94]

Conclusions

There is a perception that Passivhaus buildings are more expensive to deliver than conventional buildings, and that this additional expense outweighs the comfort benefits and longer-term savings in running costs. While it is true that individual Passivhaus components (certified triple-glazed windows, for instance) are less widely available than lower-specification alternatives, it is not necessarily true that a Passivhaus building has to have a higher capital cost. There are savings in heating distribution, radiator sizes and boilers, and much of the perceived additional expense can be put down to the cost of the training and supervision of contractors unfamiliar with the Passivhaus assurance processes. Wilkinson School benefits from the value that can be delivered by an experienced construction team drawing on the learning, design development and experience of previous projects. Data collected in the first year from Wilkinson, the first-generation Passivhaus schools and the pre-Passivhaus Willows and St Luke's shows how objective feedback has improved each successive project (Figure 13). In the first year of operation Wilkinson very closely matched its design targets. Primary energy use is slightly higher than the target of 120kWh/m² at 143kWh/m², but with Soft Landings in operation and some fine-tuning in the second year it should be possible to achieve this goal. In any event the overall energy use is extremely low.

By contrast, the CarbonBuzz[95] database shows that UK school designs are on average consuming 150% more energy than their design-stage predictions.

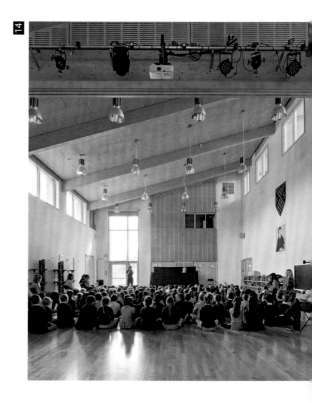

14

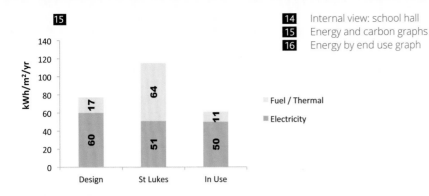

14 Internal view: school hall
15 Energy and carbon graphs
16 Energy by end use graph

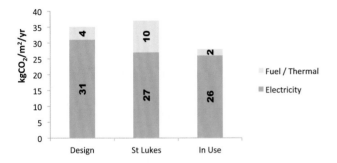

Title	Wilkinson Prmary School
Location	Wolverhampton
Completion date	February 2014

The energy demand by end use illustrates the predicted low space-heating demand you would expect to see with a Passivhaus design. The energy and carbon graph (Figure 15) compares the in-use energy both with the design prediction and with the previous school, St Lukes. This shows a significant improvement on the performance of St Lukes but also on the design prediction. Further interrogation of sub- meters would help to illuminate in what areas these savings were made.

The building energy demand by end use graph only illustrates the design prediction and was estimated using guidance provided by CIBSE TM54. This was because there was no sub-meter data available.

Actual monthly usage data has been provided by Wolverhampton City Council. The annual usage has been metered across a full period between 2014 and 2015. The metered data is read directly from the meter.

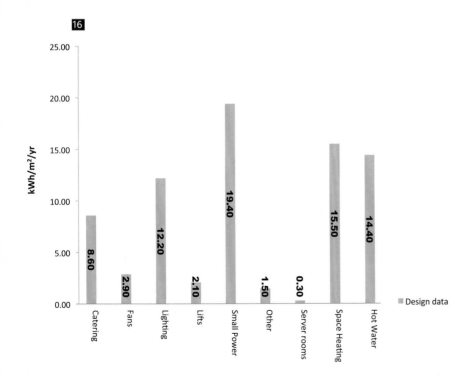

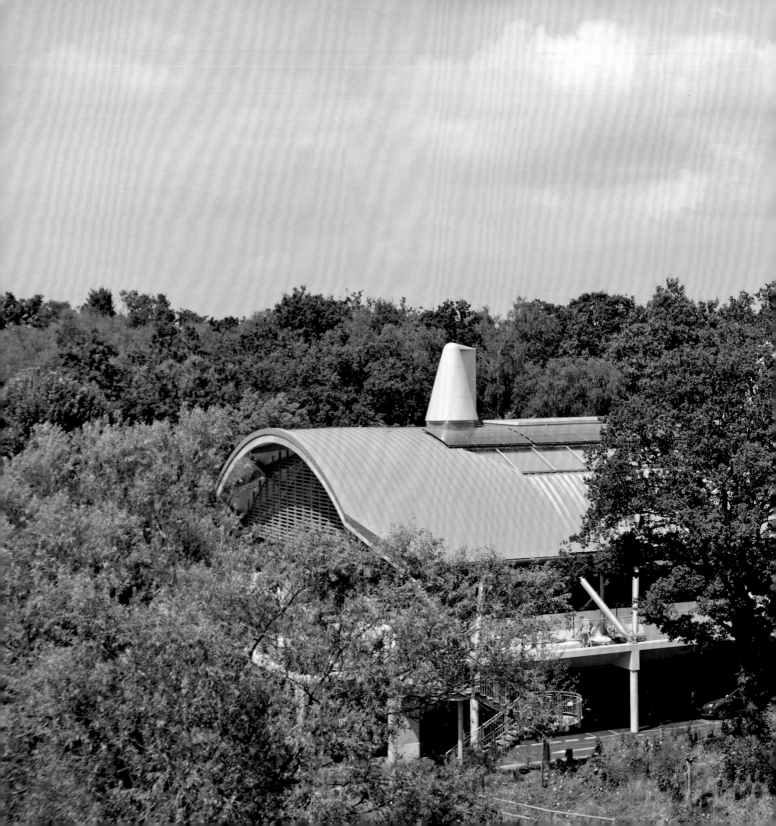

CASE STUDY 7

Living Planet Centre – WWF
Woking

The BREEAM Outstanding Living Planet Centre is the new home of the World Wildlife Fund (WWF) in the UK. The building was designed to ensure minimal environmental impact, in both construction and use, reflecting the ethos of WWF. It also provides an innovative public front for the organisation, and was described by Sir David Attenborough as 'a remarkable, elegant, symbolic and beautiful building'.

Client	World Wildlife Fund
Architect	Hopkins Architects
Structural engineer	Expedition Engineering
Services engineer	Atelier Ten
Landscape architect	Grant Associates
Lighting design	Speirs + Major
Main contractor	Willmott Dixon
Post-completion testing	Willmott Dixon and WWF Facilities Team

Overview

The Living Planet Centre houses 340 staff over two storeys in a collaborative, open-plan environment, together with conference and educational facilities and the new WWF Experience, which welcomes members of the public into the building. The building is suspended above an existing council car park alongside the Basingstoke Canal on the outskirts of Woking. Office space is arranged on two levels around a double-height internal street that gives focus and sociability to the internal environment. Two hundred 'hot' desks are provided for staff at a ratio of 5.88 desks per ten staff, determined following a detailed review of the office culture and space usage in WWF's previous headquarters (Figures 02 and 03).

The construction cost was mainly funded through a capital appeal, to avoid diverting funds from conservation projects. During the long search for a suitable site the client team set about refining a comprehensive brief for the project, with the aim of creating an exemplar for working practice, resource efficiency and for the use of low embodied energy and non-polluting materials.

01 External view: timber louvre screen on west elevation
02 First-floor plan: public entrance, conference and education space to the east (right side of image)
03 Mezzanine plan with main conference room

Key

1	Gallery space	7	Piazza
2	Education room	8	Lockers
3	Board room	9	WWF Experience
4	Cafe	10	Open plan office
5	Library	11	Bridge to town centre
6	Reception	12	Breakout space

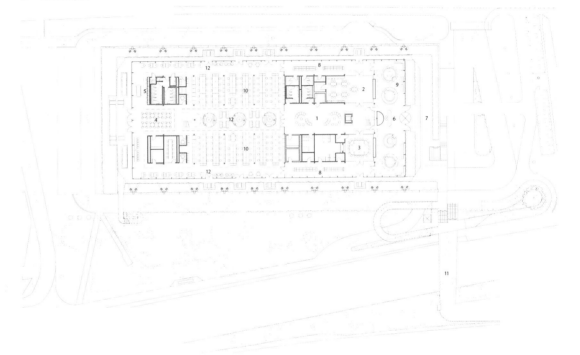

Key

1	Conference room
2	Open-plan office
3	Project room
4	Meeting room
5	Breakout space
6	Kitchen

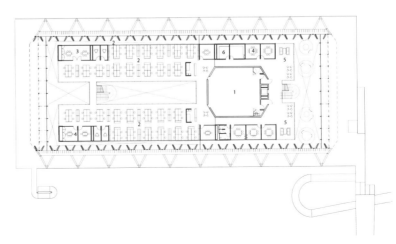

04

05

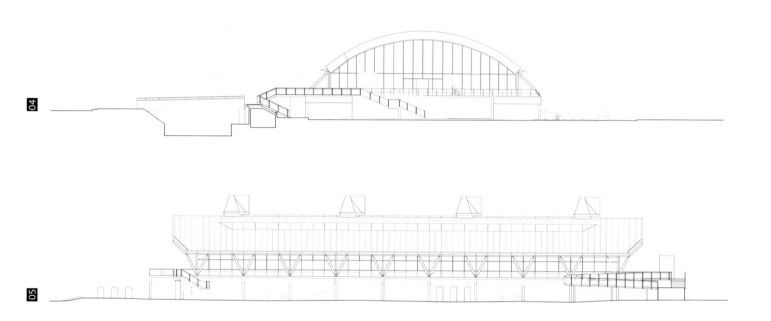

Design approach

The building's raised plinth and mezzanine are constructed of high-quality fair-faced concrete with a high proportion of cement substitute (ground-granulated blast furnace slag, or GGBS). Its roof is a dramatic structural timber gridshell, 37.5m wide. This is capped with recycled aluminium roofing featuring photovoltaic panels and large metal wind cowls to assist with the ventilation of the building. The eastern and western ends are glazed, with timber louvres providing protection against solar gain (Figures 06 and 07). The open-span nature of the structure allows for easy future adjustment of internal layout, and works with the raised floor's inherent flexibility to help future-proof the building.

The project benefits from of state-of-the-art IT systems, partly donated in kind, and based around refurbished technology from the 2012 Olympics. WWF monitors and annually reports on all of its employees' domestic and international travel and uses high-quality video conferencing to help reduce transport-related carbon impacts.

06

04 Front elevation
05 Side elevation
06 External view
07 Internal view from first-floor mezzanine, looking west
08 Good daylighting is achieved across all of the deep-plan floor plate, but there are no views out from the first-floor work stations

Environmental design

The open office areas are designed to promote good ventilation and to benefit from good daylighting across the deep plan, with a daylight factor of four or more across the floor plate (Figure 08). The design team worked together to manage the competing demands for roof space, balancing glazing areas for natural daylight (avoiding artificial lighting) with the area devoted to electricity production via photovoltaic (PV) panels. There is 510m² of PV in total (55kWp), providing about 20% of the building's regulated energy needs.[96] Daylighting models and shading analysis were used to improve the access to solar radiation, resulting in a design change to the orientation of the footprint by 9°.

During the design process lengthy studies were made, researching the environmental impacts of various material and construction choices and looking at the embodied energy of particular aspects, such as increased insulation thicknesses, against the potential carbon saved. These carbon-profiling studies led to some unexpected outcomes for an ultra-low-energy building: the choice, for instance, of double rather than triple glazing in the main east and west façades.

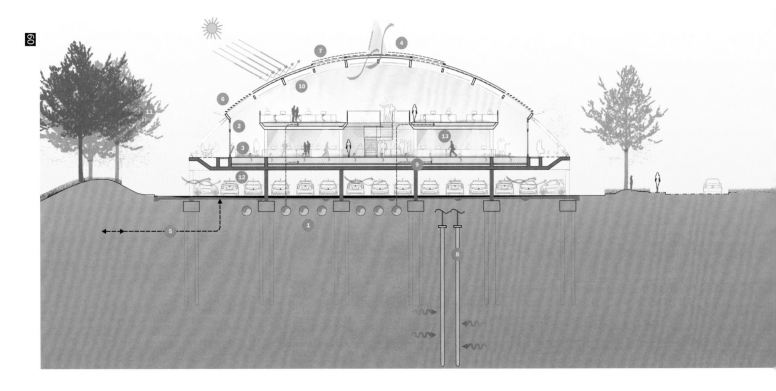

The building can operate for about two-thirds of the year in natural ventilation mode, with fresh air entering above the podium-level glazing and doors via manually operated vents. The work areas are entirely open plan and therefore air can move freely under the mezzanine floors; it is exhausted through four large roof-mounted cowls (Figures 10 and 11). Green and red indicator lights are distributed across the work areas to show whether the building is in natural or mechanical ventilation mode (an alert is also sent to everybody's computer). In mechanical ventilation mode air is supplied via a 500mm-deep floor plenum. The air is pre-heated by a series of earth tubes located approximately 1.2m below the car park surface. Stale air is extracted from grilles around the perimeter, and heat is recovered by the air-handling units located in the undercroft parking area. The mechanical ventilation supplies tempered air to meeting rooms and the conference area throughout the year. Heating and cooling is provided by a Groenholland heat pump connected to twenty 100m-deep boreholes. The data server is also cooled by the building's ground-source heat pumps.

1. Earth ducts (100m length minimum)
2. Louvred openings for natural ventilation (open in mid sea
3. Openable door (open in mid season)
4. Cowl for exhaust air (closed in winter)
5. District heating from the Woking district energy system
6. Solar control glazing with external shading
7. Photovoltaic cells integrated into rooflights
8. Borehole for ground-source heat pump
9. Displacement ventilation
10. High thermal mass
11. Deciduous trees for solar shading
12. Car park natural ventilation
13. High efficiency interior lighting with daylight dimming and occupancy sensors

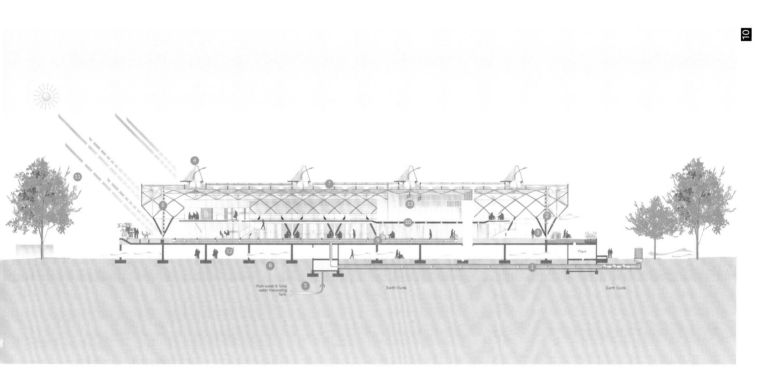

10

1. Earth ducts (60m length minimum)
2. Louvred openings for natural ventilation (open in mid season)
3. Openable door (open in mid season)
4. Cowl for exhaust air (closed in winter)
5. District heating from the Woking district energy system
6. Solar control glazing with external shading
7. Photovoltaic cells integrated into rooflights
8. Borehole for ground-source heat pump
9. Displacement ventilation
10. High thermal mass
11. Deciduous trees for solar shading
12. Car park natural ventilation
13. High efficiency interior lighting with daylight dimming
 and occupancy sensors

Monitoring and post-occupancy feedback

The Living Planet Centre has been monitored in the first year by contractors Willmott Dixon and by WWF's building-management team, who report regularly on the energy and water consumption of their UK buildings, and also the carbon emissions associated with travel and consumables. WWF benchmarks its performance against its own baseline and industry standards, seeking to make substantial improvements every year. The post-occupancy evaluation included energy and social performance measures. A user questionnaire was completed soon after occupation, providing useful feedback on some of the controls systems and revealing the general level of understanding of the building's environmental systems and user interactions. The controls philosophy was explained to a wide user group at handover, and messages are reinforced in the user guide.

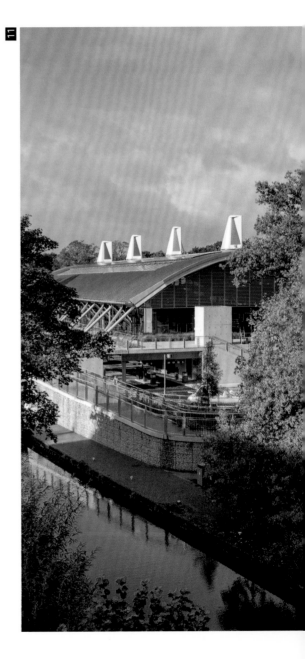

There were initial problems with the set-up of the building management system (BMS), which was not recording the data from sub-meters. Now that these have been overcome there are regular post-handover meetings between the building manager, the main contractor, the M&E subcontractor, controls engineers, the heat pump manufacturer and the building designers. An action plan has been devised to inform the monitoring and for making operational changes and improvements. The services engineer, Atelier Ten, can provide high-level checks on temperature and ventilation settings (they can access the BMS remotely) and the controls installer has been taken on board to provide ongoing management of the Trend controls system. The contractor also undertook smoke tests to verify the ventilation rates in the meeting rooms. As a result of these activities a number of adjustments have been made:

- extra vents have been added to the meeting rooms to increase the extraction rates
- alterations have been made to the night-purge routine to improve efficiency
- manual controls have been installed on the roof cowls
- various set points and ventilation rates have been adjusted to improve comfort
- chiller settings have been lowered on the ground-source heat pumps during summer mode.

Although the building is performing considerably better than the industry benchmarks, the first year's energy consumption shows a discrepancy between the predicted use and metered use.[97] The monthly winter average consumption (October–March) was 11.03kWh/m^2 and the summer average (May–September) was 8.08kWh/m^2. This gives a total energy use of 114.66kWh/m^2/yr compared with the predicted energy use of 74.87kWh/m^2/yr.[98]

The public areas of the building, the conference and educational facilities, have proved very popular and as a result the operating hours are longer than anticipated. These are also the areas that have the most active conditioning and energy usage. Work is ongoing to establish how much of the difference between predicted and actual usage can be attributed to under-performing fabric and services and how much is as a result of incorrect or enforced assumptions (by regulation and compliance conventions) in the prediction model.

11 External view: rooftop ventilation cowls
12 External view: timber louvre screen on west elevation
13 Internal view from ground floor looking west

155

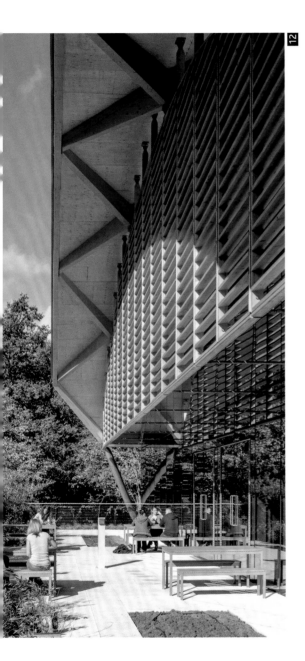

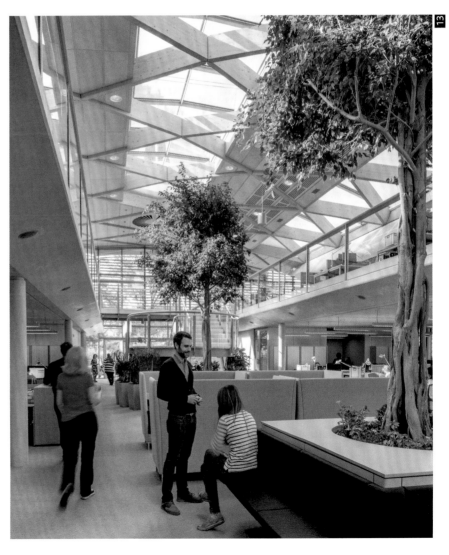

Conclusions

The Living Planet Centre is a project where the client's ambitions have been clearly researched in a demanding but clearly articulated brief, which has prompted imaginative and collaborative working from an enthusiastic and knowledgeable delivery team. Innovative work has been undertaken with regards to operational and embodied energy, and this has informed construction techniques, material choices and engineering solutions from first principles.

The carbon-profiling work has also helped to achieve a balance between carbon associated with embodied energy, the 'capital' carbon cost of installation, and the long-term potential savings in operational carbon emissions over the life of the building. As a result there was a greater focus on reducing the embodied energy of the construction.

Title	Living Planet Centre
Location	Woking
Completion date	2013

The overall energy use by WWF HQ is an increase from the design prediction, however it is an improvement over the benchmark by the Better Buildings Partnership. As further data is gathered and published on this project it will be easier to understand the causes of the performance gap.

Energy graph based on data collected between November 2013 and August 2014, showing in use-energy compared with design prediction and Better Building Partenership benchmark.

15

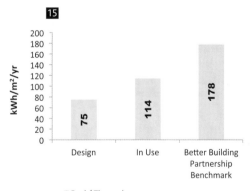

■ Fuel / Thermal

CASE STUDY 8

One Brighton
Brighton

One Brighton is a pioneering project in terms of environmental ambition and early adoption of new technologies, and through the extent of its monitoring. The findings from over three years of research on the project have informed industry guidance and briefings on district heating, building performance evaluation (BPE) techniques, and heat recovery systems for ventilation and heating.

Client	BioRegional Quintain and Crest Nicholson
Architect	Feilden Clegg Bradley Studios
Structural engineer	Cameron Taylor
Services engineer	Fulcrum Consulting
Landscape architect	Nicholas Pearson
Main contractor	Penne
Post-completion testing	GHA Monitoring Programme 2011–13

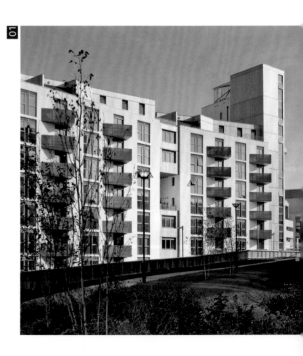

Overview

One Brighton is a pioneering urban housing scheme developed in a 50:50 joint venture by BioRegional Quintain and Crest Nicholson following the principles of 'One Planet Living'. The project aimed to use zero-carbon footprinting through a combination of energy demand reduction; on- and off-site renewables, including renewable heat; and a 9.4kWp photovoltaic installation. However, zero carbon is only one component of the ten measures used in the One Planet Living footprinting tool, and One Brighton includes many other innovations aimed at making sustainable living a possibility, including initiatives to reduce water usage, to reduce waste in construction and in use, and to encourage sustainable food production and support biodiversity (Figure 02). The concept grew in part out of the learning and experiences gained developing the BedZED eco-village in south London, and also from BioRegional Quintain's mission for a comprehensive and holistic approach to sustainability. Its focus is very much on enabling and supporting sustainable living in an accessible and affordable environment.

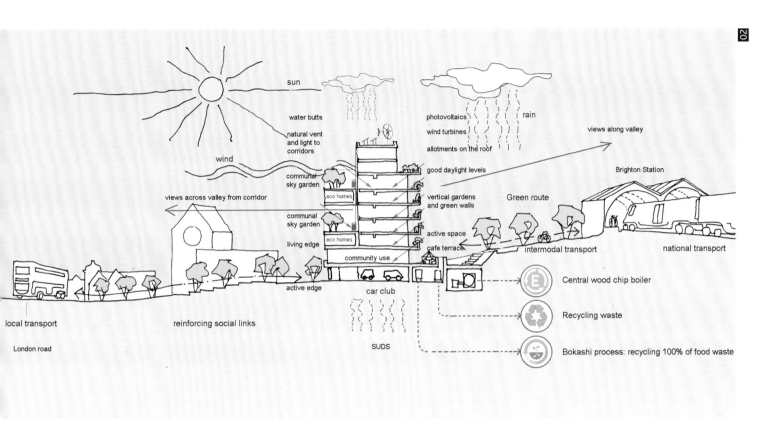

02

Environmental diagram labels:
- sun
- water butts
- natural vent and light to corridors
- wind
- communal sky garden
- views across valley from corridor
- eco homes
- communal sky garden
- living edge
- eco homes
- community use
- active edge
- car club
- local transport
- London road
- reinforcing social links
- SUDS
- photovoltaics
- wind turbines
- allotments on the roof
- rain
- good daylight levels
- vertical gardens and green walls
- active space
- cafe terrace
- Green route
- intermodal transport
- views along valley
- Brighton Station
- national transport
- Central wood chip boiler
- Recycling waste
- Bokashi process: recycling 100% of food waste

1	Zero carbon
2	Zero waste
3	Sustainable transport
4	Sustainable materials
5	Local and sustainable food
6	Sustainable water
7	Land use and wildlife
8	Culture and heritage
9	Equity and local economy
10	Health and happiness

03 One Brighton has been monitored post occupancy as part of the research programme of the Good Homes Alliance and in the Innovate UK BPE programme.

Design approach

One Brighton is located as part of the larger New England Quarter regeneration project, close to the city's main rail station. In addition to residential accommodation it provides community space and 1,134m² of commercial studio space, which goes some way to meeting One Planet Living ambitions for an equitable and local economy.

The residential accommodation consists of studio apartments, one- and two-bedroom units organised in two blocks of eight and eleven storeys respectively. The blocks have a conventional plan, with central corridors at each level serving mainly single-aspect apartments. Sky gardens (Figure 04), common balcony/garden spaces, provide sheltered outdoor spaces on alternating floors and help to articulate the rendered and timber-clad façades (Figures 06 and 07).

One Brighton was constructed using a design and build arrangement between 2008 and 2010.

Environmental design

The fabric strategy for the buildings was to achieve cost-effective performance from natural and sustainable building materials. Insulation levels for the external components aimed at a 15% improvement on the then-current Part L (2006), and an airtightness of 5m³/h.m²@50Pa, but not the demanding levels set for BedZED. The external wall construction, simple extruded clay 'Thermoplan' blocks and wood-fibre insulation, protected by a proprietary render, provided a simple construction build-up and a good strategy for reducing thermal bridging around window openings. Internally the soffit of the concrete frame structure is exposed within the apartments and ventilation ductwork and lighting is neatly designed into a perimeter bulkhead, which

04

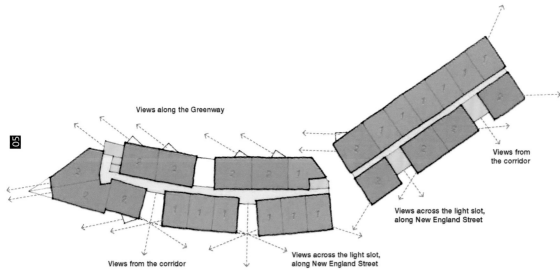
05

Views along the Greenway

Views from the corridor

Views across the light slot, along New England Street

Views from the corridor

Views across the light slot, along New England Street

04 View out of sky garden/light slot 163
05 Plan layout diagram
06 External view
07 Sky garden locations

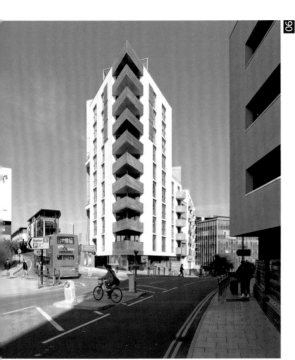

allows most of the ceiling thermal mass to be exposed. The mechanical ventilation system uses heat recovery (MVHR), which is now commonplace in dense urban housing but at the time was a comparatively new technology in the UK.

The heating system used a centralised biomass-fed boiler which was also comparatively innovative; however, the design and installation was complicated by the relative lack of experience of the project team and the lack of information and support provided by the boiler supplier.

Monitoring and post-occupancy feedback

The Good Homes Alliance initiated a phased monitoring programme in October 2011 concentrating on one household.[99] In-depth monitoring under an additional Innovate UK-funded project of five households commenced in February 2012 and continued until September 2013, though two households withdrew from the monitoring towards the end of the programme. Site-wide energy-use information was collected for heating, hot-water and electricity usage for each of the 172 dwellings through the energy services company (ESCo) that manages and charges for energy use on the scheme. The detailed monitoring included co-heating testing, for fabric performance and air-permeability testing, as well as air-quality and temperature monitoring.

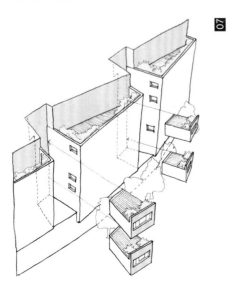

In use there have been problems with quality of locally sourced woodchip fuel causing smoke to be fed back through the supply auger and triggering fire alarms within the plant area. The biomass boiler has also proved to be unreliable, leading to a greater use of the gas back-up boiler (the biomass was only operating for 14 months of the 20-month Innovate UK monitoring period).[100] The measured efficiency of the biomass boiler was estimated to be 69.6% compared with a design assumption of 85%. The biomass boiler has now been replaced by a new Fröling boiler with ongoing funding support provided by the Renewable Heat Incentive (RHI) scheme.

Preliminary resident feedback and research by BioRegional Quintain suggested that there were problems in summer with some apartments overheating. Occupiers reported that the ventilation controls were difficult to operate and there were design and installation issues with the MVHR ductwork and position of the main unit (in the ceiling above the bathroom), which meant that filter replacement was inconvenient. The developer has employed a 'green caretaker' to help run the buildings and support occupiers with what

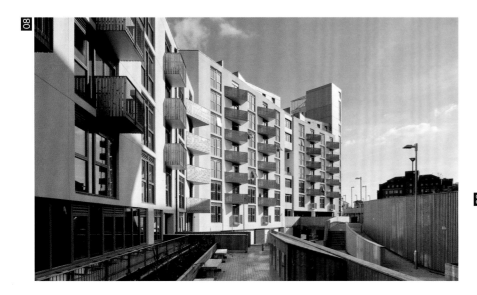

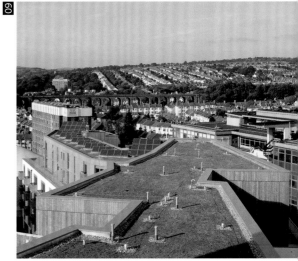

would have been unfamiliar heating and ventilation systems. The causes of the overheating prompted the commissioning of a further study to supplement the wider-ranging Innovate UK monitoring, and specifically with regard to how the building would perform under different climate change scenarios.[101]

Investigations into the ductwork and MVHR installation revealed widespread failings in the ductwork installation, balancing and commissioning of the systems. This mirrored the findings at Derwenthorpe (see Case Study 9), where the lack of skills and familiarity with the technology both in terms of design and execution were also plainly evident. Research from both of these projects has prompted recent guidance and new technical standards (GHA Technical Brief 03[102] and NHBC Standards Chapter 8.3[103]). The consequences are poorer air quality from clogged filters and room outlets, and higher running costs. The running costs for the ventilation system are also high because of the reliance on mechanical ventilation in the summer to achieve good 'purge' ventilation. The system was designed to function in summer at higher flow rates without the heat re-circulation mechanism (summer bypass mode) and this is a reasonable strategy considering the scheme's location near busy roads and railway lines. However, leaving aside issues to do with pollution and noise on some elevations, it would have been helpful for residents to be encouraged to use the windows for natural 'purge' ventilation as well as the boost ventilation.

08 External view: workspace on ground floor
09 External view: planted roofs
10 External view: most units are single-aspect but some have side windows to sky gardens and better cross-ventilation
11 Sky garden

165

Overheating was observed in all the study dwellings, but one in particular showed bedroom temperatures exceeding 26°C for more than 50% of the time during the months of May to October. As with other instances of overheating[104] there are likely to be several contributory causes: internal gains from appliances and equipment; gains from the district heating pipework and the heat exchanger in each flat (which remains fully charged with hot water throughout the year); and gains from unshaded windows. These will be compounded by the single-aspect dwellings (little natural cross-ventilation) and the under-performance of the ventilation system, with measured ventilation rates significantly lower than the design commissioning value.

Overall the building fabric at One Brighton measured well, achieving close to the design targets, but perhaps not the potential performance achievable with the simple-fabric approach of externally insulated frame and wall. In practice the design airtightness values had been harder to achieve than expected because of the large deflections on the thin post-tensioned concrete slabs, which created a variable gap at the head and foot of the extruded block wall. The wall construction with thin bed joints is also less forgiving of inaccuracies in a vertical plane, as there isn't a depth of mortar bed to adjust for differences in level.

The role of the thermal mass either in alleviating the overheating problem or possibly compounding it has not been established. For an effective use of the thermal mass the structure would need to be cooled down with night-time ventilation. In the flats where occupants ran the ventilation system at high levels throughout the summer this would be beneficial, but in the flats where the ventilation was not run or used in background mode only there would be potential for thermal mass to simply accumulate heat. This might contribute to the high temperatures measured in the bedrooms, especially in periods of high external temperatures but only small diurnal variation. The Innovate UK study showed markedly different energy use for ventilation, suggesting that some occupiers were reluctant to use it either for cost reasons or because of unacceptable internal noise. A further climate adaptation study was undertaken by a group of Good Homes Alliance consultants, including Feilden Clegg Bradley, the original architect, and led by Inkling.[105] In this study a dynamic thermal model was used to investigate the performance of the dwellings in future climate scenarios, after the modelling assumptions (for occupancy patterns etc.) had been verified against the measured data. This study confirmed some beneficial effects of thermal mass, but all of the mitigation measures assumed the use of the ventilation system running at high volumes in combination with opening windows. Interestingly, for the small number of dual-aspect dwellings (a number have side windows into the sky gardens) the modelling showed much more tolerable internal conditions, confirming the wisdom of climate-change mitigation strategies that are now being built into planning legislation. Examples of this include the London Plan Housing Design SPG and Brighton and Hove Council's One Planet Living sustainability action plan.

Conclusions

Although some of the carbon- and energy-saving targets for the project have not been met there are many positive aspects of this project, not least the continued 'living research'. This has provided much information for an industry unfamiliar with low-carbon technologies such as communal biomass heating and MVHR. The scheme is well liked by residents, with many citing innovations such as the roof-top allotments as a valuable community and environmental focus. In addition the research outputs are readily accessible, with concise summaries, and the social innovations such as the resident Green Caretaker, the continued involvement of the development team, and the updating and replacement of under-performing technologies prove its value as a live research project.

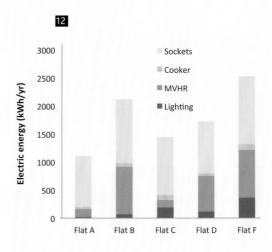

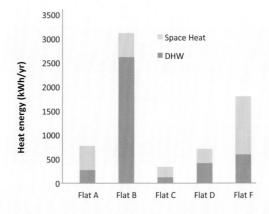

12 Energy consumption by end use graph
13 Coefficient heat-loss graph
14 Percentage variation in performance graph

167

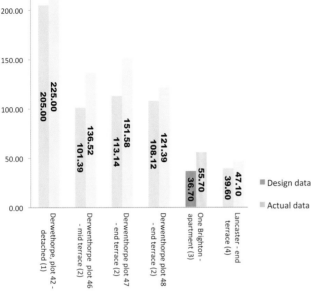

13

Heat-loss Coefficient (W/K)

- Design data
- Actual data

- 225.00 / 205.00 — Derwethorpe, plot 42 - detached (1)
- 136.52 / 101.39 — Derwenthorpe plot 46 - mid terrace (2)
- 151.58 / 113.14 — Derwenthorpe plot 47 - end terrace (2)
- 121.39 / 108.12 — Derwenthorpe plot 48 - end terrace (2)
- 55.70 / 36.70 — One Brighton - apartment (3)
- 47.10 / 39.60 — Lancaster - end terrace (4)

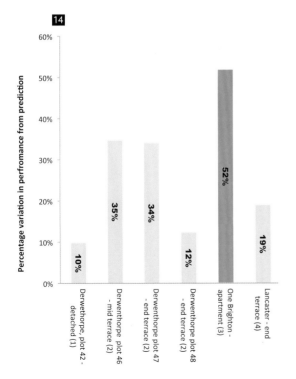

14

Percentage variation in performance from prediction

- 10% — Derwethorpe, plot 42 - detached (1)
- 35% — Derwenthorpe plot 46 - mid terrace (2)
- 34% — Derwenthorpe plot 47 - end terrace (2)
- 12% — Derwenthorpe plot 48 - end terrace (2)
- 52% — One Brighton - apartment (3)
- 19% — Lancaster - end terrace (4)

Title	One Brighton
Location	Brighton
Completion date	2009

Annual total energy consumption by end use graph: Five apartments were monitored to understand their energy consumption by end use and total heat input. The variation in energy use between homes for the MVHR units was probably caused by the different use of boost mode. Some homes used boost in summer to try to counter the overheating (following the advice in the home user manual). The poor quality of the ductwork installation and the inaccessibility of the filters could also have caused different energy consumption between apartments. The MVHR fan will consume more energy if it is working against the resistance of blocked filters or compressed ductwork.

Coefficient heat-loss graph: A single apartment was tested at One Brighton. The low heat-loss coefficient reflects the modest size of the apartment, the small exposed external surface area and the attention to fabric performance in the design. Testing apartments with a co-heating test is relatively complicated as it is necessary to maintain all adjacent apartments (to the side, above and below) at the same elevated temperature as the test dwelling for the duration of the test. This may be a contributory factor in the discrepancy between design and measured performance.

Image 13/14:
(1) Testing conducted by S. Stamp, R. Lowe and H. Altamirano, from the UCL energy institute and provided by the Joseph Rowntree Foundation
(2) Testing conducted by D. Miles-Shenton, D. Farmer and P. Matthew from Leeds Metropolitan University and provided by the Joseph Rowntree Foundation
(3) Data from UCL, (2014), 'One Brighton - ongoing monitoring', Innovate UK: buildingdataexchange.org.uk/report/One+Brighton+-+ongoing+monitoring/800/
(4) Data from F. Stephenson and D. Johnston, (2014), 'Lancaster co-housing development', Innovate UK: buildingdataexchange.org.uk/report/Lancaster+Co-housing+Development/869/

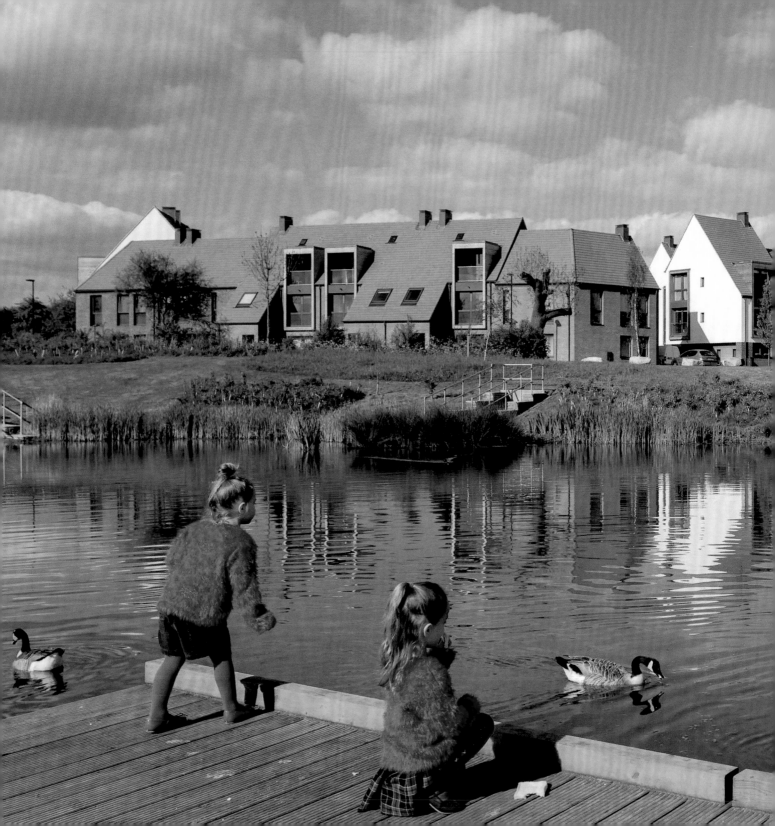

CASE STUDY 9

Derwenthorpe
York

The first phase of Derwenthorpe (64 houses of an eventual 540) is the outcome of a long-term vision, conceived and sustained by an exceptional client, the Joseph Rowntree Housing Trust (JHRT). Derwenthorpe aims to become a vibrant and supportive mixed-tenure community by providing high-quality, energy-efficient and well-managed homes – an exemplar that can be replicated by other housing providers.

Client	Joseph Rowntree Housing Trust
Architect	Studio Partington
Structural engineer	Alan Wood & Partners
Services engineer	Arup
Landscape architect	FIRA
Development partner	David Wilson Homes
Project manager	MDA
Post-completion testing	Leeds Beckett University, York University Centre for Housing Policy, UCL

Overview

The project's ambitions sought to establish best-practice benchmarks in place-making; sustainable transport; landscaping and ecology; and in community building in addition to the more commonplace energy and space standards, largely represented by the Code for Sustainable Homes. While some initiatives built on Rowntree's ethos and legacy, following the precedent set by nearby model village New Earswick, others looked forward, aiming to provide a residential community that meets not only the demands of the current inhabitants but also those in the future.

The design focused on the creation of high-quality public space, with careful attention given to the design of streets, play areas, landscape and parking courtyards to ensure that all spaces were subject to overlooking and that play areas and recreational facilities were close to homes (Figure 03).

01

01 External view: homezone with two-bed terraced homes 171
02 External view
03 External view: the central play area and square, with energy centre beyond

An energy centre was built at the heart of the scheme in its initial phases, and this incorporated teaching and generous community spaces, helping to provide a focus and resource for the emerging community. As with previous JRHT pilot projects there is a recognition that leading by example also requires a certain amount of objective reflection on successes and failures, and a commitment to disseminate learning and research. Derwenthorpe has evolved into a live research project. In addition to testing fabric and technology performance, a three-year research project by York University's Centre for Housing Policy has evaluated the in-use performance of the homes and occupant behaviour.[106] Further work is being undertaken by the Building Research Establishment (BRE) on indoor air quality, and the efficacy of the mechanical ventilation

with heat recovery (MVHR) systems used in the Phase 1 homes. The brief for subsequent phases (now under construction) has been modified with this learning, tempered always by the priority of making the homes affordable and accessible.

Design approach

The houses are light and well proportioned with generous flexible rooms, designed to comply with the requirements both of Lifetime Homes and Standards and Quality in Development. Dual-aspect main living rooms bring natural light deep into the plan and allow cross-ventilation throughout the year, while high ceilings of 2.6m and 2.7m lend an overall sense of light and space.

All houses have been carefully oriented, with larger windows facing south, and many houses have sunspaces to maximise useful solar gain (Figure 04). The sunspaces act as a thermal buffer throughout the year, collecting solar energy in the winter and helping to cool the houses in the summer, providing secure ventilation at a high level and making use of the stack effect for ventilation. On the street elevations the sunspaces are also used to provide a degree

04 Internal view: living room with sunspace
05 External view: playground
06 External view: entrance porch
07 External view: entrance porch and front garden

173

of privacy to the south-facing living rooms, while maintaining high levels of daylight.

On the garden side they provide a practical indoor/outdoor space where plants can be grown, wet clothes and boots can be left, and children can play with direct access to the garden.

All houses are designed to the same standard and with the same appearance regardless of tenure, with 40% being for rent and shared ownership and 60% for private sale. The affordable homes are 'pepper potted' across the whole site, avoiding grouping of tenure and promoting equality and diversity.

Environmental design

One of the key objectives at Derwenthorpe was to counter fuel poverty by reducing heating demand and by closing the performance gap. The Derwenthorpe house designs set out to safeguard the residents and reduce their vulnerability to fuel poverty by ensuring that the thermal standards were achieved on site and verified by measurement and testing. A 'fabric first' approach was adopted, ensuring that the basic fabric of the home and its fixed elements (walls, windows, etc.) were working as efficiently as possible. Good U-values, low air permeability, carefully controlled cold bridging and modern methods of construction were used to achieve Code for Sustainable Homes Level 4, with five homes achieving Level 5 through water-efficient fittings and

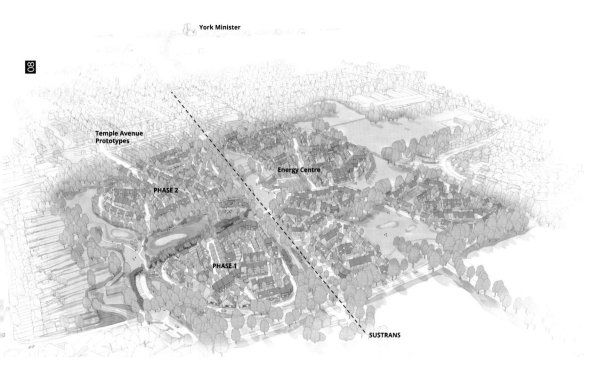

08

York Minister

Temple Avenue
Prototypes

Energy Centre

PHASE 2

PHASE 1

SUSTRANS

09

appliances, and 1.75kWp of photovoltaic (PV) panels generating electricity. The design standards and construction technologies were set through the development of prototype homes, which were evaluated by the design team and a comprehensive testing regime led by the Centre for Excellence in the Built Environment, Leeds Beckett University.[107]

The decision to use community heating, fired by locally sourced biomass, was not only a response to government carbon targets but also an attempt to build some safeguards and self-governance into the management of residents' energy supply, and to provide heat from locally sourced fuel.

Informed by the prototype testing, the houses were constructed using partial-fill cavity thin-bed masonry walls, and a structurally insulated panel roof system (SIPS). The masonry wall construction, with rigid PIR partial-cavity insulation and the inner thin-bed blockwork leaf, provides high insulation levels and some temperature-regulating effects via thermal mass. The SIP panel roofs are straightforward to construct and provide a robust solution for thermal performance and airtightness, due to minimal penetrations through the airtightness barrier. Trussed roof constructions with insulation at ceiling level were economical but far less robust in terms of energy performance than the SIP roofs of the majority of homes.

08 Aerial siteplan: Phase 1 is at bottom left
09 House types: plans and elevation – five-bed detached, extendable two-bed and three-storey town house

175

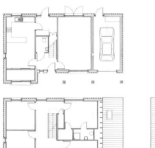

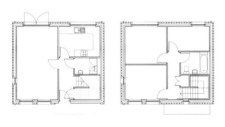

Monitoring and post-occupancy feedback

Testing and evaluation of the first phase at Derwenthorpe is being undertaken with four distinct approaches, each serving a particular objective:

- Mid-construction tests and inspections are regularly carried out to help maintain construction quality, particularly with regard to fabric performance and services commissioning.
- A sample of homes has been tested with a forensic post-completion test, to verify the whole-house heat loss and services installation as handed over.
- Specific technology testing is looking at recurring challenges created by the adoption of new technologies with regard to ventilation and indoor air quality.
- Wide-ranging post-occupancy monitoring covers everything from resident experiences to carbon footprinting and evidence of the emerging community, conducted over a period of three years.[108]

Overall there is a high level of occupant satisfaction with the design of the homes and the wider environment. The project has also been successful in reducing occupant fuel bills. However, the project has been less successful in influencing residents' other lifestyle choices, such as transport. In addition there has been a mixed response to the biomass boiler, due to issues of operation during later construction phases and concerns over cost. This shows how difficult it can be to deliver a truly sustainable community.[109]

The mid and final construction testing has shown in general that construction standards are consistently high. While only a proxy for overall quality, it has been reassuring to see that all of the Phase 1 homes achieved an airtightness of around 2m³/h.m²@50 Pa with very little variation across the phase. The developer partner building the homes used airtightness testing at completion of the external walls and roof panels as well as after the services installation, helping to highlight to later trades the importance of maintaining the integrity of the various barriers and membranes and establishing the line of airtightness.

The co-heating testing can only be carried out during the winter and relies on maintaining the home for a sustained period (ideally four weeks) at a constant internal temperature of 25°C, and a temperature difference between inside and outside ('Delta T') of at least 15°C. The internal temperature is maintained by a resistance heater, and the heat is distributed evenly internally by fans; the energy consumption of both is monitored. Remote sensors are used

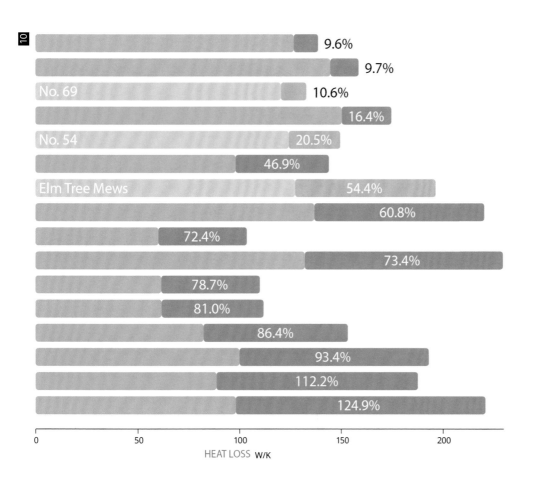

Key

X axis	Heat loss coefficient
Y axis	Sample of 16 homes tested by Leeds Beckett University.

to maintain the home in an effective state of steady heat loss, allowing a coefficient of heat loss or whole-house U-value to be obtained. For reliability the test is carried out over a long period to allow for the effects of external weather (for instance direct solar heating) to be accounted for in the data analysis. In terraced or attached homes the adjacent properties also have to be maintained in the heated state, so that only heat losses through the external wall and roof are represented in the overall figure. The process is long and arduous, and must be carried out by experienced researchers.

10 Heat loss: measured heat-loss coefficient compared with design prediction: all homes tested by Leeds Beckett University up to 2012

11 External view: typical three-storey house with balcony to main bedroom

177

A shortened version of the test was used on all the Innovate UK residential projects, but inconsistent results revealed the shortcomings of the approach. Construction teams had failed to recognise the significance of external conditions, the length required for accuracy of the results and the importance of leaving the home undisturbed during the period of the test. However, when used correctly the method is reliable. It also presents an opportunity for additional tests whose accuracy can be relied on when the steady state of heat loss is maintained, for instance thermography and heat-flux testing. Testing with heat-flux sensors at Derwenthorpe and on the prototypes established that U-values were variable in different wall constructions, highlighting both the inaccuracy of the conventional U-value calculation methods and the possible effects of weather and wind pressure within the cavity-wall constructions. Wall, floor and roof build-ups were all found to consistently under-perform when compared with the manufacturer's predicted performance. Windows, however, showed a good correspondence between claimed values in trade literature and measurements made on site.

Post-completion testing of three of the early homes has shown a significant narrowing of the performance gap between predicted and actual energy use, with new homes coming close to the performance achieved by the prototypes. However, a notable fall-off in performance was detected in the last home to be co-heat tested,[110] due possibly to a relaxation of the high quality-control standards established in the first months, but also to a decision to experiment with more conventional roof construction for the simple houses.

Testing information for the MVHR systems has revealed problems similar to the observations made by the NHBC Foundation[111] in many of the Innovate UK findings, and in the One Brighton development (Case Study 8). The design criteria set for Derwenthorpe exceeded the Building Regulations Part F (Ventilation) requirements and also required improved acoustic performance. With full knowledge of the NHBC work, and the general problems the industry in the UK has found with mechanical ventilation, a lot of effort went into the design and location of the mechanical ventilation and heat recovery (MVHR) units and the coordination of ductwork. Units were made accessible for filter changing, and ductwork was on the whole well installed and correctly insulated. However, installed systems still proved noisy, and in some instances failed to deliver the required supply rates without intrusive noise. It is likely that the problems are being caused by the design of the terminals at the supply side of the system, probably exacerbated by the architect's desire to group all roof penetrations and terminals within the purpose-made roof cowls/chimneys,

and also by the extended runs of ductwork between the external fresh-air inlet and the MVHR unit. Although MVHR is increasingly used in new housing, especially urban housing (it is estimated that a quarter of all new homes have MVHR installed),[112] it would seem that there is still an alarming lack of design construction and commissioning expertise in the UK.

Conclusions

Much of JRHT's research is already in the public domain and has been influential in improving the housing industry's awareness of the performance gap, and by promoting a more systematic approach to testing homes and ensuring that what is handed over to an occupier will meet the design intentions.

The work by York University has revealed interesting comparisons between the phases. Phase 1 homes were marketed as being low energy and sustainable, and many of the for-sale homes were bought by people actively wanting to pursue a sustainable lifestyle. In the second phase of generally smaller homes the emphasis has been on affordability, and residents' expectations and lifestyles can therefore be different, perhaps leading to different levels of perceived satisfaction. It will be interesting to see whether the overall ethos resonates with the ordinary as well as the 'enthusiast' residents.

A consistent finding, across all tenures, has been the appreciation of the design of the homes – appearance, spaciousness and the overall quality of the external environment – suggesting that energy targets and low-carbon ambitions may not be the only or even the most significant markers of success of the project.

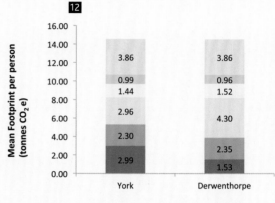

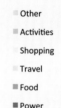

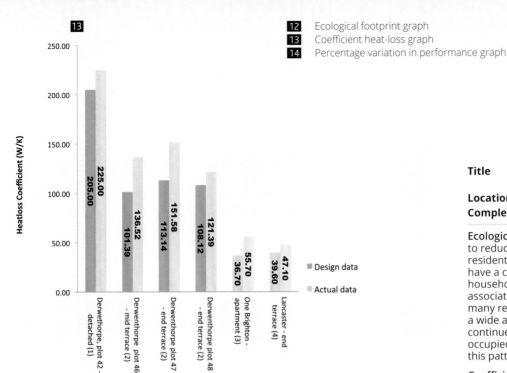

13

12 Ecological footprint graph
13 Coefficient heat-loss graph
14 Percentage variation in performance graph

Heatloss Coefficient (W/K)

- Design data
- Actual data

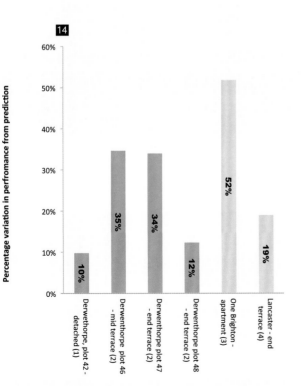

14

Percentage variation in perfromance from prediction

Title	Derwenthorpe Phase One (64 homes)	
Location	York	
Completion date	July 2012	

Ecological footprint graph: despite the efforts to reduce the energy use within the homes residents of the first phase of Derwenthorpe have a comparable carbon footprint to other households in the city. Carbon emissions associated with transport are a major factor, with many residents attracted to Derwethorpe from a wide area but not changing jobs. The project continues to be monitored as other phases are occupied and it will be interesting to see whether this pattern repeats.

Coefficient heat-loss graph: the measured heat-loss coefficient for Derwenthorpe Phase 1 shows a similar discrepancy to the prototype homes with a difference of 10–25% between predicted and measured heat loss. Site measurement using heat-flux sensors revealed that both wall and floor U-values were noticeably different from the calculated, theoretical performance. The Zero Carbon Hub raised the issue of a review of calculation procedures for U- values as one of its 'priority actions' in the report 'Closing the Gap Between Design and As-Built Performance: End of Term Report' (Zero Carbon Hub, 2014).

Image 12:
Data from D. Quilgars, A. Dyke, R. Tunstall and S. West, 'A Sustainable Community? Life at Derwenthorpe 2012 – 2015' Joseph Rowntree Foundation, 2016

Images 13/14:
(1) Testing conducted by S. Stamp, R.Lowe and H. Altamirano, from the UCL energy institute and provided by the Joseph Rowntree Foundation
(2) Testing conducted by D. Miles-Shenton, D. Farmer and P. Matthew from Leeds Beckett University and provided by the Joseph Rowntree Foundation
(3) Data from UCL, (2014), 'One Brighton - ongoing monitoring', Innovate UK
(4) Data from F. Stephenson and D. Johnston, (2014), 'Lancaster co-housing development', Innovate UK

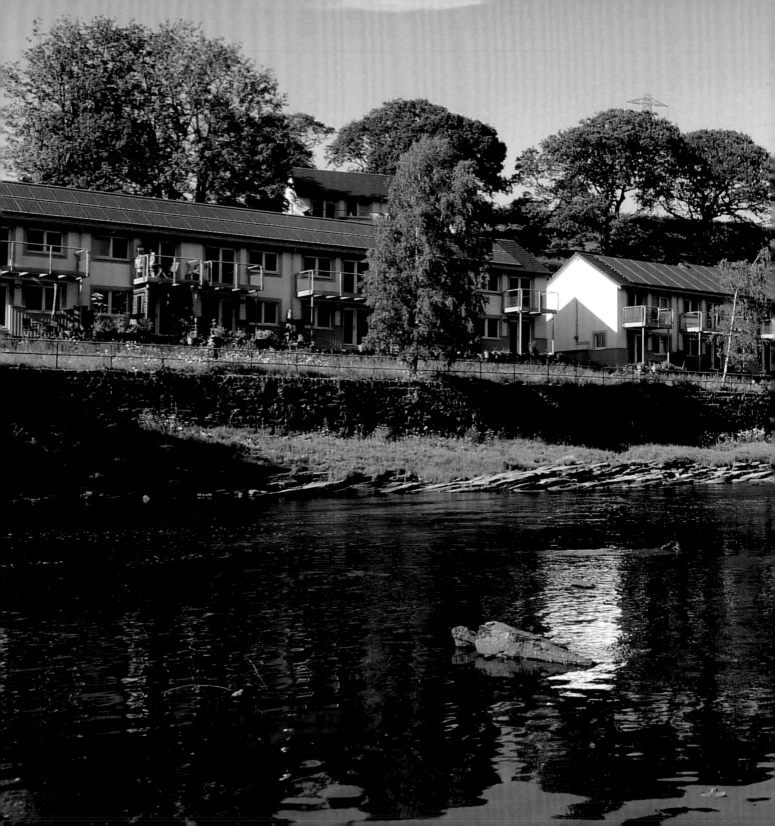

CASE STUDY 10

Forgebank–Lancaster Co-housing
Halton

Forgebank is an eco co-housing development
consisting of 41 homes, shared buildings,
a low-carbon workspace and riverside
woodland habitat. It aspires to be a cutting-edge
example of sustainable 'eco' design, for both
living and working, and to foster a neighbourly,
inter-generational community.

Client	Lancaster Co-Housing
Architect	Eco Arc Architects
Structural engineer	Ramboll
Services engineer and Passivhaus designer	Alan Clark and Nick Grant
Passivhaus certifier	WARM
Main contractor	Whittle Construction
Post-completion testing	University of Sheffield and Leeds Beckett University

Overview

The five founders of the Lancaster Co-housing project first looked for a
suitable development site in 2006, and after a long search settled on an
idyllic position next to the River Lune. The aim was to develop a community
of like-minded enthusiasts who would pledge funds to purchase land,
secure planning and collaborate in the development of a sustainable living
environment. The original intention was to find a site in Lancaster to make
car-free living possible; the chosen site, three miles from town, is a little
further out than had been hoped for.

The sloping brownfield site on the northern bank of the river suggested the
creation of compact terraces of houses with living rooms facing south, towards
the view, and with extensive south-facing roof areas for photovoltaic (PV)
panels (Figure 01). A 160kW community-owned hydro-turbine has also been
installed at the eastern end of the site, making the scheme a net exporter of
energy. Heating and hot water is provided via a district-heating system fuelled
by a biomass boiler.

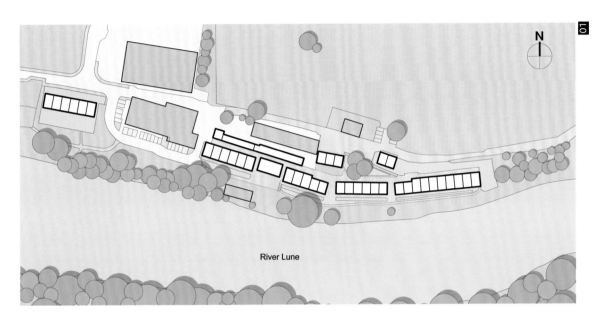

River Lune

Design approach

The designs for the houses themselves evolved through a participatory process, guided by experienced Passivhaus designers, Eco Arc Architects, and project managed by one of the co-housing group founders. Several of the people who joined the project had been pioneers in some aspect of ecological or community living, and wanted to learn from living together and to share their learning with a wider audience. Despite the abundance of renewable energy, the project aimed to reduce the energy used in the buildings to a practical minimum, and to increase their longevity in order to reduce the impact of embodied energy.

The time spent with designers Eco Arc Architects developing the brief and the layout of the homes has clearly been rewarded. Although it was a drawn-out process (decisions taken by the co-housing members are reached by consensus) the end result has lived up to expectations. The homes are small, but some space-consuming activities have been taken out of individual dwellings and planned into communal areas.

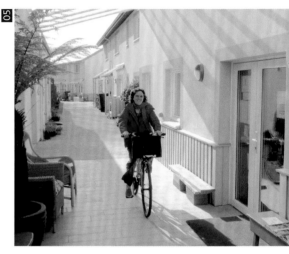

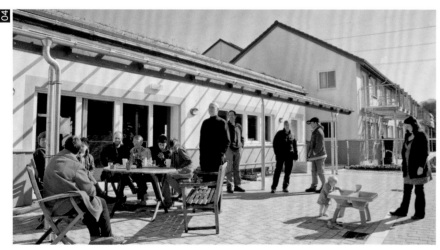

There is a large bicycle store, communal guest rooms, a common house for shared meals and a communal laundry (Figures 03 and 04). Some communal parking is provided but car ownership is discouraged and, as a result, the layout feels compact and neighbourly, with a pedestrian street, footpaths and riverside terraces in place of tarmac kerbs and parking areas (Figures 05 and 06).

03	External view from the eastern end of the scheme
04	Communal space outside the shared common room
05	The car-free street
06	External view
07	External view: apartments at the top of the site
08	'Living' roofs

185

Environmental design

Committing to the Passivhaus standard and to post-construction certification was an ambitious target for a scheme of this scale, and although the specialist resources of experienced Passivhaus consultants and suppliers were available the contractor had the daunting task of educating and enthusing an inexperienced group of subcontractors. The main contractor joined the project team at an early stage, having been appointed through a two-stage partnering contract that set out to guarantee the final cost. Decisions on cost and buildability were confronted at an early stage, leading to some spatial simplification of the houses (the loss of 'cathedral' ceilings on some dwellings) but also helping to manage expectations of what could be achieved within the fixed budget (Figure 09).

Forgebank has been studied in two rounds of the Innovate UK programme. Thermography and co-heating tests were undertaken by Leeds Beckett University, and the Building User Studies (BUS) survey was conducted by Sheffield University. Further long-term evaluation is under way with York University's Housing Unit and the Stockholm Institute. The BUS survey showed one of the highest satisfaction levels of any housing scheme visited by the researchers, with residents liking most aspects of the project but particularly the setting and outlook of the homes, and the comfort levels and low running costs.

The work by Leeds Beckett on the building fabric revealed some gaps in insulation, especially around the roof eaves and above ceilings, and some air leakage at the mitred joints of the window frames. The contractor was appointed in a two-stage tender and embraced the challenge of delivering the Passivhaus standard. Airtightness levels averaged 0.4 m^3/h.m^2@50Pa, an improvement on the extremely demanding Passivhaus target of 0.6 m^3/h.m^2@50Pa. However, there was a constant challenge to bring all of the subcontractors up to the same level of understanding and competence to deliver the necessary construction quality. The role of airtightness champion was elevated to one of all-round educator and quality monitor.

A co-heating test was carried out in January 2013 on an end-terrace 65m^2 dwelling. The test is used to measure the heat-loss coefficient for the dwelling fabric (effectively a whole-house U-value) and relies on being able to establish an elevated and stable internal temperature in an unoccupied dwelling for a continuous period of weeks. When this stable temperature is maintained (typically 15–20°C above external temperature) the dwelling will have reached a good approximation of steady-state heat loss. A measurement of the energy required to maintain this temperature, with corrections for external conditions, is then used to derive a heat-loss coefficient.

Unfortunately the research team did not have control of the adjacent dwelling, which in normal test conditions would be maintained at the same elevated temperature as the test dwelling, to discount heat loss through the party wall. It is likely that there will have been some heat transfer to the adjacent occupied home.

During the test it also proved harder to maintain a constant internal temperature compared with typical dwellings, as periods of high solar insolation caused rapid temperature rises in the south-facing rooms, of up to 5°C above the target temperature. The research team used techniques to

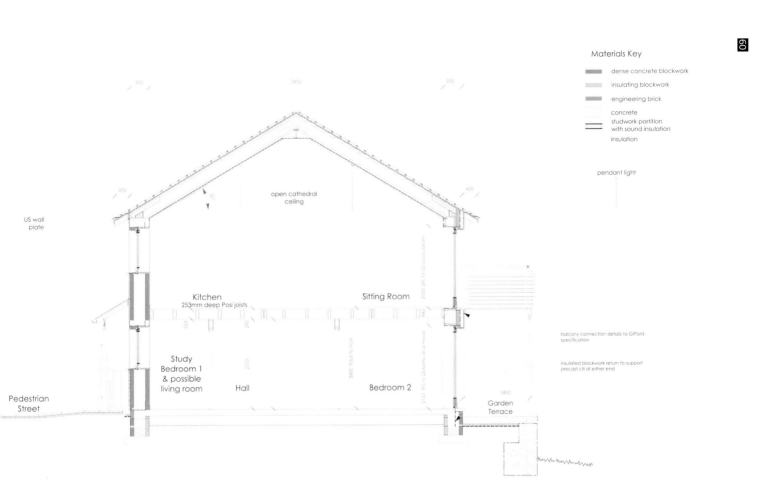

Materials Key

dense concrete blockwork
insulating blockwork
engineering brick
concrete
studwork partition
with sound insulation
insulation

pendant light

open cathedral
ceiling

US wall
plate

Kitchen
253mm deep Posi joists

Sitting Room

Study
Bedroom 1
& possible
living room

Hall

Bedroom 2

Pedestrian
Street

Garden
Terrace

balcony connection details to Gifford
specification

insulated blockwork return to support
precast cill at either end

discount these solar heating effects in the data analysis, but the Lancaster test highlights the complexity of accurate measurement in such highly insulated and airtight homes. The large contribution to internal temperature from solar gains is in itself a demonstration of Passivhaus principles in operation.

Apart from the minor deviations from the ideal test procedure the test results were among the best of the Leeds Beckett data sample, with only a marginal difference between the predicted heat loss and the measured data (see Figure 14, coefficient of heat-loss graph).

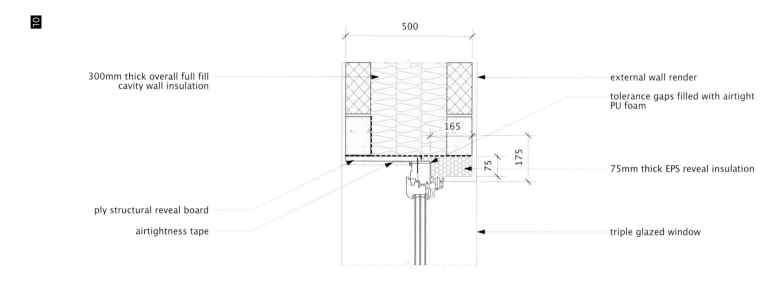

10

300mm thick overall full fill cavity wall insulation

ply structural reveal board

airtightness tape

external wall render

tolerance gaps filled with airtight PU foam

75mm thick EPS reveal insulation

triple glazed window

500

165

75

175

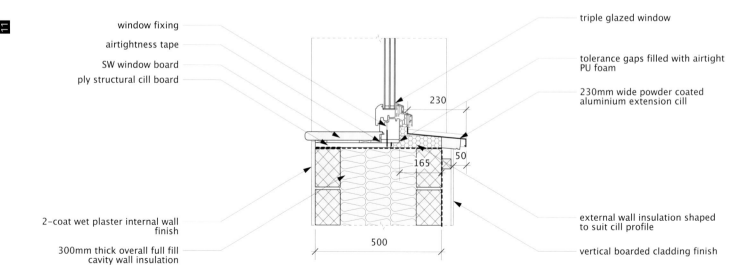

11

window fixing

airtightness tape

SW window board

ply structural cill board

triple glazed window

tolerance gaps filled with airtight PU foam

230mm wide powder coated aluminium extension cill

230

165

50

2-coat wet plaster internal wall finish

300mm thick overall full fill cavity wall insulation

external wall insulation shaped to suit cill profile

vertical boarded cladding finish

500

10 Cavity wall window head
11 Cavity wall window cill
12 Cavity wall ground floor to wall junction

12

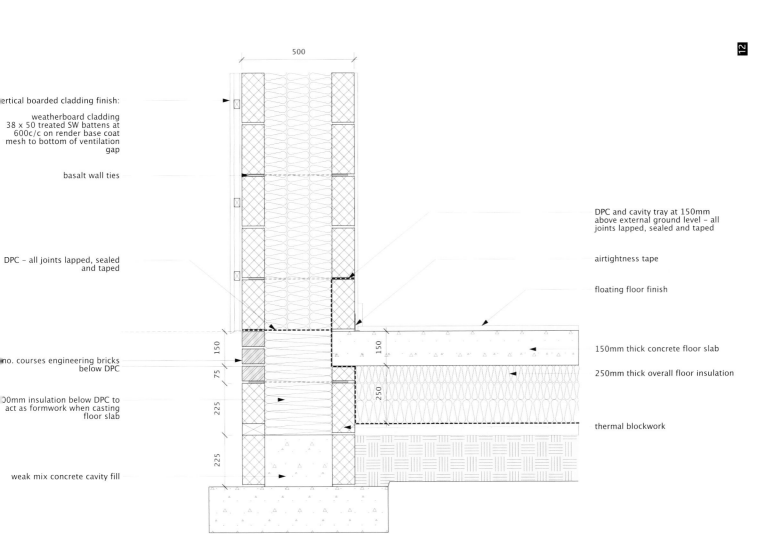

vertical boarded cladding finish:

weatherboard cladding
38 x 50 treated SW battens at
600c/c on render base coat
mesh to bottom of ventilation
gap

basalt wall ties

DPC – all joints lapped, sealed
and taped

no. courses engineering bricks
below DPC

00mm insulation below DPC to
act as formwork when casting
floor slab

weak mix concrete cavity fill

500

150

75

225

225

150

250

DPC and cavity tray at 150mm
above external ground level – all
joints lapped, sealed and taped

airtightness tape

floating floor finish

150mm thick concrete floor slab

250mm thick overall floor insulation

thermal blockwork

Monitoring and post-occupancy feedback

For most of the residents, living in a Passivhaus will have been a new experience, but fortunately for the group a number of members had building and project management expertise that included some familiarity with Passivhaus. Experiences of running the homes are shared and high levels of support provided for all the members by the volunteers with building-services experience. Filter changing in the mechanical ventilation with heat recovery (MVHR) units is organised by one group member, with a bulk order of filters arriving twice a year from the Green Building Store, which supplied the German MVHR units. The ventilation controller has a calendar-type indicator counting down to the next filter change, but no warning that a filter may have become blocked is provided by the system. This is the only minor criticism of the otherwise well thought-out and usable ventilation controls.

Until quite recently whole-house ventilation systems were rare in the UK, but a rapid uptake in mainstream housing has prompted concerns about the industry's ability to design, install and commission such systems (see NHBC Foundation report NF 52).[113] In the UK market there are plenty of low-specification 'rebadged' products but the demand for high-performance equipment (essential for Passivhaus operation) is low, leading to some frustrations – there was no English language technical or user manual for the Forgebank units, and filters are relatively expensive compared with prices in mainland Europe. (The literature problem was overcome by the support team at the Green Building Store, and German-speaking co-housing members.) The group engaged experienced Passivhaus designers at the outset, helping to ensure that the ventilation system was carefully designed, minimising pressure losses with short duct lengths and planning the position of outlets and return air grilles carefully – but most importantly, there was no cutting corners on the specification of the units. Some minor lifestyle adjustments have been necessary at Forgebank. Some residents have had to stop using candles and tea lights, which after some investigation were proven to be the cause of premature filter contamination. Many respondents in the BUS survey noted a drier air quality, compared to their previous homes,[114] though this was not perceived to be problematic, and where limited monitoring has been done internal conditions have been shown to be near optimal for internal humidity. In the future strategies may be required for dealing with summer overheating – although there are extensive balcony shades the MVHR unit does not have a summer bypass – using the windows for purge ventilation and internal blinds to provide some shading in the living space (Figure 13).

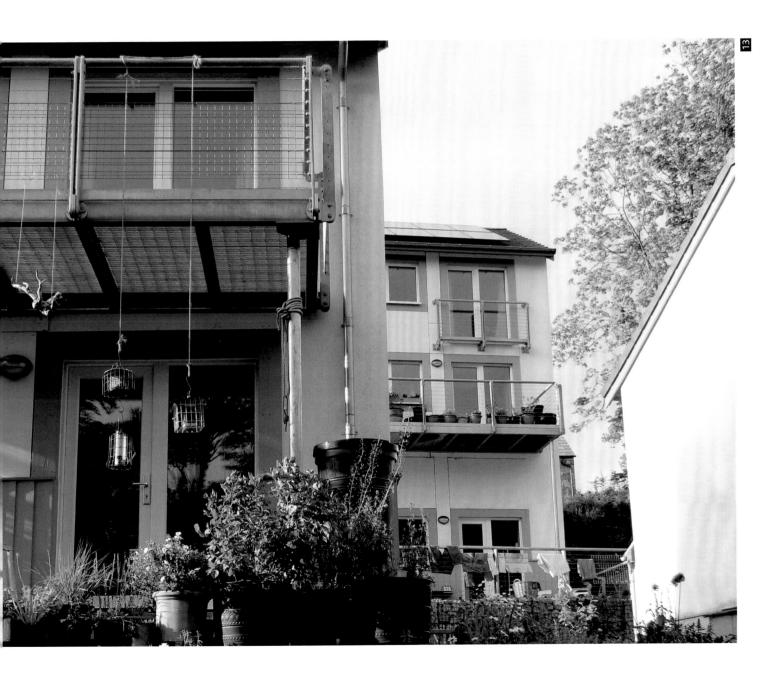

Conclusions

As with other Innovate UK projects that have measured well and showed high levels of user satisfaction, there is a demonstrable link between the commitment of the client team in devising the brief and developing the design, and the continuation of that commitment through the construction team. At Forgebank a conscientious and skilled contractor maintained the project objectives from first procurement through to handover. When the scheme was completed it was one of the largest certified Passivhaus projects in Europe. Passivhaus, through its design protocol (Passivhaus Planning Package, or PHPP) and accreditation of products and components, embeds quality standards and controls. But it is a demanding standard to execute for our building culture, which has embraced a plethora of design standards and targets but has not been focused on outcomes and measured quality. Forgebank is a frequently visited exemplar, and offers monthly tours.
The account of the detailing and construction of Forgebank published in *Green Building* magazine between Winter 2011 and Spring 2013[115] holds many insights and lessons for the aspiring low-energy neighbourhood or community.

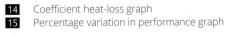

14 Coefficient heat-loss graph
15 Percentage variation in performance graph

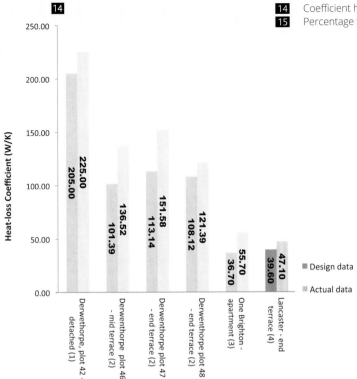

14

Heat-loss Coefficient (W/K)

- Design data
- Actual data

Derwethorpe, plot 42 - detached (1): 225.00 / 205.00
Derwenthorpe plot 46 - mid terrace (2): 136.52 / 101.39
Derwenthorpe plot 47 - end terrace (2): 151.58 / 113.14
Derwenthorpe plot 48 - end terrace (2): 121.39 / 108.12
One Brighton - apartment (3): 55.70 / 36.70
Lancaster - end terrace (4): 47.10 / 39.60

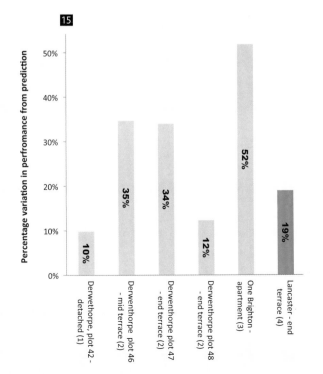

15

Percentage variation in perfromance from prediction

Derwethorpe, plot 42 - detached (1): 10%
Derwenthorpe plot 46 - mid terrace (2): 35%
Derwenthorpe plot 47 - end terrace (2): 34%
Derwenthorpe plot 48 - end terrace (2): 12%
One Brighton - apartment (3): 52%
Lancaster - end terrace (4): 19%

Title	Forgebank Co-Housing
Location	Halton, Lancaster
Building type	41 houses – 6 freehold, 35 leasehold, all private (and community facilities)
Completion date	March 2012

The discrepancy between predicted and measured heat loss for the Lancaster home is less than at Derwenthorpe and One Brighton. The design emphasis on reducing thermal bridging and the site supervision and verification demanded by PH Certification will have contributed to the result. Beware, however – although the design target is very low the Lancaster dwellings are also very small compared with the other houses on the graph (approx 30% of the floor area of Derwenthorpe Plot 42). The heat-loss coefficient is the total for the dwelling, not the heat loss per unit of area. Refer also to the full Innovate UK report for the challenges to researchers using co-heating tests to measure Passivhaus homes.

(1) Testing conducted by S. Stamp, R.Lowe and H. Altamirano, from the UCL energy institute and provided by the Joseph Rowntree Foundation
(2) Testing conducted by D. Miles-Shenton, D. Farmer and P. Matthew from Leeds Beckett University and provided by the Joseph Rowntree Foundation
(3) Data from UCL (2014) 'One Brighton – ongoing monitoring'
(4) Data from F. Stephenson and D. Johnston, (2014), 'Lancaster co-housing development', Innovate UK)

Conclusions

It is reassuring to know that there are practices, professionals and academics who are dedicated to understanding how our buildings work, and are willing to share this information – as is evident from the breadth of case studies and essays in this book. However, the case studies; Innovate UK research programme; and discussions with contributing authors, architects and engineers make clear that there are also a number of emerging themes and areas of concern.

Firstly and most alarmingly there are some practical issues that recur regularly, including:

- the industry's failure to establish clear protocols for setting up and commissioning building management systems
- the frequent issues with sub-metering
- in the domestic sector, the unfamiliarity generally with the installation, servicing and commissioning requirements of ventilation systems.

If we fail to address these first two systemic problems it is very unlikely that we will ever be in a position to improve building performance. How can we get started if the basic diagnostic information is not in place? In the domestic sector, where whole-house ventilation is becoming more common, we desperately need the training and accreditation schemes that can guarantee that the relevant skills are taken up. Perhaps we will see a new trade specialising in this field, rather than leaving the critical installation of ductwork to general labourers and the commissioning and balancing to electricians, as we do now. In the meantime it is estimated that nearly a quarter of new homes every year are being handed over with mechanical ventilation and heating recovery (MVHR) systems.[116] Given the findings of the Innovate reports and the research by the NHBC Foundation there must be serious doubts over their performance, and whether adequate indoor air quality is being achieved.

In addition, despite many projects following similar protocols for the collection of information (for example the TM22 methodology) there remain challenges around getting this into a format that is meaningful and understandable to a wider audience, including designers. This is particularly the case when predictive models focus on regulated energy only, making comparisons with

in-use energy difficult. There needs to be a much clearer and more explicit understanding of what is being predicted and how data will be collected.

There are ongoing efforts by industry to collect and publish data on energy performance, notably projects like CarbonBuzz or the Building Data Exchange from the Innovate UK research programme. This data is intended to be used to spot trends and identify benchmarks. We have found that the context of the data can be as valuable for designers as the aggregated information – for example learning how to optimise ventilation strategies, or understanding operational problems with particular technologies. In addition, the most valuable benchmarks are those that relate to previous projects by the same team, where there is a clear understanding of what the benchmark represents and how feedback can be applied. For example, Heelis was used as the most relevant benchmark for the Woodland Trust building.

Another recurring theme is the balance between complexity and simplicity in technology and building services, and also in building design and form. Here the designers' skills must be honed. Understanding the energy model is essential to avoid unnecessary complication, which impacts on energy performance, and also to inform design decisions. We need to be aware of energy-related improvements that might be needed generally to balance specific architectural invention and delight. We need to acquire what Bill Gething describes as 'energy literacy'. The spatial and structural ingenuity of a building such as John Hope Gateway creates its own challenges. The structural timber roof, visually expressed but passing from inside the thermal envelope to outside, creates bridges for heat losses and complexity in detailing. The well-used terraces with their overhanging canopies extend the internal spaces outwards, but the constant activity and movement from inside to out throws up another set of dilemmas for the economical control of the internal environment. In the schools projects designed by Architype there is a noticeable trend towards simplicity in the later buildings, arising from a better understanding of the energy model and the buildings in operation. But at what point does this simplification become too reductive – with the energy model determining or even overriding inventive design? The answer must surely be easier to find if the development and understanding of the energy model is in the control of the designers and not executed remotely for separate compliance purposes. Likewise, we must be wary of the complexity in services and operation that seems to make buildings difficult to use, inefficient and wasteful in their running, but also in the redundancy of under-used or unused technology that Dr Judit Kimpian identifies. Here the compliance

regime and the sustainability certification system must be partly at fault, but without real-world feedback it is hard to see where these processes can be improved, or regulation made more appropriate for buildings in use.

We are fortunate to have had such a concentrated investment in building research realised in the Innovate UK programme, but it is regrettable that much of the learning has to be extracted from lengthy reports and data. Will it help to improve practice and regulation? The information gathered may be there to be 'mined', but the network of experts and the culture of cross-disciplinary study have dissolved. In the future we will need to look to the enlightened clients in university estates departments and in organisations such as the UK Green Building Council and Better Buildings Partnership, which have started to publish data and promote performance-led processes. These are also the client bodies that seem best placed to set benchmarks.

We also need to find ways of valuing other aspects of design as part of the building performance evaluation process. Several projects in this study – Greenfields, John Hope Gateway and the WWF Living Planet Centre – have both administrative and public functions, and the success of the public activities in each, including unforeseen numbers of visitors, has made comparison between predicted and actual performance harder. In these situations it is important to be able to understand that this, in part, is a measure of the success of the building. Therefore, when considering the performance gap it must be understood in the context of other issues and the wider impacts of our buildings. In Derwenthorpe, although the average energy use in the homes by residents was smaller than the average in York, their transport use was much higher. Derwenthorpe is a desirable place to live, attracting people from a wide area but in many cases increasing their travel distance to work. Understanding and being able to balance the diverse ways in which design and use come together will be important in the future so we can reduce overall energy use.

In the professions we continue to embrace sustainability to the point where nearly all buildings claim some sustainable credentials – often expressed through 'badges' and accreditation, but with little hard evidence that these good intentions are being delivered. Universities and professional bodies have yet to act in a coordinated way to bring together research so that professionals can improve their practice.

Finally, collectively we have not found ways of consistently working together with fellow consultants, contractors, occupiers and building managers that can reinforce and improve the profession. We believe there is a case for a different approach, calling as others have for a 'new professionalism' in which the responsibility for creative endeavour continues beyond the issuing of a completion certificate or a handover. This carries with it three undertakings: that we assume responsibility for our building's operation; that we

acknowledge mistakes and recognise failures, for improvement and for learning; and that we undertake to learn from the user experience of our buildings. Implicit in this approach is an emphasis on outcomes and the processes that achieve them, rather than standards.

It may seem regrettable that policy commitments to zero-carbon buildings have faltered, but perhaps in this pause – and it must surely only be a pause – we can take stock of whether our approach and our professional duty should be reappraised.

References

1 PROBE (Post Occupancy Review of Buildings and their Engineering) – the case studies are still a valuable reference source that can be accessed from the Usable Buildings Trust: www.usablebuildings.co.uk and CIBSE www.cibse.org

2 Wolfgang Preiser, Harvey Z Rabinowitz and Edward T White, *Post-Occupancy Evaluation* (Routledge Revivals, 2015). See also, Wolfgang Preiser, *The Evolution of Post-Occupancy Evaluation: Toward Building Performance and Universal Design Evaluation* (University of Cincinnati, 2002).

3 Bill Bordass, POE and Feedback: *Getting Started* (Usable Buildings Trust, 2006).

4 Mark Way, Bill Bordass, Adrian Leaman and Roderic Bunn, *The Soft Landings Framework*, Second Edition BSRIA BG 54/2014 (BSRIA and the Usable Buildings Trust, 2014).

5 www.busmethodology.org

6 TM 22: Energy Assessment and Reporting Methodology (CIBSE, 2006): www.cibse.org/Knowledge

7 www.carbonbuzz.org

8 Paul Fletcher and Hilary Satchwell, Briefing: *A Practical Guide to RIBA Plan of Work 2013 Stages 7, 0 and 1* (RIBA Enterprises, 2015).

9 Penoyre & Prasad, *Retrofit for Purpose* (RIBA Publishing, 2013).

10 Committee on Climate Change, 2013 *Progress Report to Parliament*, Chapter 3: 'Progress Reducing Emissions from Buildings': www.theccc.org.uk/wp-content/uploads/2013/06/CCC-Prog-Rep-Chap3_singles_web_1.pdf

11 The PROBE Studies can be viewed at www.usablebuildings.co.uk, a review of which can be found in *Building Research & Information*, special issue on post-occupancy evaluation, 29(2), March–April 2001.

12 Summary reports of the programme can be found at: buildingdataexchange.org.uk/

13 'Innovate UK building performance evaluation Programme: Findings From Non-Domestic Projects: Getting the Best from Buildings' (Innovate UK, 2015), available at: buildingdataexchange.org.uk/wp-content/uploads/bpe/BPE%20Final%20Non_Domestic_Report_PDF.pdf

14 'Overheating in Homes: The Big Picture', (Zero Carbon Hub, 2015): www.zerocarbonhub.org/sites/default/files/resources/reports/ZCH-OverheatingInHomes-TheBigPicture-01.1.pdf

15 'CIBSE TM46 Energy Benchmarks' (CIBSE, 2008): www.cibse.org/knowledge/cibse-tm/tm46-energy-benchmarks

16 www.buildingdataexchange.org.uk

17 Fletcher and Satchwell, *Briefing* (2015).

18 www.bimtaskgroup.org/gsl/

19 www.bsria.co.uk/services/design/soft-landings/

20 'L2A Conservation of Fuel and Power in New Buildings Other Than Dwellings': www.planningportal.gov.uk/uploads/br/BR_PDF_AD_L2A_2013.p

21 CarbonBuzz, a RIBA/CIBSE platform: www.carbonbuzz.org/

22 www.gov.uk/government/publications/display-energy-certificates-and-advisory-reports-for-public-buildings

23 'TM54 Evaluating Operational Energy Performance of Buildings at the Design Stage' (CIBSE, 2013): www.cibse.org/knowledge/cibse-tm/tm54-evaluating-operational-energy-performance-of

24 'BREEAM UK New Construction Non-domestic Buildings Technical Manual 2014' (BRE Global, 2014): www.breeam.com/BREEAMUK2014SchemeDocument/

25 PROBE Studies: Energy for Sustainable Development, William Bordass Associates, 'Building Use Studies and Target Energy Services', *Building Services Journal* (1995–2002). Carried out under the Partners in Innovation scheme (jointly funded by the UK government and the Builder Group, publisher of *Building Services Journal*): www.usablebuildings.co.uk/

26 For the full reports see 'Closing the Gap Between Design and As-Built Performance: End of Term Report' (Zero Carbon Hub, 2014): www.zerocarbonhub.org/sites/default/files/resources/reports/Design_vs_As_Built_Performance_Gap_End_of_Term_Report_0.pdf and 'Closing the Gap Between Design and As-Built Performance: Evidence Review Report' (Zero Carbon Hub, 2014): www.zerocarbonhub.org/sites/default/files/resources/reports/Closing_the_Gap_Between_Design_and_As-Built_Performance-Evidence_Review_Report_0.pdf

27 Lowe, R.J. et al., 2007. Evidence for heat losses via party wall cavities in masonry construction. *Building Services Engineering Research and Technology*, 28(2), pp.161–181.

28 Tom Dollard, *Builders' Book: An Illustrated Guide to Building Energy Efficient Homes* (Zero Carbon Hub, 2015).

29 Tim Clark, 'AJ Housing Survey: Post Occupancy not on Architects' Radar': www.architectsjournal.co.uk/home/aj-housing-survey-post-occupancy-not-on-architects-radar/8678486.fullarticle

30 Delivering buildings with virtuous circles of learning is discussed in Adrian Leaman, Fionn Stevenson and Bill Bordass, 'Building Evaluation: Practice and Principles', *Building Research & Information*, 38(5), p. 564.

31 For an expanded discussion on this project please see Simon Bradbury (2015), 'Interrogating the Dynamics of Regulation in the Design of Energy Performance of Housing', *Architecture and Culture*, 3(3).

32 www.schosa.org.uk/content/schosa-conference-2015

Gupta, R. (2014) *Embedding post-occupancy evaluation in architectural education: from specialism to mainstream*. Available at: http://architecture. brookes.ac.uk/news/resources/Embedding-POE-into-arch-education-AAE-conference-2014.pdf [Accessed 31 August 2016].

Claire Jamieson, 'The Future of Architects', RIBA: www.buildingfutures.org. uk/assets/downloads/The_Future_for_Architects_Full_Report_2.pdf

Further discussion on the value of good design can be found in F. Samuel, 'Accentuate the Positive', *RIBA Journal*, July 2014.

The schools are St Luke's CE Primary School (2006–2009); the Willows Primary & SEN School (2006–2010); Oak Meadow Primary School and Bushbury Hill Primary School, both delivered at the same time (2009–2011); and Wilkinson Primary School (2012–2014).

The Soft Landings programme is to enable the delivery of better buildings; a BSRIA defined process.

(Passivhaus) Primary Energy is the total amount of regulated (heating, hot water, etc.) and unregulated (plug loads, small power, appliances, IT, etc.) energy consumed in the building. It is measured at the raw source (e.g. coal/oil/biomass/renewable) prior to conversion to usable energy (e.g. electricity) and prior to delivery to the building through the National Grid, where losses are incurred.

Architype was assisted greatly in this journey by a number of organisations and individuals including the AECB members, Elemental Solutions and WARM, and by design team consultants E3 and Price and Myers.

From *Building Research & Information*, 44(1), January–February 2013, Table 1, p. 6. See also 'Collaboration for Change: The Edge Commission Report on the Future of Professionalism', *The Edge* (May 2015).

Collaboration for Change: The Edge Commission Report on the Future of Professionalism, 2014: www.edgedebate.com/wp-content/uploads/2015/05/150415_collaborationforchange_book.pdf

Building Research & Information: Special Issue on New Professionalism guest edited by Bill Bordass and Adrian Leaman, volume 41, number 1, January/February 2013: www.tandfonline.com/toc/rbri20/41/1

S. O'liveira, E. Marco and B. Gething, 'What do we say we teach about energy? Viewed through the lens of UK architecture undergraduate education', 2015, 7th International Conference on Engineering Education for Sustainable Development, Vancouver, Canada, 9–12 June 2015. Vancouver, Canada: cIRcle, University of British Columbia: eprints.uwe. ac.uk/25709

ACE Performance Gap Paper: www.ace-cae.eu/uploads/tx_jidocumentsview/521GA213Perform-GapEN.pdf

C. Robertson and Dejan Mumovic, 'Assessing Building Performance: Designed and Actual Performance in the Context of Industry Pressures', Proceedings of Sustainable Building Conference 2013, Coventry University.

[46] www.carbonbuzz.org

[47] *Technical Memorandum No. 46* (CIBSE, 2008).

[48] www.carbontrust.com/media/81361/ctg047-closing-the-gap-low-carbon-building-design.pdf

[49] buildingdataexchange.org.uk

[50] connect.innovateuk.org/web/design-and-decision-tools

[51] retrofit.innovateuk.org/

[52] connect.innovateuk.org/web/design-for-future-climate

[53] Jason Palmer, Daniel Godoy-Shimizu, Amy Tillson and Ian Mawditt, *Building Performance Evaluation Programme: Findings from Domestic Projects* (Innovate UK, 2016).

[54] Jason Palmer, Nicola Terry and Peter Armitage, *Building Performance Evaluation Programme: Findings from Non-Domestic Projects* (Innovate UK, 2016).

[55] Esfand Burman, *Building Energy Performance Gap: A Way Forward*, Building Performance Evaluation – Understanding the Performance Gap, University College London, 15 February 2016, www.zerocarbonhub.org.

[56] Paul Ruyssevelt: http://www.carbonbuzz.org/downloads/PerformanceGap.pdf

[57] Palmer *et al*., *Building Performance Evaluation Programme* (Innovate UK 2016).

[58] Judit Kimpian, Esfandiar Burman and Sophie Chisholm. 'Final Report for Building Performance Evaluation on Three New Build Academies: Academy 360, Petchey Academy and Stockport Academy', Innovate UK Building Performance Evaluation Programme, Project no. 1798–16365.

[59] Jason Palmer, Daniel Godoy-Shimizu, Amy Tillson and Ian Mawditt, *Building, Performance Evaluation Programme: Findings from Non-Domestic Projects* (Innovate UK, 2016)' (2013).

[60] Kimpian *et al*. (2013), 'Final Report for Building Performance Evaluation on Three New Build Academies: Academy 360, Petchey Academy and Stockport Academy', Innovate UK Building Performance Evaluation Programme, Project no. 1798–16365. (2013)

[61] www.wellcertified.com

[62] www.busmethodology.org.uk

[63] Kimpian, *et al.* 'Final Report for Building Performance Evaluation on Three New Build Academies: Academy 360, Petchey Academy and Stockport Academy', Innovate UK Building Performance Evaluation Programme, Project no. 1798–16365 (2013).

[64] Judit Kimpian, Jamie Bull and Esfandiar Burman, 'Final Report for building performance evaluations on Pool and Tremough Innovation Centres', Innovate UK building performance evaluation Programme, Project no. 450043 (2015).

[65] Esfandiar Burman, Judit Kimpian and Dejan Mumovic, 'Towards an integrated building energy assessment framework to account for the externality of performance gap', Proceedings of the First International Conference on Urban Sustainability and Resilience (ISSN 2051-1361), Poster Presentation, 5–7 November 2012, University College London (2012).

[66] Esfandiar Burman, 'Assessing the Operational Performance of Educational Buildings against Design Expectations: A Case Study Approach', EngD Urban Sustainability and Resilience, University College London (2015).

[67] Judit Kimpian, Esfandiar Burman, Jamie Bull, Greig Paterson and Dejan Mumovic, 'Getting Real about Energy Use in Non-Domestic Buildings', Proceedings, CIBSE ASHRAE 2014 Technical Symposium, Dublin, Ireland, 3–4 April 2014 (2013).

[68] Bill Bordass, Ken Bromley and Adrian Leaman, 'Comfort, Control and Energy Efficiency in Offices', BRE Information Paper IP 3/95 (February 1995).

[69] Building Research & Information, special issue on post-occupancy evaluation, 29 (2), (March–April 2001).

[70] Bill Bordass, 'Flying Blind – everything you wanted to know about energy in commercial buildings but were afraid to ask', Association for the Conservation of Energy and EEASOX (October 2001).

[71] Frank Duffy, 'Reflections on Stage M: The Dog That Didn't Bark', in Shauna Mallory-Hill, Wolfgang Preiser and Chris Watson (eds), *Improving Building Performance*, Chapter 26, pp. 315–320 (Wiley, 2012).

[72] J. Fairclough, 'Rethinking Construction Innovation and Research', Department of Transport, Local Government and the Regions (DTLR, 2002).

[73] Malcolm Bull, 'What is the rational response?', *London Review of Books* 34(10) 3–6 (24 May 2012).

[74] T. Markus, P. Whyman, J. Morgan, D. Whitton and T. Maver, *Building Performance* (Wiley, 1972).

[75] Frank Duffy, 'Linking theory back to practice' *Building Research & Information* 36(6), (2008), pp. 655–758.

[76] *Building Research & Information*, special issue on post-occupancy evaluation, 29(2), (March–April 2001).

[77] Jason Palmer and Peter Armitage, *Building Performance Evaluation Programme*: Early Findings from Non-Domestic Projects (Innovate UK, November 2014).

[78] Mark Way, Bill Bordass, Adrian Leaman and Roderic Bunn, *The Soft Landing Framework*, Second Edition, BSRIA BG 54/2014 (BSRIA and the Usable Buildings Trust, 2014).

[79] Bordass, *Flying Blind* (October 2001).

[80] Robert Cohen and Bill Bordass, 'Mandating Transparency About Building Energy Performance In Use', *Building Research & Information* 43(4), (2015), pp. 534–52.

[81] www.carbonbuzz.org/

[82] Robert Cohen, Barry Austin, Paul Bannister, Bill Bordass and Roderic Bunn, 'Design for Performance: A Scheme to Guarantee New Build Energy Performance', CIBSE Technical Symposium, Heriot-Watt University, Edinburgh (14 April 2016).

[83] See http://www.busmethodology.org/ for further information.

[84] See David Johnston, Dominic Miles-Shenton, Jez Wingfield, David Farmer and Malcolm Bell, (2010), 'Whole House Heat Loss Test Method (Coheating)': www.leedsmet.ac.uk/as/cebe/projects/coheating_test_protocol.pdf

[85] David Butler and Andy Dengel, 'A Review of Co-Heating Test Methodologies', NHBC Foundation: www.nhbcfoundation.org/Publication Primary-Research/Review-of-co-heating-test-methodologies-NF54

[86] See www.cibse.org/knowledge/cibse-tm/tm22-energy-assessment-reporting-methodology for further information

[87] A full report of the post-occupancy evaluation of the building is included Pete Burgon and Bill Bordass, 'Woodland Trust HQ, Building Performance Evaluation: Final Report' (Innovate UK, 2014): buildingdataexchange.org.uk wp-content/uploads/2015/11/450028-Woodland-Trust-HQ.pdf

[88] A full report of the post-occupancy evaluation of the building is included in Richard Partington Architects, 'Greenfields Community Housing Headquarters, Building Performance Evaluation, Final Report' (Innovate UK 2014): buildingdataexchange.org.uk/wp-content/uploads/2015/11/45000 Greenfields-Community-Housing-Headquarters.pdf

[89] A full report of the post-occupancy evaluation of the building is included in 'Crawley Library, Building Performance Evaluation: Final Report' (Innovate UK, 2014): buildingdataexchange.org.uk/wp-content/uploads/2015/12/450003-Crawley-Library.pdf

[90] The design prediction was estimated using BRUKL calculations (which follow Part L Regulations) and CIBSE TM54. BRUKL calculations do not account for all end uses and include only heating, hot water, cooling, fans and pumps, and fixed internal lighting. Other end uses such as small

ower, server rooms, lifts, catering and external lighting were added
ollowing the guidance provided in TM54 in order to compare actual
nergy use with a more accurate design estimate. The results were
resented in Rajat Gupta and Mariam Kapsali, 'A tale of two civic buildings:
omparative evaluation of the actual energy performance of a "sustainable"
ommunity centre and a public library building', Proceedings of CIBSE
echnical Symposium 2015, 16–17 April 2015, London (2015).

cotech Issue 21, November 2009.

ee Case Study 7: Living Planet Centre for a simple and elegant alternative
olution.

aper to Passivhaus conference on Passivhaus school design by Nick Grant
nd Alan Clarke (2013).

O₂ emissions provide a proxy for ventilation, however rates below
,000ppm do not guarantee that there is adequate ventilation for the
emoval of other indoor air pollutants; see M.G. Apte, W.J. Fisk and J.M.
aisey, 'Associations Between Indoor CO2 Concentrations and Sick
uilding Syndrome Symptoms in U.S. Office Buildings: An Analysis of the
994–1996 BASE Study Data', Indoor Air, 10(4) (2000), pp. 246–57.

ww.carbonbuzz.org

he regulated energy of a building is the energy used for heating, cooling
nd fixed services such as lighting, pumps and fans, but it does not include
he energy used for operating computers, servers, security systems and
lug-in equipment (which all contribute to a significant portion of the
verall use). The essays by Bill Bordass and Judit Kimpian explain why
egulated energy is a rather unhelpful concept for designers and clients
ying to understand overall building performance.

s reported in the UK Green Building Council on-site learning study: www.
kgbc.org/resources/case-study/case-study-site-learning-wwf-living-planet-
entre

id.

ood Homes Alliance Monitoring Programme 2011–2013: Technical
eport One Brighton – Results from Phase 2: Post-Occupation Evaluation'
014).

nnovate UK Building Performance Evaluation Case Study: One Brighton
ongoing monitoring, project reference 450009' (University College
ondon, Good Homes Alliance, 2014): buildingdataexchange.org.uk/report/
ne+Brighton+-+ongoing+monitoring/800/

esign for Future Climate, Good Homes Alliance Research: Thermal
odelling report on sample flats' (Inkling, 2013).

ww.goodhomes.org.uk/downloads/members/gha-technical-brief-03.pdf

ww.nhbc.co.uk/Builders/ProductsandServices/TechZone/nhbcstandards

104 'Understanding Overheating – Where to start (NF44)' (NHBC Foundation, 2012).

105 'Design for Future Climate, Good Homes Alliance Research' (Inkling, 2013).

106 Deborah Quilgars, Alison Dyke, Rebecca Tunstall and Sarah West, 'A Sustainable Community? Life at Derwenthorpe 2012–2015' (Joseph Rowntree Foundation, 2016): www.jrf.org.uk/report/sustainable-community-life-derwenthorpe

107 Dominic Miles-Shenton, Jez Wingfield, Ruth Sutton and Malcolm Bell, 'Temple Avenue field trial – evaluation of design and construction process and measurement of fabric performance of new build dwellings' (2010): www.leedsbeckett.ac.uk/as/cebe/projects/tap/tap_part1.pdf

108 Quilgars et al., 'A Sustainable Community?' (2016).

109 ibid.

110 Johnston et al., 'Innovate UK building performance evaluation, Post-Construction and Early Occupation Study – Derwenthorpe Coheating Test Report' (Leeds Beckett University, 2013).

111 Andy Dengel and Michael Swainson, 'Assessment of MVHR Systems and Air Quality in Zero Carbon Homes NF 52' (NHBC Foundation, 2013): www.nhbcfoundation.org/Publications/Primary-Research/Assessment-of-MVHR-systems-and-air-quality-in-zero-carbon-homes-NF52

112 Op cit Johnston et al.

113 www.nhbcfoundation.org/publication/assessment-of-mvhr-systems/

114 ibid.

115 Available to download from Green Building Press: www.greenbuildingpress.co.uk/article.php?article_id=2072 ?

116 'Assessment of MVHR Systems and Indoor Air Quality in Zero Carbon Homes', NHBC Foundation NF 52 (NHBC, September 2013).

Index

Image credits

AHR
54, 57, 58/59, 60 – 67

Architype Ltd
50, 51, 52, 129, 130 top, 140 right, 141 right, 142, 143

Atelier Ten
152, 153

Bill Bordass
85 top right

Cullinan Studio
108, 109, 110 right, 111

Dennis Gilbert/VIEW
48/49, 136/137, 138, 139, 140 left, 141 left, 144

Eco Arc
182/183, 183, 184 - 189

Feilden Clegg Bradley Studios
83, 85 left, 161 top, 162 bottom, 163 bottom

Good Homes Alliance
161 bottom

Hopkins Architects
149, 150 top & centre,

James Newton Photographs
113

Janie Airey
22, 146/147, 150 bottom, 151, 156/157

Lancaster Cohousing Company
180/181, 191

Leigh Simpson Photography
12, 126/127, 128, 130 bottom, 131, 133 bottom left, 134

Luke Mills/Eco Arc
44

Morley von Sternberg
148, 154, 155

Oxford Brookes University
122

Paul Raftery
104/105, 106, 107, 110 left, 114

Penoyre and Prasad
119 top, 123 top right

Peter Cook
4, 80/81, 82, 84, 86, 87, 88/89

Procter Photography
68, 171 left

Ramboll UK Ltd
120/121

Sandra Adkins, NHBC
25

Simon Bradbury
36, 42, 91, 103, 115, 124/125, 135, 145, 157 right, 166, 167, 178, 179, 193

Simon Bradbury/Studio Partington
17

Studio Partington
10/11, 94, 95 left, 97, 98 left, 98/99 bottom, 102, 170, 174/175, 176

Tim Crocker
22, 34, 158/159, 160, 162 top, 163 top, 164, 165, 168/169, 171 right, 172, 173, 177

Timothy Soar
92/93, 95 right, 96, 98 top right, 99 top, 100/101, 116/117, 118, 119 bottom, 121 right, 123 bottom left

ZCH
25